Food and Cultural Studies

Food today is an object of particular fascination. While the media industries produce increasingly more sophisticated television programmes, books and magazines devoted to food, widespread anxieties have emerged about the production, distribution and safety of what we eat. This book sets out to develop an analysis of these issues from the perspective of cultural studies, exploring everyday food practices in relation to broader questions about national identity, globalization, consumption and ethics.

Food and Cultural Studies re-examines the interdisciplinary history of food studies, from the semiotics of Barthes and the anthropology of Lévi-Strauss to Elias's historical analysis and Bourdieu's work on the relationship between food, consumption and cultural identity. The authors then go on to explore subjects as diverse as food and nation, the gendering of eating in, the phenomenon of TV chefs, food-related moral panics and the ethics of vegetarianism.

This book will make compelling reading for students and academics interested in both consumption and cultural studies more generally.

Bob Ashley, Joanne Hollows, Steve Jones and **Ben Taylor** all teach media and cultural studies at Nottingham Trent University, UK.

Studies in Consumption and Markets
Edited by Colin Campbell
Department of Sociology, University of York, UK

and Alladi Venkatesh
Graduate School of Management, University of California, Irvine, USA

Consumption has become a major focus of research and scholarship in the social sciences and humanities. Increasingly perceived as central to any successful understanding of the modern world, the meaning of the individual and collective consumption of goods is now a crucial issue at the heart of numerous contemporary debates on personal identity, the social and cultural structure of postmodern societies, and the historical development of modern industrial society. This new series will publish work on consumption related topics across a number of disciplines.

Titles in this series include:

The Dynamics of Advertising
Barry Richards, Iain MacRury and Jackie Botterill

Ordinary Consumption
Edited by Jukka Gronow and Alan Warde

The Changing Consumer
Markets and meanings
Edited by Steven Miles, Alison Anderson and Kevin Meethan

Food and Cultural Studies
Bob Ashley, Joanne Hollows, Steve Jones and Ben Taylor

Marketing Modernity
Italian advertising from fascism to postmodernity
Adam Arvidsson

Food and Cultural Studies

Bob Ashley, Joanne Hollows,
Steve Jones and Ben Taylor

Routledge
Taylor & Francis Group

LONDON AND NEW YORK

First published 2004
by Routledge
11 New Fetter Lane, London EC4P 4EE

Simultaneously published in the USA and Canada
by Routledge
29 West 35th Street, New York, NY 10001

Routledge is an imprint of the Taylor & Francis Group

© 2004 Bob Ashley, Joanne Hollows, Steve Jones, Ben Taylor

Typeset in Goudy by Exe Valley Dataset Ltd, Exeter, Devon
Printed and bound in Great Britain by The Cromwell Press, Trowbridge, Wiltshire

British Library Cataloguing in Publication Data
A catalogue record for this book is available from the British Library

Library of Congress Cataloging in Publication Data
A catalog record for this book has been requested

ISBN 0–415–27038–3 (hbk)
ISBN 0–415–27039–1 (pbk)

Contents

Acknowledgements

Figures 2.1 and 2.3 are reproduced from 'The Culinary Triangle' by Claude Lévi-Strauss, which was first published in *Partisan Review* (volume 34, number 4, 1966), and appear by permission of Professor Lévi-Strauss.

Certain passages from Chapter 10 first appeared in 'Food writing and food cultures: the case of Elizabeth David and Jane Grigson' by Steve Jones and Ben Taylor (*European Journal of Cultural Studies*, volume 4, number 2, 2001) and are reproduced by permission of Sage Publications Ltd.

Preface

This book came out of our experience of team-teaching a new module, The Culture of Food, which had been motivated by a shared realization that our leisure time was increasingly dominated by eating, cooking and shopping for food. Soon after the module was conceived, there appeared a flurry of books such as David Bell and Gill Valentine's *Consuming Geographies* (1997), Alan Beardsworth and Theresa Keil's *Sociology on the Menu* (1997), Alan Warde's *Consumption, Food and Taste* (1997) and Carole Counihan and Penny van Esterik's reader *Food and Culture* (1997). From different disciplinary perspectives, all of these books seemed to be the product of a particular cultural enthusiasm and we became increasingly interested in its relation to the interdisciplinary field of cultural studies. In our discussions of the shape of the module, we were struck by how food had periodically surfaced as an object of interest in cultural studies, yet had never really developed as an area of study. Our decision to explore these issues resulted in this book, and one way of reading it is as an introduction to 'doing' cultural studies through the examination of food cultures.

The book is organized around a series of discrete chapters which foreground some of the key issues in food-cultural studies. We hope it offers an introduction to some key theoretical frameworks for understanding food cultures while, at the same time, developing new ideas through a series of case studies. If there is an underlying thread running through all the chapters, then it is probably the idea of a circuit of culture, developed first by Richard Johnson (1986) and subsequently used and refined by Peter Jackson (1992) and the Open University *Culture, Media and Identities* team (Du Gay *et al.*, 1997). The meaning or 'life story' of any food cultural phenomenon – a foodstuff, a diet, table manners – needs to be understood in relation to five major cultural processes: production, regulation, representation, identity and consumption. For example, the bacon butty we might decide to eat at lunch has

undergone a process of (probably intensively farmed) production, is subjected to a series of regulations from pig-rearing to food retailing. Our consumption of the sandwich, how and where we consume it, carries connotations which probably derive from certain class, gender, ethnic and religious identities as well as the historical forms within which pork has been represented. There is no prescribed journey around the circuit – each process is unthinkable without the rest. While later in the book we show how cultural studies has been accused of privileging some of these processes over others, overall we aim to give some sense of how food culture needs to be seen in the round.

This book couldn't have been written without the patience and support of a wide network of people. The biggest thanks must go to the various publishers and editors who have supported the book. Our students on the module have helped to shape and refine many of our ideas. We would also like to thank the following friends and colleagues who have also contributed to the ideas of this book and lent us materials: David Bell, Viv Chadder, Sam Haigh, Kevin Hetherington, Stuart Laing, Phil Leonard, Rachel Moseley, Bev Skeggs, Dale Southerton, Estella Tincknell and Dave Woods. Special thanks must go to those with whom we most pleasurably eat and cook: Christine Ashley, Jane Dodge, Joe Dodge-Taylor, Mark Jancovich and Annabel Taylor.

1 Food-cultural studies – three paradigms

Mike Leigh's 1991 film *Life is Sweet* depicts a restaurateur called Aubrey, nervously awaiting the opening of his bistro, the Regret Rien. In an attempt to impress a waitress with his *savoir-faire*, Aubrey runs through his first night menu, an offal-rich list that includes hors d'oeuvres of tripe soufflé and saveloy on a bed of lychees. The waitress reacts with horror ('Oh, not brains!') and Aubrey's prospective clientele agree: no one shows up for the opening.

Aubrey's comical menu is, of course, a satire on contemporary food trends. There has indeed been something of an offal boom in recent years, exemplified by London's St John restaurant which features such delights as bone marrow salad and crispy pigs' tails (Henderson, 2000). Equally, there has been a vogue for combining ingredients from different parts of the world in new, and not always appetising, ways. If Aubrey's idea of fusion cooking is a peculiarly distasteful one ('tongues in a rhubarb hollandaise; liver in lager'), it is also one recognizable in newspaper restaurant reviews. This chapter will also attempt to fuse diverse ingredients, though the result is not, we hope, a tripe soufflé. The stew we propose to produce by the end of the chapter is a brief and provisional history of what we will term 'food-cultural studies'. To achieve this we focus on a particular moment in the formation of what has come to be known, generally critically, as 'British' Cultural Studies (see, for example, Turner, 1990; Clarke, 1991; Schwarz, 1994). At a key point in its development a polarization of 'culturalist' and 'structuralist' methods was partially and temporarily resolved through the adaptation of Gramscian hegemonic theory. Analysis of this moment allows us to return to 'the fundamental issue for any kind of cultural study' (Tudor, 1999: 17), namely the complex relationship between power structures of various kinds and human agency. A hegemonic approach is used to suggest one way in which 'dominant' ideologies and the aspirations of subordinate groups might be usefully articulated together. The three sections therefore offer

a modest and critical guide to structuralist, culturalist and Gramscian approaches to the study of food culture, and also a history of food's place in the evolution of cultural studies. In order to ground these theories we will explore three instances of gustatory culture – the pig, the bar and the abattoir. Apologies to the herbivorous, but there is little here, in Aubrey's words, of the prune quiche.

Pork and difference

> It could be said that European civilization . . . [has] been founded on the pig. Easily domesticated, omnivorous household and village scavenger, clearer of scrub and undergrowth, devourer of forest acorns, yet content with a sty – and delightful when cooked or cured, from his snout to his tail. There has been prejudice against him, but those peoples . . . who have disliked the pig and insist he is unclean eating, are rationalizing their own descent and past history.
>
> (Grigson, 1975: 7)

The cookery writer Jane Grigson opens her *Charcuterie and French Pork Cookery* with a moment of bathos. Despite the heroic tone in which the pig is celebrated, the reader will be well aware that the values of civiliz-ation are generally held to exist in opposition to that animal's uncultiv-ated characteristics. Unlike other edible mammals, the pig exists only as the subject or object of digestion. It eats and is itself eaten: it is a signifier of appetite. The pig's appetite enters popular wisdom as something uncontrolled (greedy pig!) and unrefined (dirty pig!), while the civilized appetite is upheld as one moderated by social convention and self-discipline. The pig wallows in its own filth, eating its own and human faeces, while civilization flushes its waste out of sight, if not out of mind.

Why is such a richly symbolic language of dislike constructed around this useful animal? One explanation can be given by returning to Grigson's opening sentence, which harmonizes a perceived opposition between pork and civilization. She notes that rather than being the antitheses of one another, pigs are part of civilization. But in arguing for a redefinition of boundaries, Grigson is pointing precisely to the ways in which mean-ing is generated through separation: civilization is distinct from animality. This distinction is then closely policed through various taboos and symbolic forms which dramatize the disruption of the opposition between civilization and piggishness as a descent into anxiety and danger.

This separation of a highly valued normative category from a threat-ening polar opposite is a common, perhaps universal, way in which

meaning is imposed on the messy material of our world. As the anthropologist Mary Douglas has noted, 'ideas about separating, purifying, demarcating and punishing transgressions . . . impose *system* on an inherently untidy experience. It is only by exaggerating the difference between within and without, above and below . . . with and against, that a semblance of order is created' (Douglas, 1966: 4). Douglas's work is generally considered to be 'structuralist' and structuralist-derived theories were central to cultural studies' early attempts to theorize the places of power and difference within culture. For structuralism, meaning is produced through the systematic generation of difference and the separation of self from other. We need to take a short detour into theory to give some sense of how this hypothesis of a system of difference has been used within food-cultural studies.

Structuralism originates with the linguist Ferdinand de Saussure's *Course in General Linguistics* (1916). As the name 'structuralism' suggests, Saussure was more interested in the deep structure, or form of language than in its content, and his work is an attempt to develop a universal science of language in which all communication corresponds to unchanging rules. Given the dauntingly monumental nature of this task, Saussure begins modestly by studying the most basic aspect of language – the units, or signs, which make up any system of communication. He proposes that we may divide the sign up into two elements: a signifier (in Saussure's system, this will typically be a word, whether spoken or written, but we may also use the terms to cover an image, sound, smell or taste) and a signified (the mental concept or meaning). The relationship between the signifier and signified is, for Saussure, usually an arbitrary one: there is no inherent reason why, for example, the three black marks 'p-i-g' should signify a non-ruminant omnivorous ungulate (this theory may be less convincing in the case of a livestock picture, or the taste of a pork chop, where the relationship seems more straightforward, though here too the signifier is constructed: see Hall, 1997). Instead, Saussure proposes that 'p-i-g' signifies the mental concept 'pig' only by virtue of its difference from other signifiers. 'Pig' signifies the oinking animal because it is not 'fig', 'pug', 'pit' or any number of other signifiers. Meaning

> is wholly a function of difference within a system . . . the 'units' which we wish to understand are purely differential and defined not by their positive content but negatively, by their relations with the other terms of the system. Their most precise characteristic is in being what the others are not.
>
> (Morley, 1992: 67)

Such an organized system of difference begins to account for the abominated position of the pig. Although Saussure hypothesizes an endless chain of differences, the social application of such a system of self and other typically involves a key distinction in which the characteristics of one individual, group or thing are held to be in stark opposition to those of another (man/woman, black/white, etc.) It was the peculiar position of the pig in early industrial society to be the familiar beast against which the developing version of civilized humanness could achieve definition. Conversely, the survival of piggishness in everyday life suggested that civilization had not been fully achieved. For Friedrich Engels, writing during the nineteenth-century heyday of British industrialism, the survival of piggishness was indicative of capitalism's failure to generate a more civilized society:

> [In the valley of the Irk] there are large numbers of pigs, some of which are allowed to roam freely in the narrow streets, snuffling among the garbage heaps, while others are kept in little sties in the courts. In . . . most of the working-class districts of Manchester, pig breeders rent the courts and build the sties there . . . The inhabitants of the court throw all their garbage into these sties . . . impregnating the air . . . with the odour of decaying animal and vegetable matter.
>
> (Engels, 1958: 68)

While in this description the industrial landscape, and the pig's unwholesome place in it, are the products of historical processes (the establishment of the factory system, the movement of rural people into cities, the renting of space for commercial use), Engels later offers a rather different explanation for the pig's survival as 'matter out of place'. Rather than the pig being suggestive of the transitional character of urban society and culture in the mid-nineteenth century, it is an index of the uncultivated nature of those responsible for bringing it to the city: the lumpen, pre-industrial Irish. For the Irish, he writes: 'have brought with them the habit of building pigsties immediately adjacent to their houses. If that is not possible, the Irishman allows the pig to share his own sleeping quarters. . . . The Irishman loves his pig as much as the Arab loves his horse' (ibid.: 106).

The connotations of piggishness are therefore transferable onto other significant others who likewise provide defining differences from the self. For Engels, the piggish Irish provide a negative standard against which the more disciplined English working class are able to define themselves.

This movement of connotations across groups and things is suggestive of a second major structuralist inheritance within food-cultural studies, found within Roland Barthes' *Mythologies* (1972). In this work, Barthes draws a distinction between *denotation* – scientific, value-free description – and *connotation*, in which social, cultural and political beliefs and values become attached to a phenomenon. Barthesian structuralism performs the valuable function of demonstrating how apparently natural or commonsense meanings attach themselves to objects and practices. An example of this is provided by his discussion of the relationship between food, national identity and imperialism in the mythology 'Steak and Chips'.

Barthes begins by reducing steak to its denotative level. Steak, he argues, is a lump of meat in which blood is visible. It 'is the heart of meat, it is meat in its pure state', defined by its 'quasi-rawness . . . blood is visible, natural, dense' (Barthes, 1972: 62). This denotative bloodiness constrains the terms of steak cookery so that they are only expressions of bloodiness – *saignant* (rare) or *bleu* (almost raw) – or euphemisms which obscure cooking's role in the transformation of meat into steak, such as *à point*. Yet as well as limiting meaning, the denotative level also generates meaning in the form of what Barthes calls 'a morality':

> [rare steak] is supposed to benefit all the temperaments, the sanguine because it is identical, the nervous and lymphatic because it is complementary to them. [For intellectuals, steak is] a redeeming food, thanks to which they bring their intellectualism to the level of prose and exorcize, through blood and soft pulp, the sterile dryness of which they are constantly accused.
>
> (ibid.: 62)

The first series of connotations, then, are around rawness, which offers a symbolic separation of the self from the presumed sterility of modern living. Barthes notes that the craze for steak tartare, a combination of raw eggs and ground beef, represents a particularly dense range of meanings about the healthiness of the natural and traditional, as opposed to the 'sickliness' of the modern. This connotation generates further layers of meaning. Despite the invasion of 'American steaks', the steak is a deeply nationalized foodstuff, 'a basic element' in the cuisine of France. It is an edible metaphor for the national family, offering a symbol of consensus across the social classes, figuring 'in all the surroundings of alimentary life: flat, edged with yellow, like the sole of a shoe, in cheap restaurants; thick and juicy in bistros; cubic, with the core all moist

throughout beneath a lightly charred crust, in haute cuisine' (ibid.). Further, this national family is one immersed in a history of military endeavour: 'Being part of the nation, it follows the index of patriotic values: it helps them to rise in wartime, it is the very flesh of the French soldier, the inalienable property which cannot go over to the enemy except by treason' (ibid.). In the conclusion to the essay, these connotations combine to offer a magical resolution to the crisis in French post-war history. At a moment of humiliating withdrawal from its empire, steak and chips are offered as a symbol of the deep horizontal comradeship and natural values hidden beneath the apparent defeat of the 1950s.

From the Saussurean position that signification is produced through difference, Barthes therefore moves to a structuralism in which signification is produced by the transference and combination of meaning. Throughout his work, Barthes is conscious of the centrality of food to other forms of social behaviour, arguing that a 'veritable grammar of food' (Barthes, 1997: 22) is needed to illuminate the range of modern social activities. In a discussion of the business lunch, he observes that:

> To eat is a behavior that develops beyond its own ends, replacing, summing up, and signalizing other behaviors. . . . What are these other behaviors? Today we might say all of them: activity, works, sports, effort, leisure, celebration – every one of these situations is expressed through food. We might almost say that this 'polysemia' of food characterizes modernity.
>
> (ibid.: 25)

Rather than meaning being produced purely through difference, therefore, a more nuanced structuralism sees it as being formed through both differentiation and association. This in turn should make us suspicious of the *completeness* of meaning. Meaning is present as a trace in other signifiers (Frenchness in steak) but it can never be entirely present. Frenchness, or steak, or the business lunch are never fully meaningful in themselves – only through their association with other signs. And further, the 'other' that has been exluded from the self during the process of signification can never be entirely externalised. Within 'Steak and Chips' there are insidious allusions to collaboration, colonial defeat and the American steak. In each sign may be read traces of the signs that have been excluded in order to produce it, or evidence of the strains required to police the boundaries of self and other.

This less stable notion of the sign complexifies our earlier observa
that the notion of the civilized self was formed, during the early mo
period, in opposition to the pig. We may equally observe that any
attempt to exclude piggishness from culture is doomed to demonstrate
precisely the proximity of human and pig. This overlap of apparently
exclusive categories has been extensively reviewed by Stallybrass and
White (1986), who apply to the human–pig relationship a structuralism
heavily influenced by the work of Mikhail Bakhtin, arguing that the
binary oppositions beloved of 'classical' structuralism can generally be
reconceived as 'a heterodox merging of elements' (Stallybrass and White
1986: 46; for more on Bakhtin see Chapter 3). They argue that the pig is
an ambivalent creature, a threshold animal that transgresses major
oppositions between human and animal (the pink pigmentation of the
pig disturbingly resembling the flesh of European babies) and between
outside and inside (pigs were usually kept in close proximity to – and
sometimes within – the house). Food meanings here seem much less
stable than in the Saussurean model.

We have argued then that cultural studies found a number of increas-
ingly complex resources within structuralist-derived theories. What the
various structuralisms *share* is a valuable sense that meaning is not a
wholly private experience, being instead the product of shared systems of
signification. Yet the extent to which these structures are shared often
gives structuralist analysis a pessimistic edge: structures exist prior to
their human subjects, profoundly shaping their consciousness of the
world and limiting their freedom of action within it. In the most austere
versions of structuralism, this amounted to a 'dominant ideology',
occupying people's minds and actions and prohibiting alternatives.

This account of culture is unsatisfactory because people's behaviour is
manifestly not entirely determined by existing structures. Indeed, some
forms of structuralism acknowledge this. As we have seen, Barthes
acknowledges that each class eats a steak that condenses that class's
sense of itself. A more clearly 'culturalist' turn within a structuralist
framework can be detected in Alison James' study of children's sweet-
eating in the North East of England (James, 1982). James observes that
the dialect word 'ket' has different meanings for adults and children. For
the former it is a noun or adjective meaning 'rubbish'. For the latter it is
a generic term for brightly-coloured sweets with splendid names such as
Syco discs and Supersonic Flyers. To comprehend the significance of
these sweets for children, James argues that we need to understand both
the structure of the adult meal and the systematic inversion of adult
structures within the world of the child. The structured rituals of adult

eating include the use of crockery and cutlery, the acceptance of a temporal order of mealtimes and swallowing rather than regurgitation. In all cases kets represent a disruption of the accepted order. Kets are largely unpackaged, passed from hand to mouth with dirty fingers, stuck to the undersides of tables, brought out of the mouth to be shown to others and eaten between meal times. James notes that:

> This ability to consume metaphoric rubbish is an integral part of the child's culture. Children . . . have sought out an alternative system of meanings through which they can establish their own integrity. Adult order is manipulated so that what adults esteem is made to appear ridiculous; what adults despise is invested with prestige.
>
> (1982: 305)

The children's food culture therefore exists both within and in opposition to a dominant familial food structure.[1] James finds within this systematic transgression resources of friendship, humour, self-definition and a resistance to regimentation which all offer alternatives to the current exercise of power. Nonetheless this creativity does not represent a permanent challenge either to the authority of the meal structure or to authority in its wider sense. The childish absorption in kets may be reconceived in structuralist fashion as precisely the illegitimate other against which the legitimate meal is established. Once the child has accepted, and been accepted into, the symbolic adult order he or she will understand the error of a pre-socialized otherness. Yet the question of how people make their own food cultures within dominant structures lingers as a problem. In considering this, we will move some way, socially, from the pigsty and the sweetshop.

Drinks and culturalism

Raymond Williams's 'Culture is Ordinary' (first published in 1958) is an early attempt to redefine 'culture' as something lived and commonplace rather than a collection of timeless works of art. The essay primarily defines culture as a set of expressive practices – print, cinema and television – but there are moments at which the term is used to cover the range of material forms available in post-war Britain, the new world of 'plumbing, baby Austins, aspirin, contraceptives, canned food' (Williams, 1993: 11).

The choice of canned food is uncoincidental. Williams was writing both within and against a tradition associated with the journal *Scrutiny*,

concerned with the ways in which the study of literature might offset the assumed decline of intellectual and moral standards caused by industrialization and 'mass' culture. Williams's brief thoughts on the new material culture engage with a key *Scrutiny*-inspired text, F. R. Leavis and Denys Thompson's *Culture and Environment* (1933). Although the book's main target is the 'standardization and levelling-down [that occurs] *outside* the realm of material goods' (ibid.: 3) at one point it compares the diet of an 'organic' Mexican peasant community with that of the encroaching modern world. While the villagers dine on maize, beans, fruits and vegetables, milk, honey, eggs, meat, rice, chocolate, brandy, *pulque* and beer, mass production is represented only by a shabby shelf of 'canned foods . . . that looked old and unappetizing' (ibid.: 133). The authors invite the English schoolchildren to whom the book is addressed to carry out an audit of their own town, searching for the traces of an 'independent' food community amidst the standardization of modernity.[2] It is important to recognize, despite Williams's misgivings about the commercial world, the significance of his rejection of this binarism of authentic and inauthentic cultural forms.

Equally, Williams stresses the diffusion of *sites* in which culture is (re)produced. Culture may be found not just in the old Britain of villages and university towns, but also in the new suburbs of 'Bootle and Surbiton and Aston'. He begins the essay with a description of moving from Wales to Cambridge as an undergraduate. Upon his arrival, it is in a food space that he experiences the symbolic violence of those who claim authority over culture:

> I was not oppressed by the university, but the teashop, acting as if it were one of the older and more respectable departments, was a different matter. Here was culture, not in any sense I knew, but in a special sense: the outward and emphatically visible sign of a special kind of people, cultivated people. They were not, the great majority of them, particularly learned; they practised few arts; but they had it, and they showed you they had it. . . . If that is culture, we don't want it; we have seen other people living.
>
> (Williams, 1993: 7)

The teashop here is an ideologically loaded space, a residual culture in opposition to the living culture of 'other people'. But a teashop is a curious place from which to consider culture as exclusive. Whatever the precise rituals of tea-drinking at Cambridge in 1939, there is a broad hinterland of mid-century cultures which tea and the teashop provide

points of access to: sites of (often women's) sociality such as the tea-rooms of the inter-war picture palaces, and the railway refreshment room of the film *Brief Encounter* (1945); state institutions such as the workers' canteens and 'British Restaurants' of the Second World War; and cultures of work, such as the Staffordshire Potteries or the Lyons Corner House 'clippies'. Tea and the teashop therefore are 'Bootle and Surbiton and Aston', as much as another inflection of them is Cambridge.[3] So where Williams presents the teashop as a bounded and defensive place, somewhere extraordinary, we might begin to live up to his notion of the ordinariness of culture by thinking not simply of the exclusiveness of the teashop, but also of the meaningful daily practices which cohere in this food space: the ways in which people, as both producers and consumers, put together a food culture with the same richness as Leavis and Thompson's threatened Mexican peasants, albeit one assembled from the goods, practices and institutions of industrialized, mass society.

Williams's work is generally characterized as tending towards 'cultural-ism', an analytical method traditionally seen as incompatible with structuralism. A simplified way of understanding this difference comes from the work of Karl Marx. In *The Eighteenth Brumaire of Louis Napoleon*, Marx notes that people 'make their own history, but . . . they do not make it under conditions chosen by themselves' (in McLellan, 1977: 300). Structuralism may be thought of as tending towards the second part of this observation. Mental and social structures exist prior to their human subjects, organizing people's thoughts and ways of living in ways suitable for the maintenance of an unequal society. Culturalism, on the other hand, recovers men and women making their own histories. Whereas structuralism is anti-humanist in its contention that structures organize people, culturalism is basically humanist in its insistence on the importance of subjective experience. Culturalism has carried out the necessary work of rescuing subordinate social groups from what E. P. Thompson called 'the enormous condescension of posterity' (Thompson, 1982: 12), the sense both that people have been the dupes of ruling social groups and that their creative output has been worthless.

Although culturalism displayed some sensitivity to the ways in which society is divided along varied and often contradictory axes of authority and subordination (gender, ethnicity, sexuality), its notion of 'the people' has largely been a Marxist-indebted one in which questions of class, and particularly the culture of the male working class, have been paramount. British cultural studies, too, has been largely concerned with native manifestations of culture, 'the peculiarities of the English', rather than with those of other nations. In terms of food culture, the most prominent

space for culturalist analysis has been the pub, a paradigmatic, often romanticized space of white working-class Britishness.

Robert Malcolmson's work on middle-class hostility to popular recreations (Malcolmson, 1973) and Gareth Stedman Jones's on the remaking of working-class culture in London (Stedman Jones, 1974) give extensive consideration to the alehouse in their accounts of popular culture. Both authors represent the culture of the people as being under attack in early modernity, though Malcolmson dates the decline of popular festivity to the late eighteenth century and Stedman Jones to the nineteenth. Malcolmson argues that drink was the lubricant that accompanied a host of recreations, including blood sports, village football and fairs, which came under attack during the eighteenth century. Bourgeois interventions against these events and their accompanying bacchanalia were suggestive of more general changes in attitudes and circumstances – specifically the enforcement of discipline on workers making the transition from agricultural to factory time and the ideological privileging of 'fireside comforts' over popular (potentially uncontrollable) revelry.

Stedman Jones argues, slightly differently, that drunken festivity and the pub permitted a temporary and provisional reordering of the class system, in which all classes could indulge: 'the pub was a social and economic centre for all and heavy drinking was as common among employers as among the workmen' (Stedman Jones, 1982: 95). Middle-class interventions against 'Vice' disrupted this cross-class accommodation, but crucially did not lead the working class to adopt middle-class standards of sobriety. Instead, the pub and the music hall became exemplary spaces for working-class leisure, largely inaccessible to those outside that class (and to the majority of working-class women):

> [T]he common people, forced to find new locations for their recreations, turned increasingly to the public house – a 'closed' space inaccessible to members of the governing classes. This process . . . entailed for all classes a privatization of leisure, privatization in the sense that leisure became class bound and impenetrable for those outside the class in question.
>
> (Bennett, 1981: 10)

In historical cultural studies, therefore, the pub has been seen as an exemplary, if contested, site of working-class leisure during the period in which capitalism became consolidated in Britain. In that strand of cultural studies which deals with contemporary life in Britain, however, the pub is usually written about as an institution in decline. Although

conscious of the pub as a site of disruption and danger, Richard Hoggart's *Uses of Literacy* (1957) looks upon it as an authentic space of residual working-class sociality, against which the new and significantly American-ized space of the milk bar appears as a site of unprecedented aesthetic and social breakdown (Hoggart, 1968: 248). Similarly, John Clarke (1979) nostalgically evokes a more authentic past when he analyses the drift towards oligopoly in the brewing industry and the shift in marketing ideologies towards attracting new consumers. The pre-war working class stood in a relationship to the pub which he describes as 'membership', in which the pub was 'a sort of colonized institution', the design and use of which had been moulded by working-class patronage despite that class's lack of formal ownership. The development of a brewing cartel, however, has led to a tendency for freeholders and tenants to be replaced by brewery-controlled managers, for pubs to be closed or redesigned, and for advertising to address previously excluded social groups:

> The new consumer differs from the old in terms of age (s/he is young), class (s/he is classless) and taste (Campari not beer). The effect of this attempt to address the new consumer is to fundament-ally change the social and economic conditions under which drinking takes place . . . these changes function to interpellate a new identity for the drinker – that of the 'consumer' rather than the 'member'.
>
> (Clarke, 1979: 245)

So while culturalism's strength lies in its 'thickened' descriptions of people's lived experiences, the example of the pub points to a central problem with the approach. In attempting to reconstruct an 'authentic' form of working-class culture, culturalist writers are forced up against the highly structured conditions of cultural production in contemporary life. Were we to continue looking for working-class pub culture (or women's, or black-British, or gay pub culture), however much we might wish to give meaning back to people, we would have to confront the power of leisure industries, advertisers and government to reshape landscapes, produce commodities and 'hail' (if not wholly determine) new consumer groups. The presence of these structures, however, disrupts any sense that culture is '*both* the meanings and values which arise amongst distinctive social groups and classes . . . *and* the lived traditions and practices through which these 'understandings are expressed' (Hall, 1981: 26) Faced with the impossibility of holding these two meanings together in the present, culturalism's response has often been nostalgically to affirm the existence of such integrated cultural forms in the past.

A similarly problematic fixation on authenticity can be found in non-British ethnography. Michel de Certeau *et al.*'s *Practice of Everyday Life: living and cooking* (De Certeau *et al.*, 1998), for example, uses food as a paradigm instance of subordinate people's resistant strategies. Although de Certeau himself argues that 'culinary virtuosities' establish 'multiple relationships between enjoyment and manipulation' (ibid.: 3), his co-author Luce Giard's description of his work minimizes this sense of a play of forces, arguing instead that everyday life offers a refuge from dominant forms of cultural production: 'beneath the massive reality of powers and institutions [are] . . . microresistances, which in turn found micro-freedoms, mobilize unsuspected resources hidden among ordinary people, and in that way displace the veritable borders of the hold [of] social and political powers' (ibid.: xxi).

As we have seen in the pub and the teashop, culturalism tends to be interested in the bounded spaces which contain these dramas of micro-domination and microresistance. The spatial isolation of culture works in the same way as culturalism's temporal quest for authenticity: it sets up a zone in which the normal operations of social power appear to be, at least temporarily, suspended. *The Practice of Everyday Life* inscribes two privileged spaces within which disruption of the established order takes place: the neighbourhood described by Pierre Mayol and the woman's body analysed by Giard. Examining these two sites gives some sense of the risk of essentialism within culturalism.

The neighbourhood is the Croix-Rousse district of Lyons, a 'transitional zone' experiencing depopulation, the ageing of its stable population and an influx of new groups such as students and immigrants. These changes involve the closure of the majority of small shops which characterized the district, yet Mayol concentrates on the grocery store run by 'Robert' that has survived the changes and offers a link to earlier modes of community behaviour. The drama in which Mayol constructs this link is a loyalty ritual involving the reward of a bottle of superior quality wine for the purchase of thirty bottles of table wine. Mayol sees the ritual as a neighbourly way in which the district resists the commercial relationships of capitalism:

> We are witnessing here the substitution of buying (which is only commercial, accountable) with exchanging (a symbolic, beneficial surplus); the practice of the neighborhood goes without an important number of middlemen (for example the advertising campaign of the company organizing this game) in order to retain only what is proper for the good functioning of the system of relations. Robert thus offers

the bottle of good wine . . . *much less as a stimulus for higher consump-*
tion of wine than as the sign of a reiterated alliance, continuing to seal the
pact that ties him to his partners-actors.

(de Certeau *et al.*, 1998: 96, emphasis added)

Just as the neighbourhood is made to stand outside or before capitalism,
so Giard's essay on femininity and cuisine constructs a bodily zone which
lies beyond the intrusions of patriarchy (see Chapter 8 for more on
Giard). She deploys women's deportment in the kitchen as a means by
which '*le peuple féminin des cuisines*' have avoided the traps of both mass
culture and a linguistic-patriarchal order:

> Women bereft of writing who came before me . . . I would like the
> poetry of words to translate that of gestures . . . As long as one of us
> preserves your nourishing knowledge, as long as the recipes of your
> tender patience are transmitted from hand to hand and from
> generation to generation, a fragmentary yet tenacious memory of
> your life itself will live on. The sophisticated ritualization of basic
> gestures has become more dear to me than the persistence of words
> and texts, because body techniques seem better protected from the
> superficiality of fashion.
>
> (de Certeau *et al.*, 1998: 154)

Here, then, is an attempt to rescue 'innumerable anonymous women' from
the condescension of posterity. Yet for both Mayol and, more insistently,
Giard, the relationship between subaltern cultures and the dominant
power (capitalism, patriarchy) remain frustratingly undeveloped. Instead,
the impression is given that a subordinate culture can live outside the
master categories of the culture as a whole. Not only does this involve
selective blindness (Giard's claim that deportment is protected from 'the
superficiality of fashion' ignores the body as a site in which fashion is
forcibly materialized), but it also simply accepts the master categories
and reverses their hierarchies (folk or popular culture rather than high
culture, silence rather than sound, the people rather than elites). That a
thickened description of everyday life need not be so coy about the
complex relationships of power between dominant and subordinate
might be illustrated through a food-cultural instance drawn from anthro-
pology, Daniel Miller's examination of soft drinks in Trinidad (Miller,
1997a).

Miller's subject is the 'meta-commodity' – an object used within the
social sciences to illustrate general truths about the relationship between

producers and consumers under global or 'late' capitalism. Miller's chosen meta-commodity is Coca-Cola, and he notes that most writing approaches the significance of the drink through an examination of company strategy, rather than through the meanings consumers make about the drink. Such research typically proposes that the mechanism by which corporate policy translates into consumer response is straightforward and unidirectional. Yet there are empirical grounds for questioning this theory of commodity power. When, in response to the increased popularity of Pepsi, the composition of Coke was changed, consumer hostility to the new formula led the Coca-Cola Company to reinstate 'classic' Coke. Equally, the monolithic authority of the corporation is disrupted by its own production practices: historically, Coca-Cola's success has been based upon a franchising system in which Coke concentrate is sold to local bottling businesses who hold exclusive rights to the drink's distribution in a region. Local marketing practices may therefore be at odds with the globalizing tendencies of the corporation – just as local consumption practices define the way in which the commodity is experienced.

To illustrate this, Miller analyses cola consumption in Trinidad. On the island, sweet drinks are never viewed as imported luxuries that the country or the people cannot afford. Instead they are seen as specifically Trinidadian (they are exported to other Caribbean countries rather than being imported from the United States); as basic necessities (defended by governmental price maintenance) and as the common person's drink (whether drunk plain or as a mixer with rum). Miller notes that various cola franchises are locally bottled by indigenous firms who correspond with the ethnic mix of the island. Although white and Chinese groups form part of this diversity, the key difference is between African-Trinidadians and East Indian-Trinidadians, the former occupying the position of 'mainstream' culture against which the latter provide the crucial embodiment of difference. This distinction is a worrying social contradiction in need of resolution. Coke forms part of a system of soft drink meanings which works to dramatize, and thereby resolve, this ethnic division.

The system of ethnic meaning relies on a binarism between 'red sweet drink' and 'black sweet drink'. The red drink ('Red Spot', 'Kola Champagne') is a 'transformation of the East Indian population' (Miller, 1997a: 178), since it carries marked connotations of Indianness. It is widely assumed to be sweeter than the black drink, just as the Indians are imagined to have particularly sweet tooths as a consequence of their role as indentured labourers in the sugar cane fields. Furthermore, the red drink typically accompanies the Indian's roti as snack meal combination, hence the success in Trinidad of the advertising hookline 'a red and a

roti'. Meanwhile, in part because of its association with rum and coke, the black drink (of which Coke is merely a high-status version) bears urban(e) connotations more associated with the black and white populations. Yet, as Miller shows, these connotations are *re-made* by consumers as a way of overcoming the divisions that inhere within Trinidad, thereby generating a sense of Trinidadian identity:

> In many respects, the 'Indian' connoted by the red drink today is in some ways the African's more nostalgic image of how Indians either used to be or perhaps still should be. So it may well be that the appeal of the phrase 'a red and a roti' is actually more to African Trinidadians, who are today avid consumers of roti. Meanwhile segments of the Indian population . . . readily claim an affinity with Coke. Indeed, to be Trinidadian is to incorporate a range of ethnicities. In a sense, then, the Africans who take 'a red and a roti' are completing their sense of being Trinidadian by ingesting what for them is a highly acceptable version of 'Indian-ness'.
>
> (Miller, 1997b: 35)

Culturalism, therefore, is a food-cultural method which has paid particular attention to the meaningful mundanity of bounded populations. As we have seen, this recovery of meaning has sometimes led to an overestimation of the ability of subordinate groups to reshape their conditions of existence, or has bracketed off the question of structured inequality entirely. But the use of Miller's rather different 'thickened description' shows that one does not have to choose between local meanings and global power structures. The two may be articulated into a complex cultural formation which insists on both the local meanings of commodities and practices and on the interplay between production (itself divided between local and global), regulation and consumption.[4] Nonetheless, although Miller rightly points to the contradictions between local meanings and global power, he does not examine how power is maintained in such an ambiguous situation: his intention is to complexify simplistic analyses of globalization rather than to offer a theory of power itself. Yet, as we have seen, cultural studies has been centrally concerned with power. It is the field's joint articulation of power and agency that we now examine.

Stockyards and hegemony

We have shown that, despite their obvious differences in orientation, structuralism and culturalism share a common belief in a dominant

ideology which is imposed from above and resisted from below. Such an account is an inadequate response to the changing distribution of power in any period. Rather than imposing their will, 'dominant' groups generally govern with some degree of consent from their inferiors, and the maintenance of that consent is dependent upon a constant repositioning of the relationship between ruling and ruled.

An example of such an attempted repositioning is offered by the British monarchy. Following the death of Princess Diana in 1997, Queen Elizabeth took part in a series of publicity events designed to show that the monarch was in touch with the everyday lives of her subjects. These included her making a trip to a drive-in McDonald's restaurant, confiding to a group of schoolchildren that she enjoyed the soap opera *EastEnders* and, most pointedly, taking a tour around a Glasgow housing scheme, ending with the Queen taking tea with a local resident, Susan McCarran. 'Her Majesty', noted the *Guardian* newspaper, 'passed on the chocolate biscuits but was content to drink the Tetley from the best china' (Seenan, 1999: 3). The event and the accompanying image attempted to articulate together heterogeneous and conflictual relationships within the British way of life (the relationship of Scottishness to Englishness, country to city and monarch to subject). Mediating these relationships was the ordinariness of the ritual and its commonplace forms. The episode condensed relations of power in such a way that they seemed mundane and unexceptional: 'I found her very easy to talk to', said Mrs McCarran, giving voice to the strategy of the visit, 'and she was very nice'. In spite of the obvious distance between the monarch and her poor subject the picture and interview went to work on the ground of deeply embedded values and popular traditions to insist that the two women formed part of one nation of tea-drinkers and chocolate biscuit enthusiasts.

Although we may clearly read the consensualizing strategies taking place in the monarch's trip to McDonald's, her tea-drinking and her claim to watch the tea-fetishizing *EastEnders*, few commentators found these efforts convincing. They seemed to be nostalgic invocations of the British people, carried out in the face of the very different, modernizing address to 'the people' that the Labour government had pursued in its early post-election period. Rather than thinking of a singular ruling class, therefore, we might read into this food-cultural episode some of the strains within a ruling historical *alliance* as it reorganized itself in the late twentieth century.

A sensitivity to the complex relationship of domination and subordination is the major bequest to cultural studies of the Italian Marxist Antonio Gramsci. The key term within Gramsci's conceptualization of

how a ruling social group maintains its authority is 'hegemony', and this word differs fundamentally from domination in that while the latter term deals exclusively with the imposition of a group's will, hegemony concerns the way in which a 'fundamental social class' (or group) attempts to exert *moral and intellectual leadership* over both allied and subordinate social groups. In those moments when a ruling group is exerting such leadership, subordinate groups actively subscribe to the values and objectives of their superiors, rather than passively accepting them (as we have seen in the case of structuralism), resisting them, or remaining immune to them (in the case of culturalism). Many British people's fondness for the monarchy is an active identification with a family that seems to embody a number of 'truths' about national life (its fundamental domesticity; its historical continuity).

Yet the Queen's unconvincing Glaswegian photo opportunity suggests that however stable and durable this hegemonic moment might appear, it is not a once-and-for-all achievement. Instead hegemony has to be continually reproduced and renegotiated. In order to not become an historical irrelevance, a ruling power must respond both to new circumstances and to the changing desires of those it rules. This dynamism indicates its flexible and self-policing ability to inhabit the world view of its subordinates, but it also forces it to reshape itself through the incorporation of the culture and aspirations of those on whose behalf it claims to govern. Rather than think of hegemony as something which can be achieved, we therefore need to conceive of it as an ongoing process, operative even at those moments when a ruling power can no longer generate consent.

The arena in which Gramsci sees this unfair exchange taking place is 'civil society', by which he means the whole range of institutions and practices (the media, religion, family life), which exist between the state and the economy. It is one of the gains of a food-cultural approach to see food and drink belonging as much to this realm of civil society as to the economy. While in subsistence or impoverished economies, the guarantee of food sources may cement a group's rule, in societies which are largely free of famine the family meal, the barbecue or the nice cup of tea are cultural forms in which a 'common sense' about the world is reconstructed. Gramsci himself notes that a static view of 'human nature' is contained within the philosopher Ludwig Feuerbach's dictum that 'man is what he eats', against which needs to be set a more dynamic version of food culture (Gramsci, 1991: 354)

To illustrate this remaking of hegemony within food culture, we will analyse one of the more widely considered instances of the popular diet,

the McDonald's hamburger. To understand its contemporary significance, we first need to consider the prehistory of this food form, specifically the development of automated processes of meat rendering in the early twentieth century. While Gramsci has predictably little to say about American food culture, he writes extensively about the emergent form of American factory production which he terms 'Fordism', after the form of production adopted in Henry Ford's motor works. Yet this mode of production emerged within the food industry. Ford acknowledged that his production ideas came from the overhead trolley, used by Chicago meatpackers in dressing beef. Prior to the appearance of assembly lines in the stockyards of Chicago, a single steer might take fifteen minutes to die, and use up several men's labour. But by the first decade of the twentieth century, one 'shackler' working on an assembly line, could hoist seventy carcases in a minute. Upton Sinclair's novel *The Jungle* (first published in 1906), ostensibly a muck-raking investigation of price-fixing and poor hygiene in the stockyards, admiringly describes the thrill of a production line in motion:

> The manner in which they did this work was something to be seen and never forgotten. They worked with furious intensity, literally upon the run. . . . It was all highly specialised labour, each man having his task to do; generally this would consist of only two or three specific cuts, and he would pass down the line of fifteen or twenty carcases, making these cuts upon each.
>
> (Sinclair, 1986: 49)

Sinclair here depicts the 'new type of man suited to the new type of work and productive process' elsewhere discussed by Gramsci. This *embodiment* of new productive processes as a form of progress was essential to Fordism's success. Equally, as scientific management came to be the model for other areas of production, so these changes radiated out into the wider culture. In particular, the production and use of the motor car – the eponymous Fordist commodity – became sedimented within post-Depression American society and culture. It was within this transformed situation that the McDonald's brothers established their first burger bar.

While the history of the McDonald's corporation, is by now fairly well-recorded (see, for example, Rifkin, 1993; Ritzer, 1993 and 1998; Smart, 1994; Perry, 1995; Vidal, 1997; Fischler, 2000; Schlosser, 2001), these analyses tend to concentrate on the corporate dimension of fast food – specifically the tendency towards monopolization and homogenization in the food industry. Without relying on what we have shown to be an

untenable notion of domination, a Gramscian perspective might help us to understand how this situation was established and how it is maintained – and also to recognize both the critical points at which such an organization of the world might begin to be disassembled and the active role of franchisees, managers, workers and consumers in reproducing a situation which is not to their lasting advantage.

As we have seen, a Gramscian account of massifying food culture begins with a change in productive techniques but quickly radiates out into two 'superstructural' issues. First the psychological dimension of hegemony – the way in which a successful hegemonic system must be internalized by the subordinate subject, so that it becomes a part of their identity – and second the ways in which these changes become diffused throughout, and embedded within, civil society, reflexively impacting upon the productive process itself.

The dynamic working-out of these issues is manifested in the history of McDonald's, the logic of whose foundation and expansion can be mapped onto the development of the new productive measures, and onto the identities and cultures which accompanied Fordism, but the specifics of which depended upon a series of contingencies. As we noted, mechanized meatpacking replaced the earlier system of local abattoirs in the nineteenth century. This mechanization became dispersed, initially to cities that grew up as part of the railway network, and later along the interstate highways that grew up in the wake of the motor car's arrival. One of these interstates, Route 66, ran from Oklahoma City to California. While at its inception this route was ideal for the predominantly middle-class Americans relocating west, the 1929 Stock Market crash and the onset of drought on the Great Plains in 1930 saw an exodus to California of impoverished farm workers from the prairie lands of the Midwest. These two migrations provided California with both an entrepreneurial business culture and with a large reserve army of transient and seasonal workers, many of whom would be employed by the aeronautical and military industries, which blossomed as a result of America's entry into the Second World War (Davis, 1990).

The McDonald brothers arrived in this transfigured landscape in the late 1930s. Their Burger Bar Drive-In was established in San Bernardino, the endpoint for millions of Americans streaming west along US 66 and a short distance from the Kaiser steelworks at Fontana. Initially the drive-in was an orthodox restaurant with waiters, crockery and glassware, but in 1948 the brothers closed their burger bar and redesigned the preparation and service of their food. Almost two-thirds of their previous menu items were deleted, including everything that had to be eaten

using cutlery. Burgers were smaller than before, but prices were dropped. Only young men were employed, in order to deter male teenage consumers and to attract families. Above all, McDonald's took scientific management principles and applied them to the restaurant trade. Food preparation and cooking were divided into simple, separate and repetitive tasks carried out by different workers. All burgers were sold with the same condiments, and in a twist on the production line, customers served themselves.

While the McDonald brothers' restaurant and their Speedee Service System were profitable enough for them to have opened a dozen franchised outlets by 1954, company histories tend to emphasise the arrival of the Multimixer salesman Ray Kroc as the moment at which McDonald's was transformed from a local operation into a national and subsequently global brand. Kroc took over the brothers' franchising operation, making a success of the practice by ensuring that every franchisee stuck rigidly to the recipes, portions and preparation methods of the San Bernardino original; by maintaining control over the properties in which the franchises operated, and by selecting franchisees in his own image, men who lacked the 'proper' business credentials of an earlier phase of capitalism (Schlosser, 2001: 95). While this created scores of new millionaires during the 1960s and 1970s, it also created a dependent franchise class and a huge new class of low-paid temporary workers. From the early 1960s, expansion was accompanied by advertising directed primarily at children, while from the 1970s expansion largely took place in overseas markets.

Useful as this history is, its narrative of corporate growth lacks a sense of how people came to accept such a development in both catering and in the broader culture. A Gramscian mode of analysis suggests several ways in which we might make sense of these developments without relying on a simplistic notion that they were imposed from above.

We have seen that Gramsci's notion of a cultural formation directs us to the prehistory of the burger: to the stockyards of Chicago and the development of particular working and consuming identities; thence to the growth of Fordist production, crucially in the automobile industry. It also locates these elements in place: these were developments which took place within specific local topographies. We have also noted the importance of contingency to any new cultural form – the agglomeration of individual creative actions and wider circumstances which provide the catalyst for its foundation. To understand its lasting appeal, however, we need to think how individuals and groups are hegemonized into working for fast food franchises, eating at them, managing them and owning them.

A variety of answers in the economic and political spheres (minimum and subminimum wages, the rise of a neo-liberal political philosophies) suggest themselves, but here we concentrate on two issues of cultural identity, both suggestive of how a leading world view is reproduced and lived by people in a position of subordination within the web of food-cultural power.

The first issue is suggested by George Ritzer (1998) in his study of 'McDonaldization'. Reviewing the work of the sociologist Karl Mannheim, Ritzer observes that Mannheim draws a distinction between 'functional rationalization' (in which a task is achieved in a standardized way) and 'self-rationalization' (in which an employee comes to identify with the task and organization). As we have seen, Ray Kroc's initial franchisees were selected on the basis of sharing a common world view, and Ritzer observes that contemporary training methods (such as McDonald's Hamburger Universities) are designed to perpetuate this commonality amongst groups who might otherwise not cohere, by persuading managers and franchisees to invest emotionally and intellectually in the corporation.

Equally, while customers are 'disciplined' into behaving in particular ways (by limited menus or uncomfortable seats), Ritzer notes that they too are educated to accept and reproduce the 'McDonald's way'. A combination of advertisements which show customers how and what to order, children who teach adults what to do (such as clear up after themselves), and the physical structure of the outlet all work to make the experience 'spontaneous', self-governing and at one with the individual subject's free identity. While these activities and identities take place in the apparently autonomous sphere of eating, McDonald's proximate activities at the level of the state (in their work in relation to schools, hospitals, sport and culture) provide a ready link between civil and political society. That this takes place in tandem with a workforce who are low-paid, non-unionized and who generally have little investment in the corporation, is precisely suggestive of Gramsci's contention that adjacent social groups need to be hegemonized, while those outside the bloc may be coerced into unwilling co-operation.

This explanation of the success of burger culture, however, still relies on a notion of cultural duping. By contrast, Elspeth Probyn's work on the 'McLibel' trial offers a more rounded notion of how the fast food corporations in general, and McDonald's in particular, attempt to win the hearts and minds of their customers and, to a lesser extent, their workforce. The trial was an attempt by McDonald's to silence opposition to its environmental, employment, nutritional and advertising practices. Although brought against a number of members of London Greenpeace,

the case focused on two activists, Dave Morris and Helen Steel, who were largely exonerated. McDonald's, by contrast, was widely agreed to have made an unprecedented public relations blunder. The story seems perfect for a mode of analysis which celebrates human agency over inhuman structures. Nonetheless, despite its subsequent problems (see Chapter 4) the corporation was not at the time vastly weakened by the episode, and Probyn's analysis positions itself within the hegemonic ground contested by both corporation and protesters to demonstrate why this might be the case. Above all, she notes, both groups played up their ownership of, and investment in, notions of 'commensality and the common good':

> Morris and Steel embody a certain political line . . . connecting McDonald's hamburgers to the exploitation of children, workers, the Third World and the environment. In opposition to this McDonald's seeks to personify and humanise an interconnected world, where the Big Mac preceded the Internet in bringing us all together. Through their promotion and advertising rhetoric, McDonald's has turned the idea of the family that eats together into a complex articulation of a global family, extending an ethics of care into the realm of global capitalism and creating its customer as a globalised familial citizen.
>
> (Probyn, 2000: 35)

McDonald's is therefore capable of generating a much more meaningful sense of 'affect' than its opponents, around 'its articulation of an inter-connected world'. While Probyn appreciates that McDonald's forms part of a highly undesirable organization of the world, she points out that its rhetoric of individual and familial agency is more persuasive and inclusive than the rhetoric of its opponents who paradoxically choose a limited counter-hegemony of command over a more expansive mode of incor-poration:

> Morris and Steel seem to think that if people are provided with the facts, they will act in a moral manner and rectify their behaviour. At the same time, however, they have little belief in the capacities of ordinary individuals to act 'on their own', let alone for others. Left to ourselves, we will litter, eat too much fat, and let our brain-washed children rule us. If McDonald's thinks that, given the right impetus, we can come together, the *McLibel* crew seem to think that unless we are ruled with strict moral laws, we will do nothing.
>
> (ibid.: 56)

There is more to which a Gramscian line could direct us, particularly issues around globalization and national identity – addressed via other theoretical tools in Chapters 5 and 6. But here we want to restate the observation that Gramsci's work directs us away from notions of 'domination' on the one side and 'resistance' or 'transgression' on the other. While acutely sensitive to issues of political power, Gramsci's work is tuned to the ways in which 'politics' is circulated and displaced within the capillary vessels of civil society (Mercer, 1984: 9). Critiques of cultural studies have tended to wilfully misrecognize this displacement, which we address by means of a brief, polemical conclusion.

Conclusion

Cultural studies has regularly constructed itself as a field with an open relationship with disciplinarity: as successively inter-, multi- and anti-disciplinary (Murdock, 1995; Grossberg, 1996; Johnson, 1996), and subsequent chapters will demonstrate the productive links that may be made with other disciplines, particularly sociologies, histories and geographies of food. However, while interdisciplinarity suggests a utopian space of uninhibited intellectual transaction, borderline disciplines are not always willing to trade. One of the responses of adjacent intellectual fields has been to caricature cultural studies as conceptualizing its 'field of objects' in an increasingly narrow way. Some social scientists have associated cultural studies with a move away from a critical assessment of the production of meaning and power in society to an uncritical celebration of everyday behaviour and, in particular, consumption. One particularly forceful response has claimed that within the developing subject area, 'issues of changing media technology, ownership, regulation, production and distribution are shrugged off and only those of consumption are addressed' (Ferguson and Golding, 1997: xiv). The assumption is that cultural studies is complicit with powerful forces in developed capitalist economies (government, business, the media) for whom consumption is also ideologically and materially central, so that the subject becomes a 'morally cretinous' discourse, 'the bastard child of the media it claims to expose' (Tester, 1994: 3). Others have seen cultural studies as being concerned only with the modish and transgressive, what Chris Jenks dismisses as the 'vanguard of heady exotica in contemporary "cultural studies"' (Jenks, 1993: 2). Taking food as an object of study, something generally thought of as paradigmatically both consumable and mundane, we have shown the drastic partiality of these critiques, their lack of close address to what cultural studies attempts to do. Above all, through

playing out the intellectual dramas of structuralism, culturalism and hegemonic theory in the arena of food and drink, we have demonstrated that non-reductive questions of power and difference are central to cultural studies – are, indeed, synonymous with the field. Throughout the rest of the book, the three methods will appear again in different guises, showing that 'the turn to Gramsci' could not provide the last word on the binarism of structure and agency. For as we shall see, a babel of other issues and theorists have intruded, and continue to intrude, onto the terrain of food culture.

2 The raw and the cooked

This chapter is concerned with the contribution of anthropological approaches to the study of food practices. As Carole Counihan and Penny van Esterik explain, anthropology has traditionally maintained an interest in food 'because of its central role in many cultures' (1997: 1), and work within the discipline has sought to explore food from a 'range of symbolic, materialist, and economic perspectives' (1997: 2). If, as the anthropologist Edmund Leach observes, the 'subject matter of social anthropology is customary behaviour' (1973: 37), then anthropology would seem to have much in common with cultural studies. Indeed, cultural studies has often borrowed theoretical approaches and categories from anthropology. Ethnographic techniques, used by anthropologists to study the practices of a particular culture, have been deployed in projects such as Paul Willis's (1977) *Learning to Labour*, a study of a group of working-class 'lads' in Wolverhampton in the 1970s. Martin Barker and Anne Beezer have claimed that, within cultural studies, '[e]thnography is now widely held to be the only sure method of catching hold of the full meanings of people's activities' (1992: 9). Meanwhile, in the study of youth subcultures, Claude Lévi-Strauss's concept of *bricolage* has been employed as a means of referring to the creative potential of subcultural style (Clarke, 1975; Hebdige, 1979).

In spite of this apparently fertile relationship between anthropology and cultural studies, however, some critics have questioned their supposed proximity. For example, Signe Howell, an anthropologist, has attempted to identify a series of crucial differences. While anthropology favours the study of other cultures, she argues, cultural studies prefers to analyse its own; and while anthropology maintains 'an unavoidable commitment to people' (Howell, 1997: 107), cultural studies is more preoccupied with questions of representation. Finally, Howell contends that, unlike cultural studies, anthropology accords a central role to empirical data.

There isn't space here to respond to Howell's argument, although debates raised in the previous chapter suggest that cultural studies is less fixated on representation than this may suggest. What is clear, however, is that any easy rapprochement between the two disciplines remains problematic. As a result, this chapter won't be seeking to resolve these potential disciplinary issues. Rather, our principal focus will be the work of Claude Lévi-Strauss, whose writings on the subject of food, as Stephen Mennell notes, 'have transfixed almost everyone working on that subject' (1996: 7). Lévi-Strauss undertakes a structuralist analysis to identify the binary differences which arguably lie at the heart of our experience. In this vein, Lévi-Strauss's analysis of food confers special importance upon the terms 'raw' and 'cooked', and upon an opposition between nature and culture. While Lévi-Strauss's approach has serious weaknesses, associated with his use of structuralism, we can nevertheless usefully deploy these categories within cultural studies in an analysis of certain food-related issues.

Lévi-Strauss on cooking

Lévi-Strauss frequently turned to an analysis of food practices in his work. He initially begins to explore such issues in the first volume of *Structural Anthropology* (first published in 1958), where he offers a comparative analysis of French and English cuisine. In the previous chapter, we saw how the starting point for Saussure's structuralist analysis of language was to break it down into its smallest, phonemic units. In a similar vein, Lévi-Strauss argues that it is possible to analyse the 'constituent elements', or 'gustemes' of different cuisines, and to distinguish 'certain structures of opposition and correlation' (Lévi-Strauss, 1963: 86). In an analysis of French and English cooking, for example, he suggests that we might identify three oppositions: '*endogenous/exogenous* (that is, national versus exotic ingredients); *central/peripheral* (staple food versus its accompaniments); *marked/not marked* (that is, savoury or bland)' (ibid.). On the basis of this set of oppositions, Lévi-Strauss suggests that the following differences emerge:

> In English cuisine the main dishes of a meal are made from endogenous ingredients, prepared in a relatively bland fashion, and surrounded with more exotic accompaniments, in which all the differential values are strongly marked (for example, fruitcake, orange marmalade, port wine). Conversely, in French cuisine the opposition *endogenous/exogenous* becomes very weak or disappears,

and equally marked gustemes are combined together in a central as well as in a peripheral position.

<div align="right">(ibid.)</div>

For all that there are marked differences between French and English cuisine, then, such differences derive from the manner in which each system configures a shared framework of binary oppositions.

Lévi-Strauss fails to develop his analysis any further at this point: it serves, rather, as an illustrative example within a broader defence of structuralist methodology. Nevertheless, as Mennell points out, there are certain problems with the analysis as it stands. Above all, it seems to draw a comparison between 'French *haute cuisine* (long eaten also by the English upper classes)' and 'English lower middle-class home cooking'. While this might be a case of Lévi-Strauss 'giving expression [. . .] to the traditional Frenchman's image of the English eating boiled chicken and swilling it down with fruitcake and port wine' it isn't 'clear that he was comparing like with like' (Mennell, 1996: 8).

Cooking is also a recurrent concern of Lévi-Strauss's *Mythologiques* (*Introduction to a Science of Mythology*), a four-volume enterprise analysing over eight hundred myths from Native American cultures, some of which concern the origins of cooking. In others, the act of cooking operates as a symbolic marker between a series of binary oppositions (heaven/earth, life/death, nature/culture). In a dazzling analytical performance, Lévi-Strauss's over-arching objective is to demonstrate the force of the structuralist claim, that divergent cultural phenomena enjoy common structural features. Over the course of his four volumes, he proceeds towards the conclusion that there is 'One Myth Only', identifying a binary, universal structure beneath the myriad mythical tales he analyses. This structure, he argues, represents

the most profoundly meaningful oppositions that it is given to the mind of man to conceive: between the sky and the earth on the level of the physical world, between man and woman on the level of the natural world and between relations by marriage on the level of the social world.

<div align="right">(Lévi-Strauss, 1981: 624)</div>

Beneath the many variations in cooking between different cultures, then, we can distinguish certain common structures at work. Alongside this now familiar idea, however, Lévi-Strauss develops another central claim. Since cooking is an act of mediation, where we transform raw

materials into a cooked product, so myths regularly 'view culinary opera-
tions as mediatory activities between heaven and earth, life and death,
nature and society' (Lévi-Strauss, 1994: 64–5). He continues:

> We thus begin to understand the truly essential place occupied by
> cooking in native thought: not only does cooking mark the transi-
> tion from nature to culture, but through it and by means of it, the
> human state can be defined with all its attributes.
>
> (ibid.: 164)

The process of cooking thus serves as a crucial mediating category between
the realms of (raw) nature and (cooked) culture. As a result, Lévi-Strauss
concludes, it enjoys a privileged symbolic function.

The conclusions about cooking which Lévi-Strauss seeks to establish
in the course of *Mythologiques* are dealt with in a more sustained fashion
in his now seminal essay, 'The Culinary Triangle' (1966), and we will
thus examine this essay in rather more detail. The essay begins by
drawing a comparison between language and other cultural systems.
Citing Roman Jakobson's analysis of the structures which govern
linguistic systems, Lévi-Strauss argues that it is at least plausible for us to
expect to discover similar sorts of structures behind other cultural
phenomena, such as cooking. Since Jakobson identifies a 'vowel triangle'
(whose apexes are 'a', 'u' and 'i') and a 'consonant triangle' (whose
apexes are 'k', 'p' and 't'), Lévi-Strauss describes a culinary triangle – see
Figure 2.1.

If the contention in Figure 2.1 is that all foodstuffs will occupy one of
the points on this triangle, then it is certainly a plausible one. Indeed, in
the case of certain foodstuffs, we can locate the various forms they might
take at different points on the diagram. Milk, for example, can be

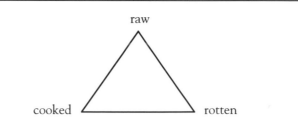

Figure 2.1 The culinary triangle.
Source: Lévi-Strauss, 1966; see Mennell, 1996: 8.

consumed as a raw product, but also in cooked (custard) and rotten (blue cheese) form. Similarly, meat can be eaten raw (steak tartare), cooked (a Sunday roast) or rotten (game). What also interests Lévi-Strauss here, however, are the processes whereby the raw becomes cooked or rotten. While 'the cooked is a cultural transformation of the raw', he argues, 'the rotted is a natural transformation' (Lévi-Strauss, 1966: 587). As a result, he suggests, we can develop the culinary triangle as shown in Figure 2.2.

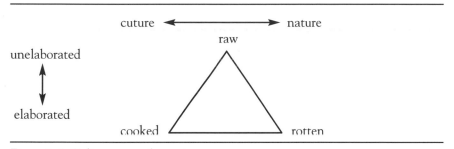

Figure 2.2 Culinary transformations.

We might note here the centrality that the nature/culture opposition begins to assume in Lévi-Strauss's analysis.

Having established the coordinates of the triangle, Lévi-Strauss then begins to draw distinctions between different means of cooking. He identifies three principal processes – roasting, boiling and smoking – with a view to locating each on the triangle itself. Roasting, he argues, 'is on the side of nature' in terms of the means of cooking (ibid.: 588), because roasted meat is directly exposed to fire. In terms of the *results* of the cooking process roasted food also has affinities with nature, since it is often raw in the middle. In contrast, since boiled food is placed in a receptacle, such as a pot, and is also mediated from the fire by the water around it, so it is 'on the side of culture' (ibid.). Boiled food, however, resembles a putrefied substance, matter which has undergone a natural process of elaboration. In terms of its results, then, boiling is on the side of nature. As for smoking, Lévi-Strauss argues that, since it is a process which brings foods into direct contact with the elements of fire and air, it is on the side of nature. In terms of the results of the process, however, smoked food, in contrast to roasted food, is cooked consistently right through to the middle. For Lévi-Strauss, this places the end product of smoking on the side of culture. In the light of this analysis, he superimposes each term on the original triangle as in Figure 2.3.

RAW
roasted
(−) (−)
Air *Water*
(+) (+)
smoked boiled
COOKED ROTTED

Figure 2.3 Culinary processes.
Source: Lévi-Strauss, 1966: 594.

In order to fully explain this diagram, we can represent the various distinctions Lévi-Strauss draws between means and results of cooking as in Figure 2.4.

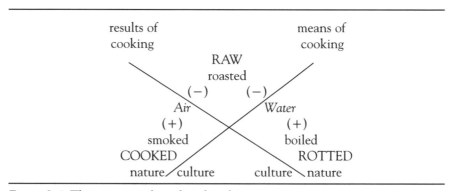

Figure 2.4 The means and results of cooking.

Lévi-Strauss concedes that there are other cooking processes of which we might need to take account, such as grilling, frying, braising and steaming (and, we might add, microwaving), where a more complex tetrahedron model might be needed in order to represent all of the various terms. He also suggests that we could further elaborate the model in terms of the different ways of cooking different sorts of foodstuffs (meat and vegetables, for example), as well as in terms of different forms of seasoning. We could even start to distinguish the range of associations that each cooking process might share with gender and class differences, amongst others, and Lévi-Strauss produces a number of examples in order to gesture more precisely towards the sort of associations we might identify (characterizing roast things as aristocratic and boiled things as plebeian, for example). The overall purpose of his analysis, however, is to

reiterate the two claims that we have already identified in *Mythologiques*; first, that there is a common structure lying beneath the range of different cooking practices (and the culinary triangle essay incorporates an impressive number of examples from various cultures illustrating the links which Lévi-Strauss attempts to identify); and second, that the opposition between nature and culture occupies a privileged position within this common structure.

Lévi-Strauss's analysis is not without its problems, however, and the first issue concerns the method that he uses in developing his analysis. We would argue that, at various points, there seems to be a certain sleight of hand operating within Lévi-Strauss's explication. This argument needs to be made quite carefully. Lévi-Strauss is not proposing that the particular connotations which certain foods or food practices enjoy remain the same across all cultures. When talking about the relationship between food and gender difference, for example, he begins by associating roasting with men and boiling with women. He goes on to point out the following, however:

> This is notably the case with the Trumai, the Yagua and Jivaro of South America, and with the Ingalik of Alaska. Or else the relation is reversed: the Assinibon, on the northern plains of North America, reserve the preparation of boiled food for men engaged in a war expedition, while the women in the villages never use receptacles, and only roast their meat. There are some indications that in certain Eastern European countries one can find the same inversion of affinities between roasted and boiled and feminine and masculine.
>
> (Lévi-Strauss, 1966: 590)

Lévi-Strauss is thus happy to countenance marked differences between different cultures. As Stephen Horrigan notes, 'empirical criticisms' of Lévi-Strauss's work 'miss the point':

> Lévi-Strauss is not claiming that, at the level of conscious thought, all societies utilize a distinction between nature and culture; his arguments are not based at the level of everyday experience. He says, rather, and this is his main point, that the human brain classifies and categorizes experience and information according to a set of binary oppositions of which the distinction between nature and culture is but one example, and that this occurs on an unconscious level.
>
> (Horrigan, 1988: 41)

What Lévi-Strauss proposes, in other words, is that the nature/culture opposition will be configured in different ways in relation to different foodstuffs and food practices in different cultures. Nevertheless, we would still maintain that there is an arbitrariness in the way in which he establishes the centrality of that oppositional system, and the culinary triangle itself, in the first place. For example, having identified his initial triangle, with raw, cooked and rotten at each apex, Lévi-Strauss proceeds to map different cooking processes (roasting, boiling, smoking) onto those terms. In terms of the results produced by such processes, he argues that roasted food is on the side of the raw, because it often resembles bloody, raw flesh in the middle, while smoked food, because it is cooked right through, is on the side of culture. But why should these particular associations be drawn? In Britain, for example, where meat is often roasted longer than it is elsewhere, the results of roasting a joint of beef might well produce a substance which looks anything but raw in the middle. Similarly, we might argue that the flesh of smoked salmon actually resembles raw flesh. The point of our argument is not that Lévi-Strauss's assumptions are necessarily misplaced at an empirical level, but rather that the force of his analysis derives from the simplicity of the model which he uses. If this apparent simplicity is actually generated by some rather crude conjectures along the way, then the legitimacy of the culinary triangle itself begins to look rather precarious. It is also worth noting that questions have been raised about Lévi-Strauss's appropriation of Jakobson's linguistic theory, a framework which provides a starting point for this triangular analysis in the first place (Mounin, 1974; Clarke, 1981: 157–83).

A further problem concerns the purpose of Lévi-Strauss's analysis, which is, as we have seen, to prove that common structures underlie the manifest differences between different culinary cultures. As Mary Douglas, a fellow anthropologist, points out, this means that 'he takes leave of the small-scale social relations which generate the codification and are sustained by it' (1975: 250). We might ask why it should be more useful to pursue issues of commonality between cultures, as opposed to pursuing the differences between them. Lévi-Strauss would explain that it is because by doing so we can identify universal forms of human thought, and that this is an achievement in itself. As a discipline, however, cultural studies has tended to view such claims about universality in a suspect manner. Indeed, just such a point is made forcefully by Roland Barthes when reflecting upon an exhibition of photographs, *The Great Family of Man*, which toured Paris in the mid-1950s. The exhibition was designed to represent the universal nature of the human condition which

lay beneath the many different social and cultural practices performed by different peoples around the world. In relation to photographic images of birth which appeared in the exhibition, Barthes asks,

> What does the 'essence' of this process matter to us, compared to its modes which, as for them, are perfectly historical? Whether or not the child is born with ease or difficulty, whether or not his birth causes suffering to his mother, whether or not he is threatened by a high mortality rate, whether or not such and such a type of future is open to him: this is what your Exhibitions should be telling people.
>
> (Barthes, 1972: 102)

As Barthes makes clear, to overlook the ramifications of small-scale differences in social relations has important consequences.[1] In his quest for universally applicable underlying structures, Lévi-Strauss's analysis of cooking runs precisely such risks.

The final problem we would identify in relation to Lévi-Strauss's approach concerns a critique of structuralism developed by the French theorist Jacques Derrida. Noting Lévi-Strauss's penchant for binary oppositions such as nature/culture, Derrida attempts to reveal the precarious character of such structures. As we have seen in our discussion of the culinary triangle, Lévi-Strauss's analytical method, in its quest for structural models, seeks to demonstrate its scientific credentials. Derrida calls these credentials into question on the grounds that the structural models which Lévi-Strauss identifies 'are always proposed as hypotheses resulting from a finite quantity of information and which are subjected to the proof of experience' (Derrida, 1992: 413). In other words the scientific pretensions of Lévi-Strauss's method are undermined by their own cultural assumptions. In this sense, as Robert Con Davis and Ronald Schleifer explain, 'one never transcends culture' (1991: 146): Lévi-Strauss's deployment of the nature/culture opposition is thus itself bound by certain cultural determinants. As a result, 'a scientifically objective examination of culture and meaning can never take place from the outside; there is no "outside" or standing free of structure . . . in short, no objective examination of structure'. If this is the case, 'then structuralism is seriously undermined as a method' (ibid.).

While Lévi-Strauss's analysis of cooking provides us with some fascinating insights into a diverse range of culinary cultures, it also raises several problems, particularly in relation to his methodology. What we would argue, however, is that the opposition between nature and culture – between the raw and the cooked – often remains an important one in

terms of the way in which food is both thought about and represented. As Leach explains in his commentary on Lévi-Strauss, 'when we eat, we establish, in a literal sense, a direct identity between ourselves (Culture) and our food (Nature)' (1970: 34). In the light of Derrida's critique of Lévi-Strauss, we do not want to use this opposition in order to ground some sort of universally applicable structural model of food practices. Rather, we want to explore the particular forms in which the nature/culture opposition is broached in relation to two brief case studies.

Consuming placenta

On 4 February 1998, Channel 4 in the UK screened an episode of *TV Dinners*, a television series which sought to examine particular, often quite quirky, examples of food consumption. This episode joined preparations for a 'welcome to the world party' being held to celebrate the birth of a new baby at which the baby's placenta was going to be offered to the guests in the form of a pâté. What we will show here is that the nature/culture opposition emerges as a key set of categories; first, in terms of the way in which the organizers of the party talk about the placenta; and second, in terms of people's reactions both to the idea of eating it and, indeed, to the programme itself. On the one hand, the baby's grandmother and her friend, who is responsible for preparing a buffet, equate the placenta with nature. As the friend flambés the chopped-up placenta in a frying pan, for example, she comments on its elemental character: 'earth and air and wind and fire, and what's all this about?' She also points out that it is 'grown in the safest place in the universe'. The baby's grandmother contrasts its natural, genetic substance with the 'modern . . . hi-tech' world of genetics, inviting the guests to 'dive into' their 'genetic genepool'. Along with the presenter, Hugh Fearnley-Whittingstall, the friends allude to the consumption of placenta as a natural and primitive means of replenishing the mother's body after childbirth. They also celebrate its gendered associations ('well done, mothers, well done, the women'), noting further that an apricot and mango mousse ring served as part of the same buffet has 'got a bit of the old cervix look about it'. That the consumption of placenta can be associated with a feminized concept of the natural in this way allows the family to legitimize their eating of it; for, as the cook notes, 'there were issues there', and the principal issue is that eating placenta, a form of human flesh, arguably breaks the taboo of cannibalism.

Paul Rozin *et al.* have identified three different motives that can lead people to reject particular foodstuffs. As they explain, the first such motive

is distaste, that is undesirable sensory properties (taste, smell, visual) of a substance. A second is anticipated consequences, what we have learned are the negative effects of eating certain substances. A third is conceptual, what we know about the nature or origin of substances.

(Rozin *et al.*, 1997: 67)

The practice of cannibalism belongs to the third category: at a conceptual level, the eating of human flesh seems wrong, and readily evokes a sense of disgust, the emotion which, Rozin *et al.* argue, is most closely associated with conceptual antipathy towards foodstuffs. This is borne out in the episode of *TV Dinners*. As a plate of focaccia morsels topped with placenta pâté is passed around the guests, some of them are invited by the producers to talk about how they feel about eating the substance. Most acknowledge the problematic status of placenta in terms of our agreed categorization of what counts as edible and inedible. One explains that it is 'the thought of it' which repulses her, while another claims that placenta pâté could 'catch on as long as people don't know what it is'. Similar ideas spurred a number of viewers of the programme to lodge complaints with the Broadcasting Standards Commission, the institution in the UK responsible for fielding such grievances. The Commission received nine complaints on the grounds that the programme was 'distasteful and some referred to the practice as cannibalism' (Broadcasting Standards Commission, 1998: 5). Channel 4, the broadcaster, stated that they had included an announcement just prior to transmission which had explained to viewers that what followed might not be to everyone's taste. Nevertheless, in the judgement of the Commission, 'in the context of a cookery series, the content of this programme breached a convention in a way which would have been disagreeable to many [...] [and] would have taken many viewers by surprise' (ibid.). As a result, the complaints were upheld.

These responses to the prospect of consuming placenta do not exploit the nature/culture opposition at an explicit level, in the way that the proponents of placenta pâté did. Nevertheless, we would argue that they maintain a distinction between cultural acceptability and culinary abomination which operates in much the same way. Here, it is the programme's breach of our cultural codes about what is edible and inedible that generated disgust on the part of certain sections of the audience: it fell beyond the bounds of acceptability in our culture. Further, it is precisely as a result of this breach that the Broadcasting Standards Commission was happy to uphold such complaints. As Kate Soper has noted, '"nature" is the idea through which we conceptualize

what is "other" to ourselves' (1995: 15–16), and thus we would argue that, implicitly, such reactions to the programme mobilize the nature/culture opposition. In contrast to the family featured in the programme, though, who endorse the consumption of placenta on the basis of its positive associations with nature, the disgust experienced by the programme's critics is based upon the otherness of such an act, which places it in the realm of nature. At the same time, however, the idea of consuming placenta, one might expect, seems an affront precisely because it goes against nature. As Soper has again pointed out,

> Against all those cases in which the 'healthy' human norm is established by reference to the custom of nature, must, of course, be set all those numerous others in which we become creatures of 'nature' in failing to conform with the custom of humanity.
>
> (ibid.: 28)

Arguably, then, the nature/culture opposition emerges in a complex and ambiguous manner in the hostile reactions to the programme.

We have explored this example at some length because, since the act of consuming placenta resides on the very boundaries of a distinction we might draw between the edible and the inedible, so it readily invokes an opposition between culture and nature, both explicitly, at the level of everyday speech, and implicitly, in the way in which such borders are policed. Anthropologists have long been interested in the sort of rules different cultures adopt in terms of sanctioning or prohibiting particular foodstuffs (see, for example, Mary Douglas's analysis of Hebrew dietary laws (1966 and 1975)). As we have seen here, the somewhat problematic status of placenta as a food, and its cannibalistic connotations, means that the nature/culture opposition lies at the heart of responses to it.

Representing the cooked

Another area where the nature/culture opposition is frequently evoked is in representations of food such as advertisements and cookery book images. Here we turn to Judith Williamson's work on advertisements, where she deploys Lévi-Strauss's analysis of the raw and the cooked. Williamson identifies two processes at work in contemporary advertising in terms of the way in which nature is represented. The first such process she explains as follows:

> Nature is the primary referent of our culture. It is the 'raw material' of our environment, both the root of all technological development

and its opposition; that which technology strives both to improve and to overcome. If a culture is to refer to itself, therefore, it can only do so by the representation of its transformation of nature – it has meaning in terms of what it has *changed*.

(1978: 103)

In order to represent the cultural transformation of cooking, in other words, our culture represents the cooked alongside the raw: in that way, it is able to show that which the process of cooking has transformed. Williamson begins to identify a range of adverts which deploy just such a technique. A 1970s advert for Chivers marmalade, for example, depicts slices of orange in the shape of a jar with a Chivers label on it. In a similar fashion, a television advert for Campbell's condensed soup in the late 1990s showed a knife slicing through cans of soup revealing raw contents inside (mushrooms, tomatoes, onions and sticks of celery). The same conventions regularly operate in cookery book illustrations as well. In *The Best Traditional Recipes of Greek Cooking*, for example, each chapter is prefaced by a photograph of some of the dishes which appear in it, surrounded by the raw materials from which they are made. The chapter on game, for instance, depicts four different dishes alongside a dead pheasant (Haïtalis, 1992: 152–3). In each case, then, the trans-formation of cooking is signified by gesturing to the product's raw materials. As Williamson proceeds to argue, such a technique in fact works to mystify the manufacturing procedures, the cooking process, whereby the products themselves were produced.

The second process identified by Williamson concerns the way in which cooked products are rearranged in nature:

When you have cooked your food, you arrange it in a nest of fresh watercress, or sprinkle parsley on top of it: it is relocated as 'the natural' which inevitably becomes symbolic, since the watercress is there to signify something about what is cooked. [. . .] But when this product is replaced in nature (quite literally a field or among flowers [. . .]) it can never be nature undifferentiated and raw, because a transaction of meaning is required, and 'nature' as a referent, is hardly closer to raw nature than the manufactured product which it signifies as 'natural'.

(1978: 122)

Again, Williamson cites a series of adverts where this relocation takes place, but this technique is also found in the practice of garnishing a

plate of food with a sprig of green herbs, as Williamson suggests above, as well as in cookery books. Robert Carrier's *Feasts of Provence*, for example, includes a recipe for *la soupe de lapin*, the illustration for which depicts a bowl of the bouillon in the middle of a grassy meadow where once, presumably, the rabbit was to be found hopping around (1992: 142). According to Williamson, this technique is used to assure us of the goodness of the cooked product through its association with nature. Soper has noted the contradictory character of the concept of nature, which, at various times and places, 'is represented as both savage and noble, polluted and wholesome, lewd and innocent, carnal and pure, chaotic and ordered' (1995: 71). As Williamson argues above, in deploying an idea of nature as wholesome, the technique of rearranging the cooked product in nature draws on a discrete, historically constructed understanding of nature. Nature, in other words, has itself been 'cooked'.

Williamson's work thus deploys Lévi-Strauss's analysis of the raw and the cooked in a critique of advertising images which, as we have shown here, can be extended to cookery book images. Cooking is a process whereby the raw materials given by nature are transformed into culture. The nature/culture opposition thus underpins some of the dominant conventions for representing food.

In the course of this chapter, we have taken a detailed look at Lévi-Strauss's analysis of food. While we have identified a number of problems with his approach, what we have also done is to show how the nature/culture opposition at the centre of his theory might be deployed in a more circumspect manner. This is not to argue that the opposition is an organizing principle in all food practices, the position which Lévi-Strauss himself occupies. What we have suggested instead is that there are certain food-related issues – our demarcation between the edible and the inedible; the manner in which the process of cooking is represented – where the nature/culture opposition enjoys a particular potency. As we have seen, however, we are not dealing here with a timeless set of categories: our notions of nature and culture are themselves 'cooked', and thus historically constructed. In the following chapter, we will explore the extent to which table manners have similarly undergone a process of cultural and historical construction.

3 Food, bodies and etiquette

This chapter will be concerned with table manners, those sets of codes and conventions, both written and unwritten, which govern the forms of social and physical conduct expected of us when we eat. In *Debrett's Etiquette and Modern Manners*, the most prominent text in the British market currently purporting to provide a definitive guide to the codes of etiquette, we find the following aphorism from a fifteenth-century book of manners:

> In halle, in chamber, ore where thou gon,
> Nurtur and good manners makyth man.
>
> (Burch Donald, 1990: 8)

Our status as human beings is confirmed, the aphorism suggests, through our display of 'good manners'. What is more, it is bound up with our social position (our upbringing or 'nurtur'). And while the word 'man' is arguably used in this context to refer to human beings generally, its gendered quality also raises questions about the relationship between gender and etiquette. The aphorism thus neatly identifies the principal concerns of this chapter. If systems of etiquette have come to function as an index of civilized behaviour, how have such systems arisen historically? Further, how have such systems responded to, or reaffirmed, distinctions around class and gender? We shall begin to explore these questions by turning to the work of two theorists, Mikhail Bakhtin and Norbert Elias, each of whom offers a theoretical account of the history of table manners. We will then consider the role and social function of table manners within contemporary society.

Bakhtin, the banquet and the body

Mikhail Bakhtin was a Russian cultural theorist whose work has been widely deployed within cultural studies, particularly his analysis of the

practices associated with carnival celebrations. This analysis appears in
Rabelais and His World, Bakhtin's lengthy study of the sixteenth-century
French writer, François Rabelais. In order to arrive at a Bakhtinian
account of the development of table manners, we need to look in some
detail at this study. Rabelais's work offers us a series of fantastic, bawdy
tales which are heavily preoccupied with the very processes celebrated
during carnival: drinking, feasting, urination, defecation, copulation and
giving birth. Bakhtin's analysis locates Rabelais's writing within the
Renaissance period from which it emerged: a crucial period of social,
cultural and epistemological upheaval which marked the beginning of
the transition from a feudal system towards a system of bourgeois hege-
mony. The popular imagery of carnival was, according to Bakhtin, a
crucial resource for articulating this sense of upheaval and transition, and
it is for this reason that we find such imagery cropping up in Rabelais's
work. A central symbol was the banquet or feast, and while Bakhtin's
primary concern in exploring this terrain is to develop an analysis of
Rabelais's work, it is nevertheless here that we find him starting to offer
an account of the relationship between food, bodies and etiquette.

Rabelais's novel, *Gargantua and Pantagruel*, begins with a description
of the giant Gargantua's birth. This takes place on Shrove Tuesday, just
as his mother and father, Gargamelle and Grandgousier, are celebrating
at a Mardi Gras feast. Gargamelle had just eaten 'sixteen quarters, two
bushels, and six pecks' of tripe (Rabelais, 1955: 48), when she went into
labour. Initially her 'bum-gut' exploded as a result of her over-
indulgence, so one of the midwives had to operate in order to restrict her
sphincter muscles (ibid.: 52). The result of this operation was to force
the foetal Gargantua up through Gargamelle's body, so that he was
eventually delivered via her left ear. His first words, 'Drink! Drink!
Drink!', proved to be an accurate indication of his future behaviour,
while his father's first words on seeing him, '"Que grand tu as!" – What a
big one you've got!' (the gullet being understood) – provided him with a
very apt name. Gargantua's birth, then, is inextricably embroiled with
the extravagance of the carnivalesque feast. Bakhtin's analysis of such
imagery revolves around a distinction between 'the popular festive tradi-
tion' of the carnivalesque banquet, and the more restricted, less exuberant
practices of the bourgeois feast (Bakhtin, 1984: 301). He represents this
distinction in the following terms:

> The popular-festive banquet has nothing in common with static
> private life and individual well-being. The popular images of food
> and drink are active and triumphant, for they conclude the process

of labor and struggle of the social man against the world. They express
the people as a whole because they are based on the inexhaustible,
ever-growing abundance of the material principle. They are universal
and organically combined with the concept of the free and sober
truth, ignoring fear and piousness and therefore linked with wise
speech. Finally, they are fused with gay time, moving toward a better
future that changes and renews everything in its path.

(ibid.: 302)

It is worth identifying four features in this account of the carnivalesque
banquet. First, it is a communal event oriented towards a sense of the
collective body, rather than the individual body. It is a 'banquet for all
the world' (ibid.: 301), rather than the private event of the bourgeois
feast. This collective dimension is further emphasized in the second
feature of the banquet, its connection with the processes of labour and
struggle. During the Middle Ages, the working day was long and arduous,
and life consisted of a continual struggle against threats such as famine,
drought, floods and disease. The banquet represented a collective celebra-
tion both of the fruits of one's labour, and of victory in this struggle
against adversity. Third, the fact that carnival made way for the suspension
of any prohibitions allowed for free and frank forms of speech to flourish
at the carnivalesque banquet. As well as generating various forms of
cursing and joking, these discursive conditions also paved the way for
'free and sober truth', for the exploration of new ideas. Fourth, the
banquet is associated with 'gay time'. In order to understand what Bakhtin
means by this, it is necessary to turn to his account of the grotesque
body, the typical means of representing the human form from a carni-
valesque perspective.

We can identify three principal features of the grotesque body, and
each of them is apparent in Rabelais's account of Gargantua's birth. First,
it is the orifices of the grotesque body which are emphasized. It is those
points at which the body opens out to the world and to other people
which are most prevalent within grotesque imagery: the mouth, the anus,
the nose, the ears, the phallus and the vagina. Second, the grotesque
body is frequently associated with food. It is a devouring body, a body in
the process of over-indulging, eating, drinking, vomiting and defecating.
One example provided by Bakhtin here is that of Gros Guillaume, who
emerged as a carnivalesque character in seventeenth-century France.
Gros Guillaume was a figure with an accentuated stomach, whose
resplendent, double-belted torso resembled a wine barrel, and whose face
was covered in flour. Third, the grotesque body is a body in transition, its

dynamism represented through the processes of eating and defecating, of dying and giving birth. It is this dynamism which is central to the sense of 'gay time' which Bakhtin identifies in the carnivalesque banquet. And crucially, it is the dynamism implicit in such imagery which provided Renaissance culture with a vehicle for articulating the emergent sense of upheaval and historical transition. While the dominant world view of the Middle Ages had been one of stasis, Renaissance culture drew on the dynamic imagery of the grotesque body in constructing an alternative, historical world view.

While the grotesque body enjoyed this privileged position within Renaissance culture, it has subsequently undergone a process of increasing marginalization within the public sphere. As a result, the consumption of food has increasingly been deprived of the positive, collective connotations of the carnivalesque feast, as Bakhtin makes clear when he contrasts the images of feasting to be found in Rabelais's work with those to be found in 'early bourgeois literature':

> The latter expresses the contentment and satiety of the selfish individual, his personal enjoyment, and not the triumph of the people as a whole. Such imagery is torn away from the process of labor and struggle; it is removed from the marketplace and is confined to the house and the private chamber . . . it is no longer the 'banquet for all the world,' in which all take part, but an intimate feast with hungry beggars at the door. If this picture of eating and drinking is hyperbolic, it is a picture of gluttony, not an expression of social justice.
>
> (Bakhtin, 1984: 301)

Within Bakhtin's account, we can identify four principal changes which have accompanied the development of this modern form of the feast. Firstly, in contrast with the carnivalesque feast, the bourgeois banquet has tended to vacate the public sphere, and is now to be found increasingly within the domestic world of the house and the private chamber. Second, the conversation which accompanies such meals lacks the freedom of carnivalesque exchange, and is increasingly brought under the control of a more sober set of discursive conventions. Third, the modern feast has lost its material connection with the struggle against adversity which the carnivalesque feast represented. When images of excess are to be found, they simply represent a gluttonous celebration of abundance, rather than a collective celebration of the achievements of productive labour. Finally, while the grotesque body was central to the

imagery of the carnivalesque feast, the modern feast offers us an alternative image of the body, the classic body, representing 'an entirely finished, completed, strictly limited body, which is shown from the outside as something individual. That which protrudes, bulges, sprouts, or branches off . . . is eliminated, hidden, or moderated' (ibid.: 320).

While the emphasis within the grotesque body is on its dynamism and its orifices, the emphasis within the classic conception of the body is on its cleanliness, completeness and closure. The classic body has been hygienically cleaned up, and eschews any sense of grotesque disorder. Its orifices – the eyes, the mouth – are typically represented as being closed, and there is little emphasis upon the organs of the lower body – the genitals, the belly – typically found within grotesque imagery. This sense of closure, Bakhtin argues, conveys an impression of quiescence and social stasis, in stark contrast to the sense of dynamism and social change represented by the anatomy of the grotesque body.

Overall, Bakhtin provides us with an account of a history of the feast since the Renaissance within which the consumption of food increasingly loses its public, celebratory potential, and its bawdy, grotesque forms of conduct, to be replaced by a more private form of consumption, accompanied by a more orderly and refined set of table manners. There are certain questions which we might raise in relation to this account. In so far as it stems from an analysis of images of the feast in the work of Rabelais, we can question the historical veracity of such images, as Stephen Mennell has done (1996: 22). In addition to this, Bakhtin arguably provides us with an overly optimistic description of carnival, an optimism which informs his characterization of the carnivalesque feast. More detailed historical studies of carnival perhaps allow us to call into question the utopian flavour of Bakhtin's analysis (Burke, 1978; Le Roy Ladurie, 1979). Further, while Bakhtin suggests that the consumption of food has become an increasingly domestic affair since the Renaissance, we can still identify occasions for public, communal forms of feasting. As Christine Hardyment (1995) notes, for example, the organization of food provision in Britain during the Second World War saw a huge increase in the number of communal meals. And while such examples might derive from adverse circumstances, rather than from any celebratory motive, even today events such as weddings provide certain opportunities for collective forms of festive feasting. Bakhtin's account of the development of the feast is painted with broad brush strokes, and it is possible that we might identify specific examples of this sort which problematize the trajectory he identifies. Nevertheless, his analysis suggests that the development of our table manners has been marked by an

increasing departure from grotesque, bawdy forms of behaviour. What is noticeable about this contention is the manner in which it complements Norbert Elias's account of the way in which a long-term process of refinement, the 'civilizing process', has impacted on the development of table etiquette. It is to Elias's work that we now turn.

Elias and the civilizing process

As Mennell has observed, the work of the German sociologist, Norbert Elias, teaches us that 'concepts and theories take shape most fruitfully when . . . they are developed while grappling with evidence of actual social processes' (1992: 270). Elias is especially critical of the sort of abstract sociological theorizing to be found in the work of Talcott Parsons, amongst others (Elias, 1978a: 221–63; 1978b). While Elias's work has received little critical attention within the field of cultural studies, the fact that it attempts to develop theoretical insights from an analysis of concrete practices suggests that it shares certain methodological commitments with the concerns of cultural studies. What is more, in turning his attention to the prosaic realm of table manners, along with other forms of etiquette, Elias shares with cultural studies an interest in everyday forms of behaviour. His account of the development of manners is to be found in the first volume of *The Civilizing Process* (1978a), which provides a survey of etiquette books, dating from the thirteenth to the nineteenth centuries. Examining these books against the decline of feudalism and the development of court society, Elias identifies the key transitions in the way in which people were expected to manage their bodies, the principal features of the civilizing process. In the second volume, *State Formation and Civilization* (1982), Elias undertakes an explanation of the civilizing process itself, arguing that it was a structural transformation in society, leading to the emergence of the nation state, which precipitated the development of increasingly refined codes of conduct. We will first look at Elias's account of these transformations, before turning to his analysis of etiquette books. Finally, we will consider some of the problems that have been raised in relation to Elias's account of the history of table manners.

Elias shares with Bakhtin an emphasis upon the Renaissance as a key turning point in the development of table manners (Elias, 1982: 5). Prior to the Renaissance, he argues, European societies were principally organized around feudal structures, where a number of baronial estates competed with each other for power. From the eleventh and twelfth centuries onwards, however, these structures gradually gave way to the emergence

of nation states, within which a central authority controlled a 'military and fiscal monopoly' (1982: 105). Initially, this authority was exercised in the form of the absolute power of the monarch, enjoying the prerogative of raising both an army and taxes. Eventually, however, these powers were ceded to bourgeois control with the advent of democratic forms of government. What particularly interests Elias in charting the civilizing process is the emergence of court society, an aristocratic elite surrounding the monarch, and the manner in which these emergent power structures ushered in new forms of body management. Overall, his approach is both 'sociogenetic' and 'psychogenetic' (1978a: vii), analysing the way in which such developments in social relations generate transformations in the structure of human personality and behaviour.

Within the feudal system, Elias argues, there were few checks on the way in which the nobility were expected to behave. Military threats from rival estates might necessitate restraint, but generally the knight's behaviour was subject to little external or internal control. 'People are wild, cruel, prone to violent outbreaks and abandoned to the joy of the moment', suggests Elias. 'There is little in their situation to compel them to impose restraint upon themselves' (1982: 72). With the emergence of court society, however, this situation changed and the behaviour of the court nobility was modified accordingly. Now that the monarch held a monopoly on the use of force, the public sphere was increasingly pacified, generating burgeoning forms of self-restraint when it came to physical conduct. At the same time, the development of the state had ushered in an augmented division of labour, and members of court society were thus inhabiting a realm of increasing interdependence. This also brought with it heightened forms of self-restraint, for one's conduct now required more foresight in so far as any action could potentially produce much wider repercussions. And in a system within which prestige was no longer won by recourse to physical force, the display of self-restraint increasingly acquired the mark of social distinction. The performance of mannered behaviour not only enabled members of the court to seek approval from figures at the top of the hierarchy, but it also allowed them to differentiate themselves from the merchant class who were increasingly seeking entry into court society. In this way, as Elias explains, the development of manners was a dynamic process, born of the competition between social classes:

> The rising bourgeois strata are less free to elaborate their conduct and taste [than the nobility]; they have professions. Nevertheless, it is at first their ideal, too, to live like the aristocracy exclusively on

annuities and to gain admittance to the courtly circle; this circle is still the model for a large part of the ambitious bourgeoisie. . . . They ape the nobility and its manners. But precisely this makes modes of conduct developed in court circles continually become useless as means of distinction, and the noble groups are forced to elaborate their conduct still further. Over and again customs that were once 'refined' become 'vulgar'.

(1982: 304–5)

Indeed, some of the etiquette books which Elias surveys acknowledge the mutable nature of table manners. Antoine de Courtin, for example, writing in 1672, notes that since 'there are many [customs] which have already changed, I do not doubt that several of these will likewise change in the future' (Elias, 1978a: 93).

While manners were a crucial resource for consolidating one's social position in the court, however, as monarchical forms of power were replaced by bourgeois forms of authority so social distinction was more readily predicated upon wealth rather than etiquette: 'what people actually achieve and produce becomes more important than their manners' (ibid.: 106). As a result, the development of manners became less dynamic, and 'forms of sociability, the ornamentation of one's house, visiting etiquette or the ritual of eating, all are now relegated to the sphere of private life' (1982: 306). As Elias notes, the social importance of manners has endured most where 'aristocratic social formations remained longest and most vigorously alive: in England' (ibid.: 306–7).

Overall, then, Elias explains the civilizing process in relation to the development of state power and the accompanying social transformations. The performance of 'refined' behaviour is motivated by the obligation to operate in an increasingly interdependent social structure, and by the need to confirm one's social position over those of competing social classes. In generating increasingly cultivated modes of conduct, 'partly the form of conscious self-control and partly that of automatic habit' (ibid.: 243), the civilizing process has a profound effect on the psychology of individuals and the way in which they present themselves to others, and in the first volume of his study, Elias provides a detailed analysis of the way in which such processes have been played out in the realm of table manners. The key feature of the historical trajectory of table etiquette in Elias's analysis is the increasing threshold of shame and embarrassment attached to certain actions. Some natural functions which were once tolerated at the table – belching, breaking wind, etc. – increasingly become a source of shame, a 'fear of social degradation or, more generally, of other people's gestures of

superiority' (ibid.: 292). Tannhäusser's thirteenth-century poem of courtly manners, for example, exclaims: 'I hear that some eat unwashed (if it is true, it is a bad sign). May their fingers be palsied!' (Elias, 1978a: 88). Two examples cited by Elias from the fifteenth century convey a similar concern with the policing of natural functions at the table: 'Before you sit down, make sure your seat has not been fouled'; 'Do not touch yourself under your clothes with your bare hands' (ibid.: 129). As Elias argues, while early etiquette books such as these make explicit the shame attached to certain bodily functions, later texts tend to lack such explicit references, suggesting that by this time the civilizing process had ensured that certain feelings of shame and embarrassment had by now been internalized (ibid.: 128–9). At the same time, the sharing of plates and bowls also began to invoke disapprobation, and the boundaries between individuals around the table were increasingly emphasized. While early etiquette books refer to shared eating utensils, diners are increasingly entitled to separate plates and separate items of cutlery, as a late seventeenth-century song by the Marquis de Coulanges suggests:

> In times past, people ate from the common dish and dipped their bread and fingers in the sauce.
>
> Today everyone eats with spoon and fork from his own plate, and a valet washes the cutlery from time to time at the buffet.
>
> (Elias, 1978a: 92)

As this quote suggests, the civilizing process saw a proliferation in the number of items of crockery and cutlery. Not only is the boundary between individual bodies increasingly policed, but so too is the boundary between the body and the food being consumed. The following extract from a French guide to etiquette published in 1774 is instructive:

> The serviette which is placed on the plate, being intended to preserve clothing from spots and other soiling inseparable from meals, should be spread over you so far that it covers the front of your body to the knees, going under the collar and not being passed inside it. The spoon, fork, and knife should always be placed to the right . . .
>
> When the plate is dirty you should ask for another; it would be revoltingly gross to clean spoon, fork, or knife with the fingers . . .
>
> Nothing is more improper than to lick your fingers, to touch meats and put them into your mouth with your hand, to stir the sauce with your fingers, or to dip bread into it with your fork and then suck it.
>
> (ibid.: 97)

What is increasingly seen, then, is an emphasis on maintaining the cleanliness of the body, and of avoiding direct contact with foodstuffs before they reach the mouth. The civilizing process thus raises the threshold of shame and embarrassment in a number of ways, generating new regimes of body management in relation to natural functions, food and other people. As Elias argues, while such regimes were often subsequently justified in terms of their apparent yield of health and hygiene, this was not the reason for their initial emergence. Rather, they were generated by the quest for social distinction and the dynamics of court society. As such, they need to be seen in terms of

> ritualized or institutionalized feelings of displeasure, distaste, disgust, fear, or shame, feelings which have been socially nurtured under quite specific conditions and which are constantly reproduced, not solely but mainly because they have become institutionally embedded in a particular ritual, in particular forms of conduct.
>
> (ibid.: 12)

Elias's account of the civilizing process echoes much of Bakhtin's analysis of the banquet. In both cases, a historical trajectory emerges within which grotesque, 'vulgar' forms of behaviour are increasingly banished from the table, and bodies are increasingly policed and cleansed. However, while Bakhtin's account lacked historical detail, Elias's emerges from an analysis of etiquette books themselves, and is couched within a detailed explanation of long-term social transformations. Nevertheless, there are still two potential problems within Elias's theory of the civilizing process, the first of which concerns the relationship between gender and table etiquette. For Elias, as for Bakhtin, the development of table manners is bound up with the historical development of society, and in particular with the struggle between social classes. For Elias, as we have seen, manners were a crucial resource for the articulation of social distinction. It is possible, however, that manners were also a means of regulating the relationship between men and women. Elias is interested in the way in which the civilizing process requires men to curb their passions, enhancing the degree of self-restraint in men's relationships with women (1978a: 184–7 and 1982: 77–82). However, he has nothing to say about the way in which codes of table etiquette seek to enforce gendered forms of behaviour. It may be that the etiquette guides which form the basis of his survey were silent on this issue. However, it is clear that more recent examples of etiquette books certainly do

recommend codes of behaviour which are, in places, explicitly predicated upon gender difference. One text, for example, *Manners and Rules of Good Society*, published in 1898, advises women to steer clear of 'the most highly seasoned and richest of the dishes' on the menu (Anon., 1898: 115–16), and goes on to make to following observations:

> Savouries . . . are not usually eaten by young ladies. They are principally intended for gentlemen . . .
>
> As a matter of course young ladies do not eat cheese at dinner-parties.
>
> (ibid.: 118)

While Elias provides us with an account of the relationship between table manners and social differentiation, then, it is possible that we also need to develop an account of the relationship between manners, food tastes and gender difference. We might also note that Bakhtin's analysis of the banquet similarly lacks this perspective.

The second problem has generated much debate amongst scholars interested in the work of Elias, and it concerns the process of informalization (Mennell, 1992: 241–6). Elias contends, as we have seen, that long-term historical development has been marked by a civilizing process which has increasingly 'refined' people's codes of behaviour. However, it is not clear that recent developments in codes of etiquette fit into this pattern. The emergence of the 'permissive society' in the 1960s, for example, would seem to represent a period within which a wide range of behavioural codes were subject to a process of informalization, and would thus appear to offer a possible counterexample to Elias's historical model. And while debates about the permissive society focus principally on moral codes and attitudes towards institutions such as marriage, the codes which determine the way in which food is consumed also seem to be marked by an increasing leniency and a decline in formal constraints. Pasi Falk, for example, identifies two trends in modern food culture:

> First, the modern condition does not only imply a collapse of an eating-community as a structuring principle of social life but it also manifests a tendency towards a marginalization of the meal, even when conceived of as a less collective social event. Second, the decline of the meal is accompanied by the rise of different forms of non-ritual eating (snacks) and other modes of concrete oral-ingestive activity which concerns substances that are not considered to be food (sweets, titbits, soft and alcoholic drinks).
>
> (1994: 29)

If the consumption of food has been increasingly deregulated in this way, if shared meals have lost their importance, and if food is consumed increasingly in the form of snacks, to what extent does this represent a reversal in the civilizing process?

The critic who has written most extensively on this issue is Cas Wouters. One of his approaches has been to examine the prevalence of the etiquette book within contemporary Dutch society. While a host of etiquette books were published in the Netherlands from the 1930s through to the mid-1960s, only one such book was published between 1966 and 1979 (Wouters, 1987: 406–7). However, Wouters is unwilling to interpret this pattern simply as a reversal in the civilizing process, and he challenges such a reading in two ways. First, he argues, a precondition for the process of informalization is the ability of people to demonstrate increasing tolerance and self-restraint in relation to the actions of others:

> In this way, they gradually came to exert more and more pressure on themselves and on each other in the direction of stronger, more even and all-round self-control, and of greater sensitivity and flexibility in getting along with each other, with all others. The level of their mutually expected self-restraint has risen.
>
> (1986: 11)

As Wouters argues, this emphasis upon increasing interdependence and self-restraint is one of the key psychogenetic features of the civilizing process. While the conduct which informalization generates might seem to depart from the civilizing process, then, the psychological structures which permit such forms of behaviour in the first place very much belong to the civilizing trajectory. Second, Wouters argues, while the period 1966 to 1979 saw a dearth in Dutch etiquette books, the period from 1979 to 1985 saw a renewed sense of formalization, with nine new texts published in the Netherlands alone between 1982 and 1985 (1987: 407). What this means, Wouters suggests, is that the civilizing process as a whole is marked by successive waves of formalization and informalization. As Elias himself argues, 'the civilizing process does not follow a straight line' (1978a: 186).

It is perhaps not clear that, within the realm of food practices, we have witnessed a renewed formalization in the codes of behaviour surrounding the consumption of food in quite the same manner identified by Wouters in relation to the publication of Dutch etiquette books. Contemporary society offers opportunities to consume food alone, in the form of a snack, whilst on the move, just as it offers opportunities to

share a more formal, more expensive meal with others in a restaurant. But even with the latter, it would seem that, in a good many cases, recent years have witnessed an increasing relaxation in the formality expected of diners. Nevertheless, as Wouters argues, simply to identify emergent forms of behaviour which are apparently less formal than preceding behavioural codes is not in itself sufficient to call into question the general applicability of Elias's thesis to contemporary social processes. With this in mind, we will complete this chapter by reflecting further on the role of table etiquette within contemporary culture.

Contemporary table manners

We will return here to look at *Debrett's Etiquette and Modern Manners*, as the text best known for its attempt to define good manners. The book is clearly aimed at the aristocracy and the upper echelons of middle-class society, for it includes a preface written by 'Iain Moncreiffe of that Ilk', the Albany Herald of Arms (Burch Donald, 1990: 7), and regularly refers to the role of servants ('Dinner is announced', for example, 'by a servant saying simply, "Dinner is served"') (ibid.: 120). What looms large in the way in which the editor of *Debrett's* characterizes the nature of the advice it imparts is a tension between modernity and tradition. On the one hand, the increasing flexibility and informality of modern etiquette is acknowledged. At the same time, the persistence of some of the more formal codes of behaviour at 'ceremonial occasions' is praised in so far as 'it happily serves to reinforce and remind us of links with the past' (ibid.: 12). The threat of modernity is most clearly summoned in the following passage:

> the most rapid changes of all are taking place in business, where electronics and an economic boom have outstripped many estab-lished customs and, at the same time, created new areas where they are required. Few of us, for example, want to hear dinky tunes on telephones or watch video advertisements in post office queues; we feel harassed by sonic bleeps in Underground lifts and are maddened when addressed like idiots by credit card computers. As technology develops, business too needs to remember that if something is likely to cause annoyance to anyone, then it isn't really beneficial.
>
> (ibid.: 13)

As we have seen, Elias argues that manners start to lose their key func-tion as the currency of social distinction within the public sphere as

social and political power is gradually transferred from the aristocracy to the new merchant classes. He also suggests that in England, where the potency of the aristocracy lasted longest, the social influence conferred upon those capable of 'refined' behaviour endured most. What *Debrett's* seems still to be playing out here is precisely the tension which Elias identifies, between the residual power of the traditional aristocracy and the newer powers of the bourgeoisie with their mercantile practices. In this way, while the etiquette advice which *Debrett's* proposes might more often than not seem quaintly outdated, we can nevertheless locate it within the long-term historical shifts identified by Elias.

The chapter on table manners in *Debrett's* also bears out Elias's thesis in so far as it belongs to the historical lineage of etiquette books. Elias's study shows how subsequent etiquette books provide an increasingly detailed and formalized set of conventions, and *Debrett's* offers a regimented codification for policing the body and the spaces within which food and drink are consumed, focusing both on formal dinners, and on less formal 'DIY dinner parties' (Burch Donald, 1990: 125). It provides diagrams illustrating table-settings, and advice on issues such as napkin-folding and the use of finger bowls. There are detailed descriptions of the conventions for serving your guests their dinner, of appropriate topics of conversation while eating, and of the polite way to eat difficult items of food such as peas and snails. There are two points in particular to raise here, the first of which concerns the number of items of equipment associated with the formal dinner. *Debrett's* provides diagrams to explain the entire range of cutlery now required, numbering eleven items in total, excluding serving utensils (pudding fork, main course fork, fish fork, meat knife, butter knife, fish knife, pudding spoon, two styles of soup spoon, teaspoon and coffee spoon) (ibid.: 111–12). A similar range is required when it comes to crockery, where *Debrett's* recommends a dinner plate, a pudding plate, an intermediate cheese or salad plate, a butter plate, a soup plate, a bouillon bowl and a crescent salad plate (ibid.: 112). As we have seen, items such as these proliferated as the civilizing process took shape, generating increasingly mediated and complex forms of contact between the body and items of food. *Debrett's* advice belongs to this process. The second point to raise concerns the way in which the proposed codes of etiquette identify clearly demarcated gender roles. In the absence of servants, the hostess is given key tasks in making her guests feel comfortable, in serving food, and in steering table talk away from embarrassing topics of conversation (ibid.: 129). Women are also primarily responsible for writing a thank-you letter after being a guest at a dinner party (ibid.: 132–3). *Debrett's*

also offers the following thoughts on the convention of women leaving the men in the dining-room at the end of the meal, a custom which:

> has fallen into some disrepute of late, but before it is relegated to the dustbin it deserves reconsideration, as there are several things to recommend it. First of all, women do have *toilettes* to put right and this is an excellent opportunity to do so. Secondly, it gives women a chance to make friendly connections with their own sex which is harder to do in a drawing-room where the sexes are supposed to mingle.
>
> (ibid.: 131)

Clearly, then, manners are deployed as a means of gender distinction, a function which, as we have seen, Elias tends to overlook.

Debrett's provides a useful example with which to reflect on the historical trajectory proposed by Bakhtin and Elias. A contemporary publication with a long heritage, it represents a continuation of the civilizing processes which Bakhtin and Elias identify. At the same time, it seeks to negotiate changes in social relations and to accommodate practices where the process of informalization has become prevalent. With its dated character, however, and with its limited social appeal, it fails to provide us with a model of how the majority of people behave today when they consume food, with a model of dominant codes of etiquette. As we have seen Falk argue, and as Wouters's discussion of informalization suggests, contemporary food practices are arguably characterized by increasingly informal, deregulated forms of behaviour, both in terms of when, and in terms of how, food is consumed. The global commercial success of fast food, providing as it does opportunities for a quick, informal snack, is evidence of this trend. It is also commonplace for cookery books to offer themselves as repositories of informal forms of food consumption, eschewing the rigidity of formal dinner conventions and the pretensions of *haute cuisine* in favour of more relaxed and less formal conventions. One such example is Elisabeth Luard's *Saffron and Sunshine: Tapas, Mezze and Antipasti* (2000), which focuses on Mediterranean and Arab food traditions, where a meal typically consists of a range of small dishes shared by everyone around the table. For Luard, this way of eating is 'a reminder of the days when we all ate out of the same pot' (ibid.: 1). It is a flexible form of eating, which allows a great deal of freedom in the sort of dishes which are put together with one another. And, at a time when 'so few of us . . . live communal lives', it evokes a sense of 'conviviality' and friendship which has ancient roots:

'those who eat the same food smell right to each other; it all goes back to the cave' (ibid.: 4). While northern European culture, 'for whom the battle has always been for survival' expects 'discipline at table', Mediterranean meals, Luard argues, 'have little formal structure – basically, it's each man for himself, dip-in-the-dish and eat-what-you-please' (ibid.: 2–3).

There are two points to raise about Luard's account. The first concerns the way in which she celebrates the greater informality of Mediterranean and Arab food practices as an alternative to those of northern Europe, explicitly looking back to earlier points within the civilizing process where communal ways of eating were more common. Here, then, informalization is characterized not in terms of the emergent and the new, as Wouters does. Rather, in evoking the past, it is characterized in terms of a form of recovered tradition. While Luard's emphasis upon informality seems to distance itself from the formalizing tendencies of the civilizing process, the second point concerns the cultural status of the food traditions which Luard's book explores. As we have seen, Elias argues that manners functioned as a key vehicle of social distinction up until the point at which the bourgeoisie emerged as the most powerful social class, and that since then social distinction has more readily been expressed through other means, such as the display of money. One of the keenest commentators on Elias, Mennell (1996) has sought to provide a detailed analysis of French and English food practices in the light of Elias's work on the civilizing process. What Mennell argues is that the civilizing process not only generated particular regimes of food-related behaviour, but that it also generated an increasingly civilized appetite. In other words, the basic diet available to people in the middle ages, which was often very sparse but at times of celebration tended towards the Rabelaisian, was gradually 'refined'. Moderation progressively became a prized quality, and the form of food eaten, at least for the wealthiest social groups, became increasingly ostentatious or genteel. What Mennell suggests, then, is that social distinction was expressed not simply through the display of 'good' manners, but also through the consumption of 'good' food. At least since the publication of Countess Morphy's *Good Food From Italy* (1937) and Elizabeth David's *A Book of Mediterranean Food* in 1950 (1991), Mediterranean food traditions have maintained a certain currency within British culture, and to demonstrate one's familiarity with them typically operates as a form of cultural capital. While the *way* in which Luard's book proposes we eat might appear to reject the currency of formal manners, it is nevertheless possible, if Mennell is

correct, that *what* she proposes we eat has a social currency that is every bit as bound up with the civilizing process.

In the course of this chapter we have looked at the work of Bakhtin and Elias in so far as it offers us a theoretical account of the historical development of table manners. It was argued that their approaches were complementary, providing an analysis of table etiquette in relation to the processes of class struggle and the resulting search for social distinction within which the body is increasingly cleansed and policed. As we have seen, Mennell draws on Elias's work in order to develop an account of the relationship between food, appetite and the civilizing process. We have now reached a point where we have started to think not just about the codes of behaviour performed when food is eaten, but about the connotations of the food itself. As Mike Featherstone has suggested, there is already much in the work of Elias which gestures towards the central concerns of the French sociologist Pierre Bourdieu (Featherstone, 1987: 205). It is now time to develop our investigation further by concentrating on Bourdieu's theories of the relationship between taste and social distinction.

4 Consumption and taste

While an interest in the meaning of food consumption can be found across many of the chapters of this book, this chapter introduces some of the key frameworks in understanding these issues. The chapter focuses on the ways in which what we eat and how we eat relate to class cultures and identities, exploring how the foods we eat are not simply an expression of individual tastes but have a wider basis in class cultures and lifestyles. Tastes are not simply a reflection of our identity but work to construct our cultural identity: we may be what we eat, but what we eat also produces who we are (Bell and Valentine, 1997).

The concept of consumption is used in different ways in the social sciences. For example, while psychologists frequently equate food consumption with 'food intake' or what we eat, economists tend to equate consumption with purchase or what we buy (Steptoe *et al.*, 1998; Warde and Martens, 1998a; Young *et al.*, 1998). However, such approaches give only a partial picture of the range of practices that might be included in consuming food. Furthermore, by equating the foods we eat with the foods we choose, such approaches ignore the material, cultural and social constraints that might limit our 'freedom to choose' (Warde and Martens, 1998a).

In this chapter, we draw on approaches to consumption found within cultural studies and work on food consumption in sociology, anthropology and cultural geography. These disciplines share with cultural studies an interest in the way food consumption involves the production of meanings and identities. Furthermore, how we make use of food is a way of 'establishing relationships and social positions' (Clarke, 1997: 154). For example, as we go on to explore in Chapter 8, the domestic consumption of food can be a means of producing the experience of family life and relationships within the family. Therefore, ways of understanding the wider processes involved in food consumption overlap with the concerns of critics such as Shaun Moores (1993 and 2000) and

Dave Morley (1986 and 2000) who have examined the ways in which domestic media technologies are given meaning, and embedded in ways that structure everyday life. What we eat, how we prepare, serve and eat foods, frequently becomes 'enmeshed within the existing dynamics of power in the domestic realm' (Moores, 1993: 104). As Alison Clarke suggests, 'the decision and complexities of household provisioning embody consumption as an arena of power in which social relations and knowledge are constantly rehearsed, rearranged and challenged' (1998: 73).

While Chapter 8 focuses on gendered power relations within the home, this chapter introduces the work of Pierre Bourdieu to focus on how food consumption produces, reproduces and negotiates the class identities and cultures that structure wider relations of power. In particular, the chapter explores how tastes for particular types of food and ways of eating are far from individual but have their basis in class cultures and lifestyles. In Bourdieu's work, as we explain below, some classes use their power to construct their own tastes as *the* legitimate tastes and pathologize the tastes of other classes. In the following section, we explore how this has structured ways of thinking about food consumption in policy debates about 'adequate' nutrition and 'proper' diets.

However, we can only ultimately make sense of the significance of food consumption by relating it back to a wider 'circuit of culture', within which consumption is only one process (Du Gay *et al.*, 1997; Jackson, 1993; Johnson, 1986). We need to understand how our consumption of food takes place within a wider framework in which we consider how foods are produced, regulated, represented and associated with specific identities. The meanings that are given to specific foods through processes of consumption need to be also understood in relation to the meanings that are created through how that food is 'represented, what social identities are associated with it, how it is produced . . . and what mechanisms regulate its distribution and use' (Du Gay *et al.*, 1997: 3). Therefore, at various points within the following discussion of consumption, we also note how consumption must be related back to this wider circuit of culture.

Representing tastes

Before moving on to look in more detail at debates about class and food consumption, it is worth noting that images of class are used across a range of representations of food consumption and inform our everyday practices. Indeed, a common pastime in the supermarket queue is to check out the contents of other people's trolleys and, in the process,

make judgements about the social and cultural identity of that person. It is on this basis that supermarket singles' nights have become popular, offering among other things, the ability to judge whether someone is 'our kind of person' from their culinary tastes. Such judgements are frequently based upon widely understood representations of class and identity. For example, in the UK, balsamic vinegar has become a means of condensing a series of images of the middle-class foodie who wishes to demonstrate their associations with restaurant cuisine, international travel and a knowledge of food fashions.

Such representations of class and food consumption, however, also inform less trivial judgements of taste. Historically, the main fields associated with food consumption have been those concerned with diet, nutrition and health. In these areas, where consumption is frequently identified with the intake of food, there have been long-standing concerns about how unequal access to material resources has an impact on what we can afford to eat. Indeed, access to both the 'correct' quantity, quality and types of foods to meet nutritional 'needs' has been taken as one of the major indicators of the extent of inequalities within, and between, nations. While such studies often have the laudable objective of understanding inequalities in order to reduce them through policy initiatives, they also frequently rest on the idea that there is some 'normal' diet which best meets our physiological needs (Fine, 1998). Therefore, while economic disparities undoubtedly have a significant impact on what we eat, some approaches to nutrition depend on images of 'normal' and 'abnormal' diets that are frequently associated with particular classes.

For this reason, while models of nutritional 'needs' claim to rest on objective scientific rationale, they frequently have cultural dimensions. First, nutritional requirements are far from natural but depend on culturally and historically specific nutritional standards which vary over time (Levenstein, 1993). Second, they often treat human eating purely in terms of physiological needs, ignoring the range of social and cultural factors which shape food habits (Fine, 1998). Third, from such a perspective, 'culture is most often viewed as an impediment to the goals of nutrition' (Lupton, 1996: 7). This has resulted in a tendency to see deviations from the legitimated diet by the working class as not simply a result of material deprivation but also cultural deprivation: that is, that they lack the right cultural knowledges and practices and hence to do not know how to consume 'properly'. A healthy diet is frequently equated with a middle-class diet and this suggests that those who claim the cultural deficiencies of the working-class diet are also maintaining the

legitimacy and distinction of their own tastes (Crotty, 1999: 145). Finally, as Deborah Lupton argues, 'the history of nutritional science thus demonstrates an increasing tendency towards the rationalization, surveillance and regulation of the diet of the masses, supported by "scientific" claims' (1996: 72). Therefore, not only are 'objective' scientific judgements also profoundly cultural, but such representations form the basis for regulation.

The discussion above suggests that tastes for certain quantities, qualities and types of food are often taken as indicators of the moral and cultural worth of different social groups' lifestyles. Indeed, such assumptions are embodied in the French gastronomer Auguste Escoffier's claim that 'La bonne cuisine est la base du veritable bonheur' which roughly translates as 'good cooking is the base to good living' (Rhodes, 1996: 10). The concept of 'good' food practices here no longer simply refers to nutritional value, but carries with it moral and aesthetic values. Furthermore, food tastes – our likes and dislikes – are not only social and cultural (rather than being biological or individual) but these tastes are related to broader aesthetic and moral classifications in which some tastes are seen as more legitimate than others. For example, in Charles and Kerr's (1988) study of the food practices of British families, some of their respondents showed a profound distaste for chips because they were associated with what they saw to be the morally and aesthetically impoverished tastes of the working class. In this way food consumption practices were bound up with representations of social and cultural types.

Such images of class and food consumption are replayed across a range of cultural and media forms and their meaning rests on our ability to recognize them. A recent example of this could be seen in the UK television series *Jamie's Kitchen* which featured celebrity chef Jamie Oliver in a show which hybridized the cookery programme, docu-soap and 'reality' talent show. The programme aimed to document Jamie's quest to turn fifteen unemployed young people, plucked from thousands of hopefuls, into chefs who would staff the new restaurant venture he was launching. However, the show usually included a cooking demonstration in each episode which was simultaneously addressed to the would-be chefs and the viewer. The programme made clear the differences in tastes between the working-class would-be chefs whose favourite foods included chips, pizza and baked beans, and those of Jamie, and by implication the viewer, for tempura oysters, speciality Italian breads and steak poached in red wine. In the process, not only were the tastes of Jamie's trainees shown to be deficient, but one of the key narratives of the series rested on Jamie's ability to 'make-over' their tastes. If we follow the ideas raised by the

model of a circuit of culture, then consumption practices will be partly informed by such representations of legitimate and illegitimate tastes.

Class, consumption and taste

This section, and the one which follows, considers the extent to which class differences are still significant in understanding food consumption practices. It is often claimed that processes such as McDonaldization have standardized eating both within, and across, nations and, in the process, eroded class (among other) differences to produce homogeneous food cultures. From such a perspective, processes of industrial mass production bring about a form of standardized mass consumption. This implies that the mode of production determines how we consume products.

While attention to the political economy is important in understanding the social relations underpinning food production, distribution and consumption, the industrialization and globalization of food production does not necessarily bring about standardized foods or standardized consumption practices (see Chapters 1 and 6). Furthermore, many critics have argued that the shift to post-Fordist modes of production in the second half of the twentieth-century is associated with niche markets rather than mass markets. This suggests a shift towards more 'individualized and hybrid consumption patterns' rather than mass consumption (Lee, 1993: 127). Finally, for critics such as Stephen Mennell, the argument that the industrialized mass production of food brings about standardized mass consumption ignores the fact that modernization has brought about 'more varied cookery as well as more plentiful food' (1985: 321).

For Mennell, the key long-term historical trend in eating practices in the UK from the Middle Ages to the present day 'has been towards diminishing contrasts and increasing varieties in food habits and culinary tastes' (1985: 322). The increasing variety of food habits and tastes results in what Mennell calls a new 'culinary pluralism' in which there is no one dominant culinary style (ibid.: 329–31). In this way, Mennell argues, modernization has not brought about standardization. However, there are nonetheless, 'diminishing contrasts' between the food habits and tastes of different social groups. In particular, he argues, there are diminishing contrasts between the food habits and tastes of different social classes.

Mennell's argument rests on a broad historical explanation of changes in food practices. In the process, he makes a convincing argument that there has been a decline in the difference between the eating practices of the higher and lower classes. Mennell does not argue that class differences

have been eradicated but instead that hierarchies have 'diminished but by no means disappeared' (ibid.: 322). Nonetheless, by emphasizing historical change, he tends to downplay the idea that class differences in food consumption are still significant economic, social and cultural differences.[1]

However, many sociologists have been more concerned with 'the persistence of social differentiation' (Warde, 1997: 39). For example, Nelson's (1993) review of historical changes in the British diet from 1860 to 1980 suggests that class differences persist in food consumption, while Tomlinson (1998) demonstrates the persistence of class difference in food tastes in the 1990s. However, while this evidence is no doubt useful in empirically documenting the existence of class differences in food consumption, they are more concerned with what is consumed rather than a wider understanding of food consumption. For this reason, they tell us little about the *significance* of class differences. From the point of view of cultural studies, it is also necessary to explore 'the meanings of differences . . . by looking at their contexts, social and cultural bases and impacts' (Ang, 1985: 107).

One of the best examples of such a study in relation to food consumption is provided by French sociologist, Pierre Bourdieu, in his book *Distinction* (1984), which is based on extensive survey research of the tastes and preferences of different class fractions in France in the 1960s. Within his wider study of consumption practices, Bourdieu demonstrates how our food tastes are far from individual but have their basis in the social relationships between different groups, and in particular, social classes. Bourdieu's study shows how the different food tastes and practices of different classes are meaningful because they are embedded within the logic of distinctive class cultures and because they are involved in the struggles for cultural power between classes. Bourdieu argues that our class position is a product of how much capital we possess, the types of capital (economic, cultural, social, symbolic) we possess, and the chances groups have to capitalize on these assets in a particular historical location (1984: 144). The experiences of different social classes predisposes them to consume differently and this is reproduced within a class culture through what Bourdieu calls the habitus, a 'system of dispositions' through which we classify and make sense of the world, and distinguish between what is, and isn't, 'our kind of thing'. Using Bourdieu's conception of class, it becomes clear that the food tastes and practices of different social classes cannot be simply explained by questions about economic inequalities: consumption practices are also a product of class-based cultural dispositions which, although a product of economic experiences, are not simply reducible to them.

For example, working-class taste

> derives from the immediacy of their work experience, and the pressure imposed by their needs. A person who provides manual labour, and whose access to the basics of sustenance and comfort is not guaranteed, has a respect and desire for the sensual, physical and immediate.
>
> (Miller, 1994: 150)

This is manifested in a taste for substantial and generous foods such as casseroles, bread and cheap cuts of meat. However, this habitus does not only shape what the working class eat: 'ways of treating food, of serving, presenting and offering it . . . are infinitely more revelatory than even the nature of the products involved' (Bourdieu 1984: 193). Bourdieu characterizes the working-class table as abundant and heaving with food which celebrates a refusal of the restraints and pretensions that characterize bourgeois culture. In a domestic context, the over-burdened table can also signify the ability to provide for the family in an economic situation where having enough food is never guaranteed (see DeVault, 1991). This refusal of formality and restraint can be seen in other food practices. For example, in the UK, fish and chips eaten with the fingers out of newspaper has been seen as a central feature of working-class culinary culture. Working-class food practices, therefore, not only emphasize the immediate and sensual pleasures of food, but of eating and sharing foods in an atmosphere which stresses 'the generous and the familiar' and 'a conviviality that sweeps away reticence and restraints' (Bourdieu, 1984: 179). (This recalls the concerns of Bakhtin discussed in the last chapter.)

In contrast, the different experiences of the bourgeoisie generate a different set of dispositions towards food: a 'person who has been brought up with the abstractions of education and capital, and who is certain of obtaining daily necessities, cultivates a distance from these needs, and affects a taste based in the respect and desire for the abstract, distanced and formal' (Miller, 1994: 150). This produces a disposition towards food which forsakes the 'immediate' satisfactions of eating and the 'biological need' to eat, in a preference towards 'light' and 'refined' foods such as fish and vegetables and for 'quality' over 'quantity'. They are more concerned with the style, presentation and aesthetic qualities of foods. This is perhaps best epitomized by the *nouvelle cuisine* of the 1980s in which fancifully presented dishes were styled out of minute morsels of food. In *nouvelle cuisine*, the visual and oral aesthetics of a dish were privileged

over the idea of food as fuel which fills you up. For Bourdieu, bourgeois eating practices are characterized by restraint, the meal governed by a 'rhythm which implies expectations, pauses, restraints: waiting until the last person served has started to eat, taking modest helpings, not appearing over-eager' (1984: 196).

These different dispositions towards food are also demonstrated in DeVault's study of domestic cooking and eating practices in the US. Working-class women tended to experiment less with food, their practices based more on 'custom and habit' (1991: 203). The function of special occasions is that they emphasize the familiar: both traditional foods and the importance of family. While working-class women reproduce a more 'restricted' culinary code because they had little opportunity to use their capital to achieve any form of profit, middle-class women took a more abstract approach to cooking, using a 'more generalized set of styles and codes' gained from cookery books and magazines (ibid.: 206). Middle-class women were more likely to use food 'as a class code' (ibid.: 223) and used food not only to promote sociability among the family but also to create alliances with friends from the same class. If food consumption is related to economic and cultural capital, it can also be used to demonstrate and generate social capital.

Bourdieu's work doesn't simply aim to describe how and why different classes consume food differently, but also to explain the significance of these differences in food practices. Food consumption, like other forms of consumption, is a site of class struggle in which the middle classes have a better opportunity to capitalize on their assets. Just as economic capital can be invested in order to produce a profit, so possession of cultural capital yields 'a profit in distinction ... and a profit in legitimacy ... which consists in the fact of feeling justified in being (what one is), being what it is right to be' (Bourdieu, 1984: 228). This sense of legitimacy is based on both a refusal of, and a sense of distinction from, those who appear only 'natural' in their tastes. In this way, for middle-class viewers of *Jamie's Kitchen* who have invested in culinary cultural capital (Bell, 2000), the series confirms the legitimacy of their tastes for focaccia over the taste for deep-pan pizza.

If bourgeois taste is based on a refusal of the 'simple' and 'vulgar' pleasures which characterize working-class taste, then the working-class habitus is also based on a refusal of the pretensions of restraint which characterize bourgeois culture, where 'the working classes explicitly challenge the legitimate art of living' (Bourdieu, 1984: 179). While some members of lower social classes may attempt to emulate the bourgeoisie by attempting to acquire the dispositions of legitimate culture, at the

heart of Bourdieu's theory is a model in which each class expresses 'aesthetic intolerance' (ibid.: 56) for other classes, but in which the bourgeoisie have the cultural power to identify what is legitimate, 'and what can then be governed and policed as illegitimate or inadequate or even deviant' (Ross, 1989: 61). While the working classes may reject the creations of celebrity chefs as ridiculous (Caplan *et al.*, 1998), the taste for the light and refined presents itself as the 'normal' diet against which the working-class diet is treated as pathological and nutritionally inadequate.

Bourdieu's theory situates food consumption practices within a wider framework of class inequality and class struggle and, in the process, demonstrates how the 'mundane' details of everyday life in the private sphere are also a site where class dominance is both practiced and challenged. Bourdieu's work on class and food consumption not only suggests that class differences matter but also that everyday food practices do not simply 'express' a class identity but also produce and reproduce class identities.

Transformations in food tastes

While Bourdieu's work has been influential in shaping the study of food consumption, some critics have argued that because his theory is based on questionnaires conducted in the 1960s, it can only offer a snapshot of food practices at a particular point of time rather than an understanding of the dynamics of historical change (Mennell, 1985). It has been argued that contemporary food cultures in the West are characterized not only by increasing variety but also by 'a demand for novelty' which weakens the relationship between class cultures and food consumption (Grunow, 1997: 28–9). However, the increasing turnover of new food products and the development of tastes for new foodstuffs does not necessarily reduce the significance of social and cultural differences or erode the different dispositions that social classes bring to their food practices. Furthermore, Bourdieu's analysis of transformations in the class structure suggests that the quest for novelty may be associated with the rise of new social classes. As Lupton argues, 'trying new foods and cuisine is also a sign of sophistication and distinction, of a willingness to be innovative and different from the masses' (1996: 127).

For Bourdieu, the rise of the new middle classes based in new service industries and white-collar jobs rather than more traditional professions transforms the social space of class relations. The new bourgeoisie, 'the new taste-makers', reject the sobriety and abstinence of the old

bourgeoisie 'in favour of a hedonistic morality of consumption, based on credit, spending and enjoyment' where people are judged 'by their capacity for consumption, their "standard of living", their lifestyle, as much as by their capacity for production' (1984: 310). The new petit bourgeoisie who tend to work at lower levels of the same industries, also invest in consumption and 'the art of living', and have an approach to life based on 'a morality of pleasure as duty' (ibid.: 366–7) which values the 'amusing, refined, stylish, artistic [and] imaginative' (ibid.: 359). Indeed, these values are strikingly similar to those that underpinned middle-class cooking practices in DeVault's study which linked 'pleasure with novelty and entertainment' (1991: 214). The new middle classes attempt to assert their distinction not only by rejecting the values of working-class culture, but also by attempting to validate their tastes as the legitimate tastes by rejecting the values of the old middle classes. However, the new petit bourgeoisie are also characterized by a far greater sense of anxiety than the new bourgeoisie: they seek to educate themselves in the art of lifestyle but are never secure in the sense of having got things 'right'. These new classes aim to gain a sense of distinction through what Featherstone (1991a) calls the 'aestheticization of everyday life'. Food practices can become a key way of making the dispositions of these classes visible and are a means through which they practise distinction.

Therefore, it is the new middle classes who are best equipped to distinguish themselves by consuming the increasing variety of foodstuffs on offer:

> the search for new taste sensations and eating experiences is considered a means of improving oneself, adding 'value' and a sense of excitement to life. . . . This is particularly the case for individuals who view food preparation and eating as aestheticized leisure activities rather than chores.
>
> (Lupton, 1996: 126)

This increased emphasis on food as leisure can be seen in the UK in the current boom in restaurants and bars offering new forms of eating out experience and the increased frequency of TV cookery shows in prime-time slots. While this also coincides with an increased participation of middle-class men in cookery as a hobby rather than a form of domestic labour (Levenstein, 1993; Hollows, 2002, 2003a and 2003b), this view of food as leisure masks the extent to which it may still be experienced as labour by middle-class women faced with the responsibility of producing imaginative and entertaining meals on a virtually daily basis (DeVault, 1991).

However, as Bourdieu's work makes clear, class differences in food consumption do not simply direct what is eaten but also shape dispositions towards food. The new middle classes may innovate by searching out new exotic foodstuffs and transgressing the cultural boundaries of the edible and inedible. Lupton refers to this as:

> a machismo of eating, an almost reverse food snobbery, in which the more repulsive the food, the more points are won for appearing gastronomically brave and adventurous. In some ways, the ability to eat such foods represents the ultimate in self-control, demonstrating mastery over accepted norms and one's own body in its very transgressive nature.
>
> (1996: 129)

These foods are usually ones that are outside the mainstream of a culture's cooking: traditional working-class dishes which have fallen out of favour and the 'peasant' dishes of another culture. For example, one of the UK's foodie bibles of the 1990s, *The River Café Cookbook*, contained recipes for poached brains, poached sweetbreads, and pan-fried calf's brains and sweetbreads (Gray and Rogers, 1995). Likewise, celebrity chef Alistair Little reinvents the traditional working-class British dish of tripe for a new middle-class audience by 'authenticating' it with a European flavour as a 'Tripe Gratin'. The bravery of the reader is further tested by the chef's informative definition of tripe as 'the stomach lining of a ruminant – a beast that chews the cud and has no fewer than four stomach compartments' (Little and Whitington, 1993: 164).

However, the new middle classes may also consume the same foods as the classes from which they seek to distinguish themselves: it is the manner in which they consume them which can earn them a sense of distinction. For example, British cookery writer Nigel Slater demonstrates this 'reverse snobbery' in his advice on chip butty-making:

> I love chip butties. But there are rules. The bread should be white and thick sliced. The 'plastic' type is more suitable than real 'baker's bread' because it absorbs the melting butter more readily. The chips should be fried in dripping, not oil, and sprinkled with salt and malt – yes, I said malt – vinegar. The sandwich should drip with butter. Good eaten when slightly drunk, and the perfect antidote to the char-grilled-with-balsamic-vinegar-and-shaved-Parmesan school of cookery. And so frightfully common.
>
> (Slater, 1993: 176)

By transgressing established class boundaries in a spirit of fun and hedonism which shows a disdain for the sober calls for healthy eating, the new middle classes can distinguish themselves from both the restraint of the old middle classes and also from the working classes who are allegedly not aware of the more aesthetic and kitsch pleasures of the art of making a 'chip butty'. Furthermore, in this way, the new middle classes distinguish themselves as 'cultural omnivores' and this 'enables the middle class to re-fashion and re-tool itself through the use and association with tastes that were once associated with the working class' (Skeggs, forthcoming). The new middle classes' taste for 'trashy' foods doesn't dissolve the relationship between class and tastes but reaffirms their own distinction (see Warde and Martens, 2000).

Lupton's work, based on interviews conducted in Australia, suggests that strategies of distinction identified by Bourdieu also operate outside France. However, while Warde's research into food tastes in the UK also confirms the persistence of class differences in food consumption, he found that few people used their food practices as strategies of distinction. Instead, he argues, 'consumption is now best characterized as undistinguished difference, a condition brought about by an obsession on the part of consumers with variety which matches the capacity of industry to provide mildly differentiated products in considerable volume' (Warde, 1997: 155). Therefore, Warde's work suggests that while there are significant class differences in food consumption, the meaning of these differences cannot be simply equated with a quest for distinction. 'Food preferences', he argues, 'exhibit a person's membership of a particular group, rather than making strong statements about either individuality (personal taste) or social superiority (inter-group distinction)' (ibid.: 125). Furthermore, the major differences between the foods different classes consume are largely a product of the unequal distribution of material, rather than symbolic, resources.

This section has examined how transformations in food practices in the late twentieth century have produced new conditions for articulating class differences in food consumption rather than eradicating them. While for some critics the practices of the new middle classes are underpinned by a logic of distinction, for others such as Warde class differences persist but are 'undistinguished'. The difference in these findings may be a product of the different methodologies employed: more qualitative data is more likely to be able to reveal the complexity of the meanings that people bring to their consumption practices. However, there is little evidence – quantitative or qualitative – to suggest that the specific dispositions which the new middle classes bring to their consumption practices

are being adopted more generally: the strategies of distinction which the new middle classes bring to their food practices are class-specific competences and dispositions.

Expanding tastes

While this chapter has concentrated on the relationship between class and taste, we want to end by gesturing to a range of other ways in which the relationship between food consumption and tastes can be studied. The section begins by briefly considering gender, ethnicity and generation and their relationship to food consumption before examining a more historical framework for thinking about changing tastes which also relates consumption back to the circuit of culture.

Work on gender, food consumption and taste frequently concentrates on how what we eat and how we eat reproduces gendered identities. For example, Lupton suggests that people's consumption practices are often underpinned by taken-for-granted assumptions that 'heavy' foods such as steak are masculine and 'light' foods such as salad are feminine. While these gendered tastes are culturally constructed, they are experienced as 'natural' because they have become 'commonsense' and are embodied as they are reproduced through practice. Furthermore, gendered preferences for light or heavy foods also work to affirm conceptions of the feminine body as light and the masculine body as strong and heavy.[2] In this way, gendered tastes, 'reproduced from infancy in the family and other sites, serve to construct individuals' food habits and preferences' (Lupton, 1996: 111).

The following chapter identifies how food consumption rituals are a key mechanism for producing and reproducing ethnic identities. National identities are affirmed not only through what is eaten but through rituals such as the British Sunday lunch in which people feel connected to a wider national community through participation in a collective activity. Likewise, diasporic communities may experience a sense of connection to a wider community through the simultaneous consumption of meals tied to a religious calendar – for example, the Jewish *Seder* brings together a dispersed community through food rituals (see Morley, 1991). However, eating practices are not simply a way of reproducing identity but also constructing identities: Caplan *et al.*'s study of Afro-Caribbean food habits in London revealed a conscious recognition 'of the symbolic importance of West Indian food for their ethnic identity' (1998: 180).

Food consumption not only works to reproduce ethnic identities but also to negotiate their meaning. For example, Marie Gillespie's work

shows how some young Londoners of South Asian origin ate only 'American' or 'British' food to distinguish themselves from people 'who are seen to eat "only" Indian food' and, in this way, from particular constructions of ethnic identity (1995: 198). For Gillespie, this rejection of South Asian culinary traditions 'can be seen as a gesture expressing the desire to establish some degree of independence from the family culture and at the same time exert some control over one's own identity' (ibid.: 200). A distaste for 'Indian' food was a means through which these young people represented their distance from one identity and negotiated new 'hybrid' identities which articulated elements of Asian, British and American cultures. The group's food tastes were consciously used as a strategy of distinction and to articulate and reproduce a sense of difference.

However, the ways in which food tastes are shaped by – and shape – classed, gendered and ethnic identities does not remain constant over time. It is also necessary to be aware of how our tastes for certain foods are shaped within specific historical formations. A useful analytic device in this context is offered by Alan Warde who identifies four antinomies, or binary oppositions, which 'comprise the structural anxieties of our epoch' (1997: 55) and frame food consumption practices and tastes. For Warde, these four antinomies – health and indulgence, economy and extravagance, care and convenience, and tradition and novelty – 'are long-standing structural oppositions, claims and counter-claims about cultural values which can be mobilized to express appreciation of food and to make dietary decisions' (ibid.: 55). The shifting equilibrium between these antinomies is a means of mapping historical change.

Warde identifies changes in how these antinomies are dealt with between the 1960s and 1990s by looking at the *representation* of food in women's magazines and by studying food *consumption*, but he also locates these within a wider framework which acknowledges trends in *production* and policy or *regulation*. In the process, he offers a way of understanding how the relationship between food consumption and *identity* is articulated within specific historical formations and within the wider circuit of culture. Such an approach offers the potential for a more historically and geographically sensitive understanding of food cultures.

If Warde draws our attention to the importance of acknowledging how food tastes are mediated through cultural forms such as women's magazines, he also acknowledges that studying consumption inevitably brings us back to questions of production. As Fine (1998) suggests, in order to understand food consumption we need to also pay attention to the wider socio-economic structures through which food is produced,

distributed, retailed and mediated. The social relations of production and the social relations of consumption cannot be studied independently as they impact on one another (Jackson and Thrift, 1995). In this way, 'food purchase, use and consumption bring together the private and the public, the local and the global' (Cook *et al.*, 1998: 162). These shifting spatial relationships identified by Cook *et al.* are explored in the following two chapters.

5 The national diet

In 1999, the first ever non-stop circumnavigation of the world by balloon was completed. The crew consisted of a Swiss psychiatrist, excitable, flamboyant, Bertrand Piccard, and an undemonstrative, pragmatic Englishman, Brian Jones, who celebrated, appropriately with a drink: 'I'm going to have a cup of tea, like any good Englishman' (Author Unknown, 1999). There is little to surprise here. Jones implicitly identifies a 'national drink' and few would quarrel with his choice. As we argued in Chapter 1, the link between Britishness and a 'nice cup of tea' is well established, taken-for-granted and very much a part of the 'national culture'. George Orwell observed as much in 1946, in his essay 'A Nice Cup of Tea' (1968a: 58–61) and Brian Jones's words proclaimed not simply his individual success, but his positioning culturally within that tradition of British adventure, daring and enterprise which explored, charted, educated and exploited so much of the globe during the second half of the second millennium.

Constructions of nations and national identities have attracted a great deal of critical attention within the humanities and social sciences over the last two decades. As Jonathan Rée (1992) argues, four books in particular defined a new orientation towards such issues, Nairn (1977), Gellner (1983), Anderson (1983) and Hobsbawm (1991). 'For all their differences, these works agree in their emphatic rejection of the idea that . . . nations are "as old as history"' (Rée, 1992: 3). This emphasis on nation forms part of a broader interest in identity, belonging and difference that have been central to the formation of cultural studies. While questions of identity are addressed at regular intervals throughout this book, here we concern ourselves with the relationship between food and local, regional and national identities. The chapter will draw on and attempt to extend the debates highlighted by Rée. Though the issues are of global significance the majority of examples will be British, and we begin by looking at some of the meanings surrounding British food – and

in particular the ways in which food participates in shaping the wider meanings attaching to Britishness. We shall then proceed to address explicitly some of the theoretical perspectives implicit thus far, with particular reference to the work of Benedict Anderson and to the theorizing of national identity rooted in structuralist discussions of difference. The chapter will conclude with a brief discussion of the significance of the concept of 'authenticity' as a marker of food quality. It is a premise of what follows that just as the nation itself is problematic and difficult to define with precision, so also, necessarily, is the concept of a national diet.

The problematic obviousness of the national diet

The concept of a British national diet does not at first sight appear problematic. If one were to ask a sample of British people what they understand by the term 'British food',[1] their responses would not be identical but would tend to overlap in ways which might encourage the notion of a 'core national diet'. A day's 'menu' might be: the full English breakfast (fried egg, bacon, sausage, tomato, etc.); roast meat (especially beef) with all the trimmings; afternoon tea with scones and/or home made cake; and fish and chips for supper. Remote though this may be from the daily food consumption of most British people, there is nonetheless a case for arguing that this constitutes a national diet as defined by the collective imaginings of the people. The idea would certainly seem to be endorsed by the food served in the restaurants of properties owned by the British heritage institution, the National Trust. A BBC TV programme *Treasures in Trust* (1995), concerned with the National Trust in general, included a section on the restaurant of the property at Bedruthan Steps in North Cornwall. Cream teas and home-made cakes were at the core of the menu. The manageress commented: 'We're not allowed to do foreign food. We're only allowed to do English food. I can't do lasagne or anything like that.' The food is not only typically English 'fayre', but defiantly national in a way which excludes foreign cuisines.

Yet not far from the surface of this apparent obviousness are very real problems. Firstly, it is highly probable that few British people have ever actually eaten the core diet in any recent single day and it may very well be the case that many Britons do not regularly eat any single item from the list. Second, what constitutes the national diet is itself subject to change over time. For example, an article by Zoe Brennan in the *Sunday Times* on 15 March 1998 reports outrage at the alleged failure of the

Prince of Wales to endorse typically British food. Invited to contribute to a recipe book designed to honour British food, the Prince offered basil and pine nut loaf and gnocchi with pesto, recipes of Italian origin. The article concludes that the future monarch 'does not like English food'. The book's publishers decided to include the recipes and the article quotes their justification: 'British food is now so eclectic that we include some Italian recipes.' What may at first glance appear to be problematic is in fact hardly remarkable, as the nation itself is far from obvious. What may at first sight appear taken-for-granted – the dominant or traditional national meanings clustering around such 'timeless' icons as the monarchy, *Pomp and Circumstance* and National Trust properties – is called into question very fundamentally by definitions of Britishness flowing from competing class, gendered or 'racial' positions. The meanings attaching to these icons will indeed vary considerably amongst members of a multicultural nation at the commencement of the twenty-first century. As well as these public emblems and rituals, nation is lived through the commonplace and the everyday, what Michael Billig (1995) describes as 'banal nationalism'. We should not suppose that things will be any different in the case of 'boiled beef and carrots' or English scones.

The British 'culinary desert' and the impact of foreign influences

Prince Charles's preferences should remind us that the impact of foreign influences on British food is long-standing and has increased in recent decades. Its corollary, and arguably its explanation, is a perception of native British food as at best mediocre. Writing in 1945 George Orwell observed that, 'It is commonly said, even by the English themselves, that English cooking is the worst in the world.' Later in the same essay he remarks: 'The expensive (English) restaurants and hotels almost all imitate French cookery and write their menus in French' (Orwell, 1968b: 56).

Such perceptions comfortably predate Orwell. Food historians trace the beginnings of this influence to the aftermath of the French revolution when many of those who had formerly cooked for the French aristocracy sought alternative sources of income in restaurants in London (as well as in Paris and subsequently New York) (Mennell, 1985: 135–44). Throughout the nineteenth century the British middle classes looked to France for models of culinary good practice.[2] These attitudes persist, as British middle-class tourists continue to holiday in France in order to 'eat properly'. This same class is willing to pay rather large sums of money for food cooked in southern England by celebrity French chefs

such as the Roux brothers, Raymond Blanc or Pierre Koffmann. Inscribed in this history is a developing perception of British cuisine as empty space waiting to be colonized by influences from abroad – and especially from France, where food is treated with seriousness, even reverence, at both domestic and professional levels and by producers and consumers alike.

The idea of the culinary desert does not register exclusively in contra-distinction to Gallic abundance. For one London restaurateur, Shreeram Vidyarthi, speaking in 1995, it explains the astonishing success of Asian restaurants in Britain:

> Indian food capturing the British imagination and the British palate is not such an amazing thing. It had to happen. . . . In terms of food culture Britain was a total vacuum. Anyone who came from overseas could fill it up. So pizza parlours and Wimpy Bars and Macburgers and Indian food – why not? You had nothing to replace it with.[3]

The story of Southern Asian catering in Britain begins between the wars. The only restaurants then available were the small number in London which catered largely for retired officials of the Raj. These were high-class establishments, exclusive and expensive. A different kind of establishment emerged during the 1930s when Siletti seamen from North Eastern India set up what were essentially workmen's cafés in dockland areas. These were small-scale beginnings. It was not until the 1950s that restaurants owned by Asians began to attract British customers. Initially menus were substantially 'British' with a small number of Asian dishes for adventurous diners. Gradually 'the curry' was introduced, until by the end of the decade it was possible for restaurants to offer menus which were almost entirely 'Indian'. Around the same time, as 'cafés' evolved into 'restaurants', curries began to attract the 'discriminating' British palate. By 1959 Indian restaurants took their place in *The Good Food Guide* alongside well-established and prestigious French-influenced establishments.

The growth in Asian restaurants in England has been dramatic. In 1950, there were six Indian restaurants in the UK. By 1970, there were 2,000; in 1982, 3,500; and in 1994, 7,500 (Hardyment, 1995: 124). The class configurations surrounding eating in 'curry houses' are notably different from those in other kinds of restaurants. If eating out in up-market establishments confers at least a level of distinction, it is also clear that the cultural capital varies substantially between categories of restaurant. (For a more detailed discussion of this see Chapter 4.) Out-

side a small and select band of restaurants located principally in London, there is no sense in which eating Southern Asian food is the preserve of the middle and upper classes. Not for the first time in this book we note the links between food and issues of social class, and it is essential that these connections be located very firmly in the context of 'race' within British culture. Christina Hardyment's positive reading of the massive presence of Asian restaurants on British High Streets as testimony to the success with which the British have negotiated multiculturalism: '(the) celebration of difference rather than obsessive integration; informed respect rather than grudging tolerance' (1995: 113) may or may not stand up to critical examination. Other writers indicate more problematic relationships between providers and consumers, and Uma Narayan (1995) is particularly interesting in exploring the relations not simply between waiters and consumers, but also between Asian restaurateurs and their staff. Narayan alerts us to some of the ways in which colonial and postcolonial relationships are replicated in the contacts between producers and consumers within Asian restaurant culture. Anecdotally a clear example is provided by the unlovely brand of white British machismo which occurs rather frequently in Asian restaurants after pubs' closing time on Friday nights. Crass racist insults are for the most part tolerated by waiting staff. Allegedly retaliation is usually covert and may be measured in the quantities of chilli – or nastier substances – which find their way into the dish.

Whilst the impact of foreign influences on British food is inescapable, we should not assume that such influences are absorbed unmodified. From the outset Asian food was adapted to suit British palates, and it is widely noted that the food served in most High Street curry houses bears little relation to anything obtainable in the sub-continent. The Chicken Tikka Masala (CTM in the trade) is a case in point. Rohan Daft (1998) suggests that 'Christmas lunch may be turkey, but our national dish is chicken tikka masala'. The basis for the suggestion is quantitative. Daft cites the 23 million portions sold annually in restaurants, the 18 tonnes sold ready-made weekly by Marks and Spencer and the infiltration of other food products by CTM – as a crisp flavouring, pizza topping or sandwich filling, for example. Far from being 'classically' or 'authentically' Asian, CTM was invented for the British palate during the 1970s, and it is alleged (though the allegation is not uncontested) that the first gravy base was a tin of Campbell's condensed tomato soup. Following on from the successes in the restaurant business, the greatly enhanced availabilty in supermarkets and takeaways during the 1990s of pre-cooked Asian food represents an important consolidation of the position

of Indian food in British food culture. This position is indeed so secure that it threatens to influence the donor culture, not simply in the United Kingdom, but also in Bangladesh and India. A headline in the *Daily Telegraph* on 3 November 1999 read 'Britain exports chicken tikka masala to India'. The story concerned the demand among British tourists in the subcontinent for dishes with which they are familiar. The same article quotes Shrabani Basu, a historian of Asian food in Britain: 'I found Balti in a restaurant in Bangalore. I was horrified.' Balti, like CTM is thought to have originated in Britain. Simultaneously, however, this depth of penetration at many levels of British food culture may presage a first check to the exponential growth in Indian restaurants. In 1998–9 there were reports of closures: 'Balti blues have hit the great British curry house. After twenty years of spectacular growth, a cold wind is blowing through the world of hot food and forcing restaurants out of business at the rate of three a week' (Rowe 1999). This is not of course to anticipate the removal of Asian food from British tables: any shift from restaurant to home consumption is itself an indicator of a deeper level of absorption into British food culture. This absorption has marked class character-istics. Cook *et al.* note that the producers of, amongst others, 'authentic' Indian foods, target only a small proportion of middle-class consumers. They identify the professional middle classes in the South East of England and parts of Scotland as those most open to culinary 'adventure': 'As well as being those with the widest variety of international cuisines on their doorsteps (particularly in the form of restaurants), these are the people who are supposedly willing to pay higher prices for goods which are the "real thing"' (Cook *et al.*, 2000: 116). With this penetration of the middle-class market in mind, it is significant that the same National Trust café which prohibited lasagne on the grounds of its foreignness offered curry to its customers because, in the words of the restaurant manager, 'seemingly curry is English'.

The role of food culture in the construction of the nation

We have explored then some of the changes over time which have affected British food and especially its receptiveness to influences from abroad, influences which may lead us to ask how far such food may be considered to be *authentically* British. The absence of definitional simplicity and stability should not, however, be taken to undermine the very concept of a British national diet. When Gilbert Adair suggests that 'fish and chips . . . constitute what one might call . . . a force for national unity' (Adair, 1986: 50), he is indicating important truths about the role

of food in the formation of national identity. A key dimension in such formations is the concept of the 'imagined community', explored influentially by Benedict Anderson (1983). Anderson's argument is that nations are essentially 'imagined' in so far as they are the focus of a sense of belonging shared by people who in the nature of things cannot hope to know each other at first hand. As Anderson comments 'the members of even the smallest nation will never know most of their fellow-members, meet them, or even hear of them, yet in the mind of each lives the image of their communion' (1983: 6). Many commentators have sought to identify the factors and agencies instrumental in the processes of constructing national identity. Anthony Smith identified key territorial, legal, economic and political factors and continues: 'nations must have a measure of common culture and a civic ideology, a set of common under-standings and aspirations, sentiments and ideas, that bind the population together in their homeland' (1991: 11). Anderson himself refers to the development of books and later newspapers as crucial to the developing of national identities: 'print-capitalism . . . made it possible for rapidly growing numbers of people to think about themselves, and to relate themselves to others, in profoundly new ways' (1983: 36). In other words, it is cultural apparatuses, as well as those of state institutions, which provide the key to an understanding of the formation of nations. Indeed, James Donald, drawing in part on Anderson, argues for the *primacy* of cultural factors:

> apparatuses of discourse, technologies and institutions (print capital-ism, education, the mass media and so forth) . . . produced what is generally recognized as the 'national culture' . . . the nation is an effect of these cultural technologies, not their origin. A nation does not express itself through its culture: it is cultural apparatuses that produce 'the nation'.
>
> (1988: 32)

Anderson's argument firmly resists any imputation that the 'imaginary' or 'culturally constructed' quality of national identity in some way undermines its validity, and he warns against any inference that 'true communities exist which can be advantageously juxtaposed to nations.' Indeed, Anderson is at pains to stress the strength of what he calls 'the *attachment* that peoples feel for the inventions of their imaginations' (1983: 6). On occasion this attachment is expressed passionately in patriotic outpourings of national feeling which readily remind us of the level of emotional charge which may attach to national identity. Clearly,

however, national feeling does not operate continuously at this level of intensity, and Michael Billig's notion of 'banal nationalizm' identifies an altogether less intense dimension of national identity, the mundane attachment, the gentle, comfortable sense of belonging, which is low key, taken for granted, but immensely sustaining (Billig, 1995: 6). Far from being removed from everyday life, as some observers claim, 'Daily the nation is indicated, or "flagged" in the lives of its citizenry. Nationalism, far from being an intermittent mood in established nations, is the endemic condition' (ibid.). It is at this level that food contributes to the formation of nations, and it is in this context that the real significance of 'a nice cup of tea', of 'fish 'n' chips' and of 'the roast beef of old England' are to be located. We should register their significance as elements in the 'common culture' and 'civic ideology' and contributors to that 'image of their communion' held in common by members of the nation, and we should further note that this significance does not correlate precisely with the numbers of British people who regularly consume tea, fish and chips, and beef.

Food, national identity and 'difference'

It is now time to return to look a little more at the claims made earlier for the important role of food in the processes by which nations are defined. A particular example from popular culture will be useful here. The British TV situation comedy series *Fawlty Towers* (1979) was massively popular, extensively repeated and a very successful earner in the export market during the 1980s and 1990s. The series is set in a hotel/restaurant and one of the most celebrated programmes is one which relates directly to food – the 'Waldorf salad episode'. An American guest who arrives late requests a Waldorf salad which the proprietor, Fawlty, has difficulty in providing, because the kitchen has closed. Fawlty cannot lose face by admitting this – still less that he has little or no idea what a Waldorf salad is. Comic mayhem follows in the clash between the increasingly desperately dissembling Fawlty and the increasingly frustrated guest. The American's assertiveness is not part of the normal scene in Fawlty's restaurant, where guests are more than happy to accept what Fawlty gives them and where to complain would be a last resort. The implication is of course that this constitutes a typically English form of behaviour – that the British in restaurants are quietly compliant, and would put up with the most appalling service rather than complain. Against this we have the behaviour of the American, the foreigner. Taking for granted his right to decent service, he complains loudly in its

absence, thus proclaiming his otherness; he is something else, something different, something the English are not. This example highlights one of the most influential of approaches in cultural studies to the processes of identity formation, which is to stress the role of difference, of the contrasting 'other' in the processes by which identities are shaped.

As we saw in Chapter 1, Saussure's work on linguistic difference became a cornerstone of structuralist thinking whose methods have been applied subsequently to the analysis of many areas of cultural practice, production and formation. And so, in terms of identity formation, we are led to the suggestion that we define ourselves by a process of differentiation from 'others', and, moreover, that those others are the most fundamental element in that process of definition. Philip Schlesinger expresses this effectively:

> identity is as much about exclusion as it is about inclusion and the critical factor for defining the ethnic group therefore becomes the social boundary which defines the group with respect to other groups . . . not the cultural reality within those borders.
>
> (1987: 235)

The primary strand in the meaning of 'us' becomes 'not them'. Food is clearly instrumental in the identification of 'other' nations. The distancing of self from those others who eat curry or spaghetti specifically, or in general from consumers of 'foreign muck', has contributed significantly to the definition of Britishness. The imagined nation which results, with its imputation of a culinary purity worthy of being protected, is a far cry from our earlier discussion of perceptions of British food as a culinary desert, vulnerable to incursions from abroad. We should not subscribe too enthusiastically to any version which presents British food as uniformly in the process of becoming a cosmopolitan cuisine. Old prejudices die hard, and it would be inappropriate to underestimate the continuing role of xenophobic attitudes in expressions of national feeling. We observed earlier the racist strand in the behaviour of some customers in Indian restaurants. A further example is the 'foreigner joke', very much alive in British popular culture, and frequently focusing on food. Irish jokes are especially prominent, as in the definition of 'Mick's grill' as boiled potatoes, sauté potatoes and chips. Likewise, in France it is the Belgians who occupy cultural space approximately equivalent to that of the Irish in the UK:

Question: Why do Belgian women have square nipples?
Answer: To get their babies ready for eating their chips.

The chip-eating Belgians are constructed as the inferior other against which the infinitely more sophisticated food tastes of the French are defined and endorsed. The objects of these 'jokes' are frequently the non-metropolitan and recently arrived inhabitants of the peripheries of dominant cultures. The foreigner joke is a modern expression of the age-old tendency to cast the country bumpkin as a figure of fun: the peripheral other patronized from the point of view of the centre. Christie Davies (1988) has argued convincingly that humour (and the Irish joke in particular) plays a key role in the policing of centre/periphery and self/other relationships.

A final example of the role of food culture in recent constructions of nation is supplied by the case of British beef and 'mad cow disease'. As we will discuss in Chapter 12, two food panics developed in 1987 and 1996 concerning the safety of British beef and its connection with the brain disorder Creutzfeldt–Jakob Disease (CJD). As anxieties about possible links between animal and human disease intensified, Germany unilaterally banned the importing of British beef products in 1996. This was followed by a European Union ban on all exports of beef-related products. As Roy Greenslade (1996) demonstrates in his discussion of national press coverage of the crisis, *The Sun* was particularly strident in its response. Under the headline 'MAJOR SHOWS BULLS AT LAST' readers were advised to 'burn German flags in public and send the ashes to Helmut Kohl; shout "we shall fight them on the beaches" at German tourists; and to boycott Belgian chocolates'. On the same day, *The Star* was equally pleased with the British Prime Minister's 'tough stance on Europe'. Its headline was 'EFF EU LOT BLASTS MAJOR'. Its editorial responded to anxieties about Britsh xenophobia expressed by Jacques Santer, the Luxembourgeois President of the European Council, with 'Shut Eur lip, Jacques prat' and proceeded: 'OK, so you lot have stitched us up something rotten with your beef ban. . . . That doesn't mean we hate you. We just can't stand your guts' (Greenslade, 1996). One context for understanding these headlines is undoubtedly the politics of Britain's relationship with the European Union, and, in particular, the way in which they are played out in the tabloid press. So too is the pejorative manner in which Germany is represented in certain tabloid newspapers. At the same time, however, some of the strength of feeling in the tabloid coverage is undoubtedly traceable to the centrality of beef amongst the meanings attaching to the nation. We have already noted the case for roast beef on Sunday as one of the central icons of Britishness. The eighteenth-century song 'Oh, For the Roast Beef of Old England' reminds us of the longevity of a connection which is observable in references in

Elizabethan sources to the vast quantities of beef eaten by the English
(Morris, 1953) and persists musically into the twentieth century with the
popular song 'Boiled beef and carrots.'[4] It is probable that the intensity of
feeling aroused by the beef ban would have been less had the issue been
another kind of food export – wheat, for example, or even fish, neither of
which has quite the resonance of British beef.[5]

At this point it is appropriate to recall our earlier quotation from
James Donald's article in which he argues that it is cultural apparatuses
that produce the nation and that these apparatuses include 'print
capitalism, education, mass media and so forth.' It is the phrase 'and so
forth' which opens up significant space in terms of the concerns of this
chapter. In insisting on the constructed nature of the nation Donald
leaves space for the identication of additional agencies which play their
part in the process. He does not refer explicitly to food among the cul-
tural apparatuses which shape nations. It is the contention of this
chapter that food culture is indeed an important contributor to these
processes. The examples we have considered indicate some of the ways
in which the meanings surrounding food enable us to shape the
identities which give meaning to people's sense of themselves as social
agents, especially in respect of national identities forged in opposition to
their others.

Tradition, authenticity and quality

Much important recent work on food by social scientists has investigated
the reasons underlying food choice.[6] In the previous chapter we
introduced Alan Warde's (1997) 'four antinomies of taste': sets of opposed
and frequently contradictory appeals which underpin food choice in
contemporary Britain. One of Warde's categories, the novelty/tradition
antinomy, is especially germane to this chapter. When we make our food
choices, Warde points out, novelty is seductive. We are continuously
enticed by retailers' and advertisers' offers of food which is 'different',
exciting', 'exotic', or simply 'new'. This could be anything which pro-
mises something different from what we ate last week and the week
before that has positive value attached to it. And yet there is simul-
taneously, and apparently paradoxically, an appeal to the traditional, to
the old-fashioned ways of eating the 'safe', comforting foods inscribed in
the well-tried practices of households and families. It is this appeal which
is of greater interest to this chapter. There is much to say about the role
of tradition in the structuring of British food taste in the last two or three
decades, in a context in which 'traditional' is frequently identified with

'countryside' and 'quality'.[7] Granary loaves, ploughman's lunches, Norfolk turkeys, cream teas and real ales are just a few of the hundreds of items marketed as traditional British food. If one were to ask the question 'why ploughman's lunch – as opposed, for example, to fireman's or railway-worker's or policeman's platter?', the answer would underline the significance of the traditional and the rural in the meanings attaching to British food.

The appeal to tradition marks very clearly one of the ways in which food participates in the construction of the nation. If we are to fully understand this function we need to set it alongside a whole raft of other cultural products and processes which participated in the shaping of the national culture during the 1980s. Many commentators have remarked on the prominence of the 'national past' in constructions of Britishness during the 1980s (Wright, 1985; Samuel, 1989; Corner and Harvey, 1991). Margaret Thatcher's project, following her first election victory in 1979, was one of national recovery from the ruinous trajectories of stagnation and decline she attributed to the 1960s and 1970s. As we have seen in our earlier discussion, validations of national identity take place simultaneously across both state institutions and cultural practices. The restoration of former 'national' glories is sometimes explicitly the driving principle of policy – as in the National Heritage Act of 1980, designed to reverse the previous administration's alleged failure to preserve buildings and monuments of national importance (Wright, 1985: 42–8). More significantly, however, the wider culture in the 1980s and 1990s was suffused with references to the nation's past. In education the National Curriculum prescribes the prioritizing of *British* history, and in English the teaching of the classics of our literary heritage, with particular emphasis on Shakespeare. In the cinema and on television 'heritage films', such as *Brideshead Revisited* and *Chariots of Fire*, first shown in 1981, set the tone for a very significant strand in screened narratives throughout the 1980s and beyond, and have become central to both the export appeal of British screened materials and also the perceptions of Britsh culture amongst recipient nations. Raphael Samuel identifies the cultural expression of what he calls 'the splendid isolationism which is characteristic of the "Little Englander" outlook' and he argues that heritage 'as a cultural ideal – or fantasy – seems to be enjoying a vigorous after-life' (Samuel, 1989: 1). Analysis of 'heritage culture' should beware, however, of simplistic readings in which cultural forms are no more than the 'reflection' of a dominant political grouping. Subordinate groups do not necessarily decode messages in the same way as they have been encoded (Hall, 1997) and it is clearly the case that

celebrations of the national past often involve a diverse range of motiv-ations and desires, not simply for an antiquated social order but also for the small-scale, the local and the artisanal.

The links between food, tradition and quality may be illustrated in a brief exploration of the associations attaching in food writing to one specific food item – British cheese. There has in recent years been a significant resurgence in the manufacture of 'specialist cheese', and the pages of the BBC publication *The Good Food Magazine* provide valuable insights into the clusters of attaching associations. A good example is a feature by Juliet Harbutt on recent winners of the British Cheese Award (November 1997). Fine cheeses are the result of traditional methods of manufacture by named craftsmen and women who personally produce very small quantities of characterful, usually unpasteurized cheese. The Supreme Champion of 1995 was Mrs Kirkham's Lancashire:

> Every day for 12 hours Ruth Kirkham works tirelessly to turn the milk from her small herd into cheese, cutting and combining three days' curd to produce the complexity of texture and taste that few Lancashires are able to achieve.
>
> (Harbutt, 1997: 65)

The limitations of other Lancashires, of course, is traceable to their tainting by modern methods of production which are less demanding of the painstaking care and attention dispensed by Mrs Kirkham. Within the broad category of traditional farm cheddar further markers of exclusivity focus principally on the scale of production. Thus the 'Best Cheddar of 1996', Montgomery's Mature Cheddar, is differentiated from other traditional (and therefore themselves, by definition, 'quality') cheddars: 'The Montgomerys make only 8 to 10 cheeses a day, compared with other local creameries which count their production in hundreds of tonnes' (ibid.: 64). Small-scale production alone, it is assumed, facilitates the care, craft skills and individual, personal involvement which are the key factors in delivering 'authenticity'. It is also crucial that the cheese be made in a 'local' creamery, as it is clear that understandings of quality in British food frequently conflate the traditional and the regional, invoking times when both the production and preparation of food were firmly located in the inherited traditions of rural cultures. Any tensions which might arise between regional and national identities would appear to be subsumed by the positive associations attaching to the former. There seems to be no problem in the *Cornish* pasty or the *Bakewell* pudding becoming synonymous with a traditional British *national* diet

any more than the lobsters being fished in Maine compromises their Americanness. The insistence that food be linked as explicitly as possible with the place of its origins would seem to be a key trend in contemporary food cultures. It is interesting in the light of our earlier remarks about French culinary hegemony to compare the associations attaching to cheese in Britain with those of wine in France, where the *appellation contrôlée* status entitles a producer to link his wine explicitly with the region of its production. This status is strictly regulated in law and much sought after by wine producers as the single most reliable guarantor of quality in French wine.

Authenticity, then, would appear to provide the key to quality in food. Problems, however, persist, not least in the contradictions surrounding 'authentic, British food'. Though traditional food generally invites us to take a nostalgic trip back to the realms of the food 'granny used to cook', there are simultaneously associations with the most innovatory and 'modish' trends in food culture. Alison James (1997) explores several recent developments in metropolitan restaurant culture, principally in London. Drawing on Bati (1991) she demonstrates the impact of 'food nostalgia' during the early 1990s in prestigious restaurants which recover for the well-heeled in the capital, an 'authentically British' cuisine. Here, an insistent consumer demand for the new is satisfied through provision which purports to be authentically antiquated, for example a renewed taste for old desserts such as bread and butter pudding. James goes on to discuss a further apparent departure from authenticity in what she calls 'food creolization' – a form of cultural blending in which a mix of ingredients, styles and influences come together in a single meal. The trend is most familiar in certain fast food outlets – chips served with curry sauce, for example, or an Italian pasta sauce served on jacket potatoes. A more up-market example is the Café Lazeez, on Old Brompton Road, London, whose description of its 'frontier burger' is quoted by James: 'a sophisticated and mouth-watering melange of the East with the West' and whose staff and decor in the early 1990s brought together Indian, Italian, British and Australian elements (1997: 81–4). James's analysis does not present creolization as an expression of a newly acquired openness and willingness to embrace multicultural influences. She points rather to the particular conditions under which creolization manifests itself and argues that, in offering low cost and maximum convenience options, the phenomenon is in part a reassertion of certain attitudes which have long been fundamental to British food culture. Food which is typically to be found in fast-food or takeaway outlets sits very comfortably alongside the imperatives of minimal effort and low

cost, which are prioritized in a culture in which food is not considered important *per se*.

We have travelled, then, a very substantial distance from the initial premise of a national food which is obvious and may be taken for granted. National foods are shifting, in a continuous state of flux and transformation. At any given time a snap-shot of what seems most characteristic of a nation will be teeming with contradictions whose departures from 'authenticity' would appear to undermine the very notion of a national food. None of this should surprise if one moves beyond thinking about the nation as static, as a geographical or political entity enclosed and fixed by those physical boundaries recognized in international law. The nation is a fluid cultural construct and food is one among many agencies which participate in its construction and the continuing processes of its redefinition. As we shall see in the next chapter, the flux of national food cultures is, in part, dependent upon processes of globalization.

6 The global kitchen

Sherwood, Nottingham, England is a suburb about two miles from Nottingham city centre. Along the Mansfield Road, Sherwood's main thoroughfare, lie a number of food outlets. There are two Indian restaurants, a Japanese restaurant, a Caribbean restaurant, a French wine bar, a pizzeria which doubles as a Moroccan restaurant, an Italian restaurant, a Mediterranean restaurant, two cafés, a good quality restaurant serving a cosmopolitan menu, and another eclectically oriented, but rather lower quality restaurant. There are two Indian and three Chinese takeaway services, a takeaway pizza shop, a fish and chip shop, a southern fried chicken shop and six bars and pubs, most of which offer some type of menu. Restaurants come and go, and within the last few years Sherwood has also boasted a Mexican restaurant and a Thai takeaway. Less than a mile away there is a McDonald's restaurant. On the retail side, there is a Kwik Save and a Co-op supermarket, a smaller Spar store, two greengrocers, two bakers, a delicatessen, a wholefood shop and a store specializing in Polish food. Within a mile are a large Sainsbury's supermarket and a new, small Tesco.

Sherwood, one might imagine, is fairly typical of British suburban areas. It offers a wide range of restaurant and takeaway opportunities, from traditional English food (the cafés, the fish and chip shop) to global franchises (McDonald's); from common forms of 'foreign' cuisine (Indian and Chinese food, pizzas), to the more 'exotic' (Japanese, Caribbean, Moroccan). Similarly, the shops and supermarkets offer products ranging from locally grown potatoes to South African butternut squash; from locally produced Stilton cheese to mass-produced Coca-Cola. From the local to the global, from the traditional to the exotic: the food industries in contemporary Britain would seem to offer us culinary and cultural diversity, particularly when contrasted with the more restricted opportunities available to consumers just thirty years ago. At the same time, however, Sherwood offers much the same array of products and outlets

that you would expect to find in other towns and cities throughout the UK. The supermarket shelves provide the same tins and cans found elsewhere, and the menus in McDonald's and Pizza Hut are identical to others throughout the country. From this perspective, food opportunities would seem to be increasingly homogenized. The quirks of seasonal and regional gastronomic difference would seem to have been replaced by a monotonous culinary uniformity.

The process which is usually held responsible for the principal changes in food provision over recent decades is globalization. This chapter will examine this process and its impact on food culture, and it will do so by interrogating the two perspectives identified above. The first perspective sees globalization as the harbinger of gastronomic cultural diversity, while the latter sees it as the herald of culinary homogeneity. Before exploring these two perspectives, however, we will turn to the theoretical debate about globalization.

Theorizing globalization

The concept of globalization emerged as a key term within social and cultural theory in the 1980s (Robertson, 1992: 8). As Barry Smart explains, debates about globalization acknowledge

> that in some respect or another our activities, our conditions, what we know of, believe, respond or react to are, to a variable degree, affected by the international economy; by the proliferation of global forms of communication; by agencies and movements operating transnationally to confront issues on a world scale; by changes in climate induced by patterns of production and consumption, military conflicts and other catastrophes; and so forth.
>
> (1993: 131–2)

It is clear that food culture is today intimately bound up with this state of affairs; that our activities as consumers of Kenyan green beans, or bananas from the Windward Isles, are, to one degree or another, affected by, for example, conditions in the Kenyan labour market, or international tariffs concerning the export of bananas. In this sense, as John Allen explains, globalization 'refers to the fact that people in various parts of the world, which hitherto may have been largely unaffected by what happened elsewhere, now find themselves drawn into the same *social space* and effectively governed by the same *historical* time' (1995: 107). The food people ate was once determined by the constraints of time and place: it

was seasonal and locally produced. Now, however, a wide range of food-stuffs is available all year and imported from the four corners of the world. This process has arguably been underway since the era of global trade and exploration during the sixteenth and seventeenth centuries, but through the course of the twentieth century it has developed with 'increasing acceleration' (Robertson, 1992: 8). In terms of food culture, as Jack Goody (1997) has argued, the process has been facilitated by the development of techniques in preserving, retailing and transporting foodstuffs, as well as by the increasing mechanization of food production.

While there may be agreement that the interconnections generated by globalization now exist, however, there remains some debate about the precise nature and direction of these processes. Here, we want to focus on two such debates: first, the politics of globalization; and second, its cultural ramifications. As a focus of political debate, globalization has both its supporters and its critics. Proponents of globalization characterize it as a process which extends to developing nations the wealth of the richest. The British politician Jack Straw, for example, has argued that to challenge globalization is to 'put at risk the real benefits that [it], and global capitalism, have brought to millions' (Straw, 2001). Straw envisages a role for national governments in managing the process of globalization in order to secure these alleged benefits. Such a position necessarily depends both upon a benign view of the nature of capitalism, and upon an optimistic view of the power of nation states to regulate the activities of multinational corporations. In contrast, opponents of globalization view it as a process which increases labour exploitation and amplifies the gap between rich and poor on a global scale. In recent years, activists have gathered to protest at summit meetings of world leaders, such as the World Trade Organization summit in Seattle in November 1999 and the G8 meeting of the world's leading economic powers in Genoa in July 2001. These critics, as Chris Harman suggests, have fashioned a 'damning, emotionally moving onslaught on the dehumanization of the system, on the subordination of people's lives to blind forces beyond their control, on the wrecking of the environment in which they have to live' (2000: 11; see also Ross, 2001: 9). As Harman contends, however, the target of this particular critique of anti-globalization is economic neo-liberalism rather than capitalism *per se*. He argues instead that '[m]ost of [the] horrors' identified in this critique 'are as old as capitalism itself and not simply a product of the last couple of years' (2000: 11; see also Ross, 2001: 9). As Phil Ross notes, the globalizing logic of capitalism would certainly seem to have been anticipated in Marx and Engels's contention that the 'need of a constantly expanding market for its products chases the bourgeoisie

over the whole surface of the globe'. As a result, they argue, capitalism 'must nestle everywhere, settle everywhere, establish connections everywhere', giving 'a cosmopolitan character to production and consumption in every country' (Marx and Engels, 1973: 37; Ross, 2001: 1).

The political debate about globalization outlined above is very much concerned with its economic logic. However, globalization is not simply played out in the economic realm. As John Tomlinson has argued, globalization is a multidimensional phenomenon, which needs to be 'understood in terms of simultaneous, complexly related processes in the realms of economy, politics, culture, technology and so forth' (1999: 16). The second debate to which we want to turn concerns the cultural consequences of globalization, and the sort of cultural patterns wrought by its interconnections. One position here is to envisage globalization as a homogenizing force, enabling mass-produced commodities to find ever more disparate and diverse markets. As Allen suggests,

> [i]f it is not all kinds of people tugging at ring-pulls of cola cans across the globe, then a similarly vast range of nationalities is to be seen taking a bite from a Big Mac . . . the basis of global culture starts (even if it does not end) with such icons.
>
> (1995: 109)

As the examples cited by Allen might suggest, the homogeneity generated by globalization is easily seen as a form of American cultural imperialism. This view has been challenged by Tomlinson (1991), among others, who argues that indigenous traditions do not yield quite so readily, nor so simply, to cultural imports. Ulf Hannerz develops a similar position, claiming that global culture 'is marked', more accurately, 'by an organization of diversity rather than by a replication of uniformity. No total homogenization of systems of meaning and expression has occurred, nor does it appear that there will be one for any time soon' (1990: 238). Such critics identify the apparent contradiction between homogeneity and diversity as a tension at the heart of globalization. Jonathan Friedman, for example, has claimed that 'cultural fragmentation and . . . homogenization are not two arguments, two opposing views of what is happening in the world today, but two constitutive trends of global reality' (1990: 311). In a similar vein, Robertson has argued for the term 'glocalization' as a means of highlighting the crucial interrelationship between global processes and local particularities. 'The global', he contends, 'is not in and of itself counterposed to the local. Rather, what is often referred to as the local is essentially included within the global'

(1995: 35). In the light of the contradictions we have ourselves identified in the culinary opportunities available to consumers in Sherwood, between uniformity and diversity, between the global and the local, this particular view of the cultural impact of globalization would seem to be worth pursuing. We will turn first, then, to examine the homogenizing trends in contemporary food culture.

Culinary homogeneity

In 1998, Coca-Cola ran a television advertising campaign. One advert began with an image of a smouldering red sky and a yellow sun accompanied by the caption, 'Australian Outback, 124°F'. Music starts to play, and it becomes clear that it is played on a didgeridoo. The atmosphere is solemn. Figures appear out of the red background. They are dancing and adorned in Aboriginal decoration. The face of a young boy appears in close-up, looking enquiringly up at the sky. He throws an empty Coke bottle into the air and the whole scene bursts into life. The didgeridoo music is replaced by a popular music jingle. Liquid rains down on the dancers, and as the camera pans around, each one of them is now holding their own bottle of Coca-Cola. The final shot returns us to the image of the red sky and the burning sun, but now the colour of the sun is of a whiter hue.

Probably unwittingly, the advert broaches the economic dimension of globalization. In 2001 Coca-Cola was sold in 195 different countries, and its manufacturers accrued $16 billion revenue from it (Shiva, 2001). According to estimates produced by the United Nations, more than one billion people currently lack access to fresh drinking water (Barlow, 2001). As Vandana Shiva points out, in 'the maquiladora zone of Mexico [the zone where North American companies outsource their production], drinking water is so scarce that babies and children drink Coca-Cola and Pepsi' (Shiva, 2001). In this context, there is an irony in the advert's offer of Coke as the solution to Aboriginal thirst. At the same time, the commercial seems to celebrate the very homogenizing impact which critics of globalization condemn. Initially, Aboriginal culture is represented as primitive and somewhat threatening. The dancers blur into the haze of the heat, their dark skin melding into the deep red of the sky. Their dance is a rain dance, and the arrival of Coca-Cola is represented as though it were the arrival of rain. This event effectively domesticizes the scene, replacing the exotic and the primitive with the everyday (the Coke, the music). The final image proclaims the colonization of the Outback and Aboriginal culture: the colours of the Outback sky now

represent the corporate colours of Coca-Cola, a fitting symbol of cultural and culinary homogeneity.

As we saw in Chapter 1, George Ritzer has explained the ability of corporations to provide standardized products on a global scale in terms of a process of 'McDonaldization' (Ritzer, 1993, 1998, 2000). According to Ritzer, the bureaucratic imperative identified by Max Weber as the paradigm of rationality in modern society has now been superseded by the form of rationalization that we find in the structures of the McDonald's enterprise, and in similar corporations, such as Coca-Cola. According to Ritzer, the success of McDonald's is based upon the principles of efficiency, calculability, predictability and control (1993: 9–12). He contends that, in applying these principles, McDonald's has 'not only revolutionized the restaurant business, but also American society, and ultimately, the world' (ibid.: xi). In this way, a McDonaldized food industry becomes a vehicle for understanding globalization itself.

Here, we want to explore Ritzer's thesis in relation to the reception of McDonald's in France. The first McDonald's opened in Paris in 1972, and it is now the largest restaurant chain in France with some 800 outlets (Normand, 1999: 29). The most detailed analysis of the fast food industry in France is provided by Rick Fantasia. Drawing on a series of interviews with McDonald's employees and customers, he argues that it is precisely the Americanness of fast food which sustains its allure (1995: 228–30). As a result, he suggests, French hamburger chains which have attempted to capitalize on McDonald's success, tend to market themselves under 'American-sounding names' (France-Quick, FreeTime, Magic Burger, B'Burger, Manhattan Burger, Katy's Burger, Love Burger, and Kiss Burger) (ibid.: 206). Alongside such chains, there are other companies (La Brioche Dorée, La Croissanterie, La Viennoiserie) who offer fast food *à la française*, providing traditional French snacks on a McDonaldized basis (Ritzer 1993: 3; 1995: 207). As Fantasia argues, however, while such chains have managed to establish themselves with some success in the USA, 'the exchange of croissants for hamburgers has not represented anything approximating an equal cultural exchange':

> they have been produced and marketed not by professional French 'boulangers' or 'patissiers', drawing upon local raw materials and family recipes, but in mechanized kitchens, supplied by centralized warehouses, using standardized recipes and processes, and sold in restaurants designed for their efficiency and visual hyperbole.
>
> (1995: 234)

Such developments add weight to Ritzer's thesis about McDonaldization as a global process whose effects are felt beyond the McDonald's Corporation itself.

Ritzer's thesis has its critics. Some have complained that it ends up as 'a lament on modernity and industrialism' (Finkelstein, 1999: 80). Others have contested the status of McDonaldization as a new form of rationalization, arguing that it ought really to be seen simply as an extension of the rationalizing processes which Max Weber distinguished in modern society at the start of the twentieth century (Smart, 1999). What is also questionable is the supposed omnipotence of global corporations in ensuring culinary homogeneity. As Ritzer himself points out, McDonald's actually has to work quite hard at negotiating regional variations in taste. The result is a range of products designed to satisfy nationally-specific palates: a salmon burger with dill sauce on wholegrain bread in Norway; Samurai pork burgers in teriyaki sauce in Thailand; Chicken Tatsuta, combining soy sauce, ginger, cabbage and mustard mayonnaise, in Japan; and so on (Ritzer, 2000: 172–3). And while McDonald's has around 15,000 outlets in 117 foreign countries (Schlosser, 2001: 229), its fortunes are currently faltering, with it announcing in November 2002 that 175 restaurants in ten countries are to close (Burkeman, 2002: 2). Such problems no doubt derive in part from the fact that, as 'the globalization of the food industry . . . shifts the locus of control from the local to the global,' so 'new areas of anxiety and uncertainty' are introduced for the consumer (Tomlinson, 1999: 126). But these problems have also been fuelled by political campaigns against McDonald's (Smart, 1994), one of the highest profile of which took place in France. Organized by José Bové of *la Confédération paysanne*, a demonstration took place in 1999 against the building of a new McDonald's restaurant in the town of Millau, in south-west France. Bové's subsequent arrest led to him being celebrated in France and beyond as a champion in the struggle against 'Mc-Domination', against globalization, American cultural imperialism and, above all, '*la malbouffe*', or 'crap food' (Taylor, 2001).

From the Coke advert to McDonald's global empire, we clearly need to register the power of a globalized food industry in terms of generating an increasingly homogenized diet. However, we also need to acknowledge that such processes do not go uncontested, and they often have to work hard to gain consent. At the same time, as we have argued above, the logic of globalization not only produces homogeneity, but also diversity. It is to the issue of gastronomic diversity that we now turn.

Gastronomic diversity

In November 2000, there was a special food issue of *Life*, the magazine published with *The Observer* newspaper, entitled 'The World on a Plate'. It was devoted to celebrating the diversity of foods available in contemporary Britain. In it, the cookery writer Claudia Roden claimed that 'our cooking has become a true melting pot – the joint heritage of our multicultural society' (2000: 29). Subsequent articles went on to explore the range of ethnic food suppliers available to British consumers and exotic twists on traditional recipes. It also offered an 'A–Z of world food' (Webster, 2000), providing a glossary of unusual ingredients from around the globe, from abalone to harissa, and from lingonberry to Zulu fire sauce. Eating globally, it would seem, has never been so easy. We are all now able to be cosmopolitan, someone who feels at home anywhere.

The 'melting pot' approach to gastronomic diversity is an optimistic perspective which views changes to the British diet as a positive form of (multi)cultural hybridity. In post-war Britain, as Stephen Mennell notes, there have been four principal waves of foreign culinary influence: 'in rough chronological order, the Italians, the Chinese, the Indians, and the Greeks and Turks' (1996: 329). Along with American fast food, they have all proved successful in consolidating their impact on the British diet. They have thus contributed to the provision of 'increasing varieties' for the British consumer (ibid.: 327). Mennell argues that this is one of the hallmarks of contemporary food culture, and that it has been accompanied by diminishing social contrasts in the diets of the population as a whole. It is not necessarily the case that these two features go hand in hand, however. As we saw in Chapter 4, for example, culinary variety itself can become a vehicle for achieving social distinction. In this sense, the consumption of exotic or ethnic foods arguably belongs to a more widespread trend within contemporary society towards the 'aestheticization of everyday life', fuelled by the consumer's 'desire to be continually learning and enriching oneself, to pursue ever new values and vocabularies' (Featherstone, 1991a: 48). Set alongside its fashion pages and lifestyle columns, the special issue in *The Observer* magazine would seem to endorse this view of gastronomic diversity: it empowers the consumer, and the cosmopolitan food emporium becomes, to use Celia Lury's terminology, 'an adventure playground for everyone' (1996: 241).

Other commentators have urged rather more caution in our assessment of the nature of culinary diversity. Alan Warde, for example, has argued that, at least in Britain, there is little evidence that food expenditure is less socially structured than it was in the 1960s. He suggests that

the apparent emergence of aestheticized, cosmopolitan patterns of food consumption perhaps 'owe[s] more to the enhanced prevalence of the discourse of choice than to newly adopted food practices' (Warde, 1997: 189). Sunday newspaper colour supplements such as *The Observer* magazine are arguably key sites for the construction of such discourses. Warde also argues that increasing culinary diversity performs an important function in terms of market mechanisms, and that overly celebratory accounts of cosmopolitan consumption perhaps tend to overlook such aspects (ibid.: 16). In welcoming the fact that our local supermarket now stocks four different types of capers, for example, we need to remember that diversity sells, and that the provision of variety is thus 'almost entirely a function of the logic of capitalist enterprise' (ibid.: 169). As Warde points out,

> [t]he glorification of variety is a primary vehicle of the intensification of commodity culture. Although nobody objects, variety may not always be a virtue. Most obviously, the year-round variety of products in the contemporary British diet is dependent upon a global division of labour which often works to the detriment of the health of the populations in the Third World.
>
> (ibid.: 161)

As we have seen earlier in this chapter, the process of globalization increases temporal and spatial interconnections between people in disparate parts of the world, and our consumption of culinary diversity is thus implicated in the working and living conditions of Third World producers of this diversity. Ian Cook (1995) has attempted to reveal the specific co-ordinates of such interconnections in his case study of exotic fruit such as mangoes. Cook traces the trajectory of the mango from the Jamaican farms where it is grown, through to its point of sale in a British supermarket. Along the way, he describes patterns of farm ownership, Jamaica's farming policies and export procedures, the role of supermarket buyers, and the marketing of exotic fruit in the supermarket. He also conducts interviews with people involved in the trajectory, recording the grievances of the poorly paid farm labourers and the feelings of guilt of the supermarket buyers as they return home to Britain. Cook concludes that an intricate picture emerges where, 'through "our" everyday food-consumption practices, "we" become involved in a complex and connected "post-colonial gastropolitics" and take an active part in the plays of domination and resistance which delimit the possibilities for "third world development"' (ibid.: 141).

What we have argued is that homogeneity and diversity, although contradictory culinary trends, both belong to the same process of globalization. What unites these trends is the interconnections they generate between manufacturers, workers and consumers in disparate places. In turn, these interconnections, to one degree or another, operate to reinforce global economic inequalities. However, what is also noticeable is the way in which the marketing of food commodities often tends to 'draw a veil across their own origins' (Sut Jhally, quoted in Cook and Crang, 1996: 135). As Robert Sack continues, 'the consumer's world attempts to create the impression that it has little or no connection to the production cycle and its places. It hides or disguises these extremely important connections' (quoted in Cook and Crang, 1996: 135). In Marxist theory, this process is known as commodity-fetishism, and it is to this issue that we now turn.

Commodity-fetishism and food culture

Marx explains commodity-fetishism in the following terms:

> A commodity . . . is a mysterious thing, simply because in it the social character of men's labour appears to them as an objective character stamped upon the product of that labour. . . . [I]t is a definite social relation between men, that assumes, in their eyes, the fantastic form of a relation between things.
>
> (1970: 72)

The exchange value of a commodity, its market price, is properly a social relation, an expression of the cost of the labour deployed in producing, distributing and retailing the commodity. A mango in UK supermarket Sainsbury's, for example, currently costs £1.49, and this sum is an expression of the various economic interconnections which Cook identifies in his analysis. The process of commodity-fetishism, however, encourages us to understand the price of the mango as a property of the mango itself. As a relatively expensive fruit, its price connotes exoticism and luxuriousness. These connotations are, we might imagine, derived from the texture and flavour of the mango itself, rather than from the complex social relations of its trajectory from Jamaica to the supermarket shelves. This conclusion is aided and abetted by the manner in which food commodities are marketed, a process which in many cases tends to limit consumers' knowledge about the conditions of their production. This is a regular feature of food advertising, where it is often used to distance the

product itself from the unsavoury connotations of mass production. A magazine advert for Baxters soup, for example, pictures a pot of soup next to the raw materials out of which it is made (vegetables and pasta), a chopping board and a kitchen knife. Next to these items is a notebook with the caption, 'Baxters make soup the same way you do. It's just that our pot is a little bigger'. The caption is written in italic script, suggesting that it might have been handwritten into a recipe notebook. The upshot of all this is to portray Baxters soup as effectively homemade. The real conditions of its production (in a factory using mechanized forms of preparation), the social relations through which it is produced, are deliberately obscured. As Celia Lury explains, then, commodity-fetishism refers to 'the disguising or masking of commodities whereby the appearance of goods hides the story of those who made them and how they made them' (1996: 41).

However, in contemporary food culture, commodity-fetishism is rather more complicated than this. Cook and Crang, for example, have argued that our knowledge about food 'is bound up with a "double" commodity-fetishism':

> that on the one hand limits consumers' knowledge about the spatially distanciated systems of provision through which food commodities come to us; but, on the other, and at the same time, also puts increased emphasis on geographical knowledges about those widely sourced food commodities.
>
> (1996: 132)

The provision of increasing culinary diversity, in other words, allows consumers to advertise their cultural capital by demonstrating their knowledge about the origins of particular foodstuffs. This possibility is perhaps most clearly seen in relation to wine, where the ability to 'locate' the grape and region from which a wine is produced enables someone to display their credentials as a wine expert. But it is also apparent elsewhere. Sainsbury's supermarket's in-house monthly, *The Magazine*, for example, includes a regular feature entitled 'anatomy of an ingredient', which seeks to provide consumers with in-depth information about the origins of particular foodstuffs. Sue Lawrence, for example, offers an account of the apricot-growing region of Turkey, visiting apricot merchants and farmers in a quest 'to discover how they are dried in the blazing sun, turning from golden yellow to autumnal orange in just five days' (1998: 72). Cookery books also operate as sites for the communication of geographical knowledge. *Cooking Class Mexican Cookbook*, for example,

offers little information about the background to Mexican culinary traditions, and draws on a straightforward concept of 'Mexican cuisine'. The book belongs to a series of *Cooking Class* volumes covering a range of national cuisines (Swallow, 1994). We can contrast this text with Rick and Deann Groen Bayless's *Authentic Mexican*. Aimed primarily at an American readership, the Baylesses dismiss most of what passes for Mexican cuisine in the USA as 'a near laughable caricature' of the original (Bayless and Bayless, 1987: 15). They proceed to offer a detailed account of Mexico's culinary heritage, its markets, its kitchens and restaurants, and its regional tastes. The recipes included in the book are all located within these regional variations, assuring us of the authentic origins of the dishes, and of the authors' knowledge of them.

Globalization threatens a sense of tradition by undermining the importance of time and place in terms of the food we eat. The search for origins, of which *Authentic Mexican* is an example, arguably seeks to retrieve some sense of authenticity in the face of this challenge. Marx's theory of commodity-fetishism, then, refers to a disregard for a commodity's relations of production, and we have argued that this remains a feature of globalized food culture. At the same time, however, we have agreed with Cook and Crang's claim that a double commodity-fetishism is often at work, generating a fascination with the origins and authenticity of particular products.

Conclusion: resisting globalization?

The impact of globalization on food culture has been both to augment homogeneity and to increase diversity. What these trends both share is the ability to disembed a culture from its locale, forging connections with disparate peoples and places, and substituting seasonal, locally-grown food for items produced much further afield. As we have seen, however, the process of globalization has not gone unchallenged or unchecked. Bové's campaign against McDonald's in France garnered support from across the political spectrum and he was celebrated as a national hero, defending French culinary tradition from the ravages of American fast food (Taylor, 2001: 59). Tomlinson has argued that, while globalization seems to pose the threat of cultural estrangement, such transformations 'are, on the contrary, rapidly assimilated to normality and grasped – however precariously – as "the way life is" rather than as a series of derivations from the way life has been or ought to be' (1999: 128). The achievement of Bové, and the campaign which he has led, lies in the success with which he has in fact managed to call into question

the apparent normality of globalized food culture, raising in turn questions about the economic logic from which it springs.

There are other examples within contemporary forms of food production and consumption which we can identify as resistant to globalization. In the next chapter, for example, we explore the emergence in recent years of farmers' markets, specializing in the locally-produced foodstuffs which the process of globalization threatens. We have also seen a renewed interest among people in growing their own food. With its accompanying television series, Hugh Fearnley-Whittingstall's *River Cottage Cookbook* (2001), for example, explores and celebrates the labour of producing your own food. Similar concerns have recently been addressed at the level of government policy. A recent UK parliamentary report into the provision of allotments noted that 'the demand for allotments is set to increase' as a result of 'continuing concerns over "green" issues and the developing agenda with regard to food and health concerns' (Environment, Transport and Regional Affairs Select Committee, 1998). Meanwhile, a report was published in 2002 for the Department of the Environment, Food and Rural Affairs on *The Future of Farming and Food*, which stressed the importance of defending local, regional and national forms of food production. In the face of a disembedded, globalized food culture, what all of these examples seek to do is to emphasize the rediscovery of embedded local and seasonal foods.

Another way in which the process of globalization is challenged is through 'ethical' food production and consumption. The Fairtrade Foundation, for example, is dedicated to countering the power of multinational corporations in controlling the production of crops in developing countries for global export. While multinational food production 'provides food choice and variety for industrialized societies at the expense of economically marginalized peoples' (Beardsworth and Keil, 1997: 41), Fairtrade activities aim to protect these marginalized groups. As its packaging claims, for example, Percol's Fairtrade Colombian coffee 'is sourced from selected small farmholdings and sold for the fair and direct benefit of the producers'. In this respect, the marketing of Fairtrade goods addresses the process of commodity-fetishism by making explicit the dynamics of the goods' production.

It is also possible that there are certain foodstuffs which, by their very nature, resist appropriation by the process of globalization. One example here is *bruscandoli*, wild hop-shoots grown in and around Venice, which the food writer Elizabeth David first encountered in a risotto she ordered in a restaurant in 1969 (Jones and Taylor, 2001). The life-span of *bruscandoli* is a short one, with the harvest lasting for just the first ten

days of May. There also seems to be some local confusion about the precise nature of *bruscandoli*, which is identified by some as a form of wild asparagus rather than as a type of hop-shoot. Nevertheless, what interests David most about the vegetable is precisely the contrast between its qualities and the processes of modern, globalized food production:

> In our English world of produce imported all the year round from all parts of the globe – strawberries from Mexico, asparagus from California, lichees from Israel, courgettes from Kenya – it is from time to time an intense pleasure to rediscover, as in Venice one does, the delicate climatic line dividing the vegetables and salads and fruit of spring from those of summer. Because of that dividing line, because they were so very much there one day and vanished the next, bruscandoli became a particularly sharp and poignant memory.
>
> (1986: 113)

The purpose of the examples that we have looked at here is to suggest that the impact of globalization is not entirely all-encompassing. As our description of Sherwood implies, the effects of globalization are indeed experienced in the texture of everyday food practices, from the diversity found in the delicatessen to the fast food homogeneity found in McDonald's. Nevertheless, while the trends we have identified within globalized food culture look set to continue, there remains a number of ways in which food producers and consumers can attempt both to preserve or re-establish the embededness of food culture, and to contest and challenge the logic of globalization, which we now explore further.

7 Shopping for food

In writing about the literature of postmodernity, with its sci-fi tropes of 'speed-up, global village[s] [and] overcoming spatial barriers', the geographer Doreen Massey has advanced the more modest proposition that 'Much of life for many people still consists of waiting in a bus-shelter with your shopping for a bus that never comes' (Massey, 1994: 163). Although it is conceivable that the shoppers' bags are bursting with durables or luxury goods, it seems much more likely that they contain food. The purchase of food is what most of us mean, most of the time, when we say we are going shopping.

Massey's focus on the bus stop astutely summons up a slightly anachronistic, vision of post-war British consumer culture. Public transport is undoubtedly a prominent issue in the UK, but the doubling of car ownership since the 1970s and transport deregulation in the 1980s problematize the notion that standing at a bus stop is a representative shopping experience. Instead, this urban vision works by establishing connections between the 'new poor', mostly younger and older people without access to cars, and the working class of the post-1945 period for whom bus travel was a less stigmatized, if still markedly gendered, activity. Rather than thinking about the world as recently reinvented, Massey asks us to think about change as an uneven process in which old cultural forms, attitudes and practices persist into the present, often as uncomfortable reminders of inequality. The image of a communally dismal shopping space summons the notion of a durable common culture.

We begin with this geographical take on food shopping for two reasons. First, you will now be familiar with the importance of space and place to food culture, particularly in relation to the questions of globalization and national identity discussed in the preceding two chapters. This chapter considers the global reach of the food retailing industries in relation to

the spaces of locality (the home, market, district and suburb) and of the nation-state. By the end of the chapter, you should have a fuller understanding of the shifting arrangements of space, place and – a key third term – time in modern daily life.

Second, we focus this chapter on *landscapes* of food shopping in post-war Britain. We argue that although certain patterns may be observed, particularly the concentration of retailing and shopping in large supermarkets, these patterns do not form a uniform and predictable narrative of change. In particular, they do not provide the basis for a pessimistic account of food shopping in which face-to-face, local provisioning has been entirely replaced by an undifferentiated out-of-town shopping experience. Often behind this pessimism is the notion that people's weekly routines, and their behaviour within supermarkets, are wholly determined by capitalist food retailers and their 'hidden persuaders'. Instead the chapter proposes that important continuities and inter-dependencies might be observed, including the return of seemingly outmoded forms of retailing and shopping. Using Raymond Williams's (1980) observation that all cultural formations contain elements of the *dominant*, the *residual* and the *emergent*, we show that the dominant element within food shopping (the supermarket) exists in uneasy and uneven proximity with residual shopping spaces (markets) and with emergent food shopping sites (home shopping on personal computers). To sensitize this schema, we once again deploy Warde's (1997) antinomies of taste to think through the spatial distribution of economy and extra-vagance, convenience and care and novelty and tradition.

Situating our argument largely in the UK, we argue that a key feature of the post-war period has been the *dispersal* of working-class communities into new towns, suburbs and estates. This situation demanded management by material and ideological means. Supermarkets are only one relatively successful, but relatively crude, means by which such management has been achieved: their crudeness indicated by the level of hostility shown to them across a range of cultural forms (Bowlby, 1997; Riddell, 2003). The market, the high street and the home have been equally adapted to manage the food needs of a dispersed and mobile population. Using the work of Anthony Giddens, we show that the initial disembedding of a community has been matched by a subsequent material and affective re-embedding. This is not, however, something fully achieved: dynamic processes of dis- and re-embedding may be seen across the spectrum of food culture. To understand this more fully, we will look, first, at the cultural moment of dispersal and its representative technologies.

Mobile privatization

We noted earlier that Raymond Williams is a key theorist of the newly dispersed community. Although Williams's focus is the broadcast media, he identifies two other 'technologies' – the small family home and the motorcar – emerging in the inter-war period but becoming consolidated after 1945 (1983: 171). The presence of a kitchen, pantry and, later, fridge-freezer in the one, and a boot in the other, came to be indispensable utilities by which the family could be inserted into the transformed network of food shopping.

These two technologies were central to the suburban mode of living that was moving from emergence to dominance during the 1950s and 1960s as people moved out of the inner-cities. (For the classic study of dispersal in the UK, see Wilmott and Young, 1957; for comparative work on suburbanization in the USA, see Spigel, 1997; for Australia, see Humphery, 1998; Putnam, 2000). We use 'suburban' here as a catchall for a variety of housing forms, from unplanned inter-war suburbs to the new towns and urban rim council estates built after 1945. By grouping these discrete spaces together, our intention is not to impute a standardized middle-class identity to the suburbs or their occupants. Cultural commentators of the period, however, were often quick to do so, and both boosterist and critical discourses of 'embourgeoisement' were prominent throughout the period, respectively praising the 'frontier' mentality of the new suburbanites (Humphery, 1998: 75) and condemning the apparent flattening-out of class differences (Hebdige, 1988). As we shall see, a version of this latter discourse continues to inform notions of supermarket shopping.

Whether they were becoming more middle class or not, working-class people in the post-war period were undoubtedly experiencing unprecedented encouragement to participate in the realm of consumption. Williams notes that, alongside their identification as suburbanites or new towners, people were also encouraged to see themselves as 'sovereign consumers'. The site in which he sees this identity being most explicitly offered, and most 'readily and even eagerly adopted' is the supermarket. Wary of succumbing to mass culture pessimism, Williams does not accept that such an identity defines the whole person. Instead:

> It is accepted only as describing that level of life: the bustling level of the supermarket. When the goods from the trolley have been stowed in the car, and the car is back home, a fuller and more human identity is ready at the turn of a key: a family, a marriage, children, relatives, friends.
>
> (1983: 188)

We shall question later whether a fully human identity is unavailable in the supermarket, but Williams's contention that identities are negotiated across space and time, not given or adopted once-and-for-all, is invaluable. It is unique to modern society that people can move relatively easily between places, and that their identities may adapt accordingly. Williams gives this back-and-forth movement the name 'mobile privatization', arguing that only such an apparently contradictory coinage could capture the ambivalence of this novel condition.

It is easy to concentrate on the 'privatization' element, with its connotations of anti-social retreat, without acknowledging the 'outward-looking' qualities of this arrangement – the re-orientation of the home and the self towards the spaces of the post-war settlement. While agreeing that some degree of retreat is involved, Williams argues that, 'it is not a retreating privatization of a deprived kind, because what it especially confers is an unexampled mobility. It is not living in a cut-off way' (1983: 171). The car, in particular, became the critical utility through which this mobility was experienced. Although initially an exclusively male technology, the car's importance as the most significant intermediary between the family and a dispersed network of consumption and welfare gradually became at least as important as its role in men's work and leisure (Lee, 1993: 130). Moreover, despite evidence that the perceived freedom of automobility involves a series of penalties such as high running costs and environmental degradation, it continues to occupy a central role in notions of individuality and family life. As Williams comments, this wisdom has become sedimented as common sense and exerts a powerful ideological pull. 'The consciousness that was formed inside [these conditions]', he writes, 'was hostile, in some cases understandably hostile, to anything from outside that was going to interfere with this freely chosen mobility and consumption' (1983: 172).

'Mobile privatization' therefore points us to the development of a form of identity, centred on the nuclear family, in which individuals' spatial relationship with the sites of consumption has been greatly extended. It also points us to the experience of this situation as a form of freedom and as a form of caring for others, however contingent and compromised. Over the next two sections, we will match this transformed arrangement with the supermarket, the pivot around which much of this unprecedented mobility takes place.

Supermarkets and the spectre of homogeneity

Although the large supermarket chains quickly adapted to the needs of the dispersed population, early supermarkets in the UK were sited in

cities and shopping continued to be a localized activity (Humphery, 1998: 73–4). Today, however, supermarkets are typically located on urban trading estates or on the urban rim, necessitating a drive to reach them. Rather than the essential quality of the supermarket being its physical characteristics or the modes of service and shopping it deploys, it is the drive to it, the notion of a mobile event, which defines a super-market (or, in the increasingly delocalized and hyperbolic stylizations adopted by the grocery industry since the 1960s, a superstore, hyper-market or hyperstore). Noting that positioning supermarkets out of town 'collapses the distinction between local and global', Peter Lunt and Sonia Livingstone observe that, when food shopping, 'a car seems essential even if the supermarket is round the corner: the time spent in the car, however short, encodes distance from the local' (1992: 98).

Lunt and Livingstone are not alone in noting that the driving shopper leaves behind the textured, heterogeneous space of locality, in order to visit a more homogenized space. Criticism of this homogeneity typically takes two forms: first, objections to supermarkets' construction of an identical landscape insensitive to local, regional or national differences, and second, condemnations of an internal homogeneity which constrains and directs consumers' actions within the stores. Typifying the first of these criticisms, the architectural journalist Jonathan Glancey detects a double inauthenticity in their design. Not only are supermarket land-scapes fundamentally homogeneous, but they also offer the illusion of difference and distinction, by tailoring their visual appeal to the cultural competencies of (particularly lower-) middle-class consumers.

> Tesco and Safeway have gone for the village-barn, old-town-hall look. This folksy style . . . can be found the length and breadth of the country skinned in a uniform garish brick no matter whether the traditional local building material is primarily stone, flint, yellow brick, red brick or clapboard. They are a representation of Middle England (or Middle Wales and Scotland) values.
>
> (Glancey, 1999: 110)

Although Glancey argues that this formulaic design is a British pheno-menon, a significant recent development in supermarket shopping has been the extension of the driving radius of British shoppers into mainland Europe. Taking advantage of cheap cross-Channel fares, the strength of the pound and low alcohol duty, British consumers travel to French and Belgian hypermarkets in search of drink and food bargains. Descriptions of this phenomenon typically stress the lack of cultural distinctiveness in the shopping experience, its cultivation of placeless

space. People conceived of as themselves homogeneous are then dis-
cursively constructed as occupying this space. The *Daily Telegraph*, for
example, noted that the flux of British supermarkets into France consists
not just of chains like Sainsbury's and Tesco, but also cash-and-carry
operations making capital out of their low-status Englishness (Boozers,
for example, or in a revealing reference to the dispersed community,
EastEnders). The people who shop at these sites appear as symptoms of
this lack of distinctiveness: 'At 3 a.m., it's heart-warming to stand in [a]
vast, open-all-hours hangar . . . and watch Britons load palettes of lager
into white vans' (Peregrine, 2001). The article therefore also picks up on
the homogeneity of *time* in the hypermarkets – food shopping is
represented as a 24-hour activity abstracted from traditional shopping
rhythms. Although this is a situation largely created by ferry companies
placing restrictive time limits on cheap fares, it merges with more general
anxieties about supermarket shopping as an all-hour activity. In rapid
succession, evening shopping, Sunday trading and 24-hour supermarkets
have become sedimented features of everyday life.

The second homogeneity typically cited by critics of the supermarket
is that the layout of the stores and the marketing strategies adopted by
retailers provokes a programmed, mass response from consumers.
Returning to the cross-channel hypermarkets, the *Mail on Sunday*
reported the 'mad' scenes of shoppers being forced to race around the
Auchan store. 'I say to my punters when I let 'em out in the car park,'
says their bus driver, 'It's Hyper-market Sweep time you got three hours
to fill the bleedin' bus' (Barrett, 2000). The reference to a notoriously
lowbrow television quiz show completes the picture of a mass in thrall to
consumerism.

Retailers undoubtedly *attempt* such a direction of people's behaviour.
Piggly Wiggly, the American chain widely recognized as the original
supermarket, was so named for its layout, which shuttled customers along
the shelves like a pig run. More recently, supermarkets have attempted
less crude forms of behaviour modification through, for example, the
construction of store 'theatre'. In some supermarkets separate delicatessen
and fish counters, and in-house bakeries piping a fresh bread smell
around the store, recreate the feel of a marketplace. But commentators
frequently mistake these retail intentions for evidence that shoppers'
behaviour is entirely predictable and conformist (Riddell, 2003). As we
shall see, there is an imperfect fit between retail intentions and people's
shopping practices.

Criticisms of the supermarket therefore cohere around the spectre of
homogenization. While this critique is justifiably hostile to the power of

retail capitalism, it is also predicated on the implicit or explicit judgement that antinomies of food taste should be kept polarized. Glancey's criticism of supermarket design and the newspaper descriptions of cross-channel shopping share the sense that a damaging elision of taste categories occurs in the supermarket. As we noted in Chapter 4, taste antinomies are 'deep-rooted contradictions, probably irresolvable . . . compris[ing] the structural anxieties of our epoch' (Warde, 1997: 55). Cultural elites certainly have an interest in maintaining such sharply defined categories as a means of generating and perpetuating their stock of cultural capital. Yet large supermarkets have little difficulty in reconciling such binarisms, even as they signal them (by, for example, running both budget and premium own-brand ranges; healthy eating and diet-busting products; cook-chilled products and recipe cards). By contrast, we shall see that the market is discursively constructed as tending towards one or other pole. Equally, the individual shopping basket may negotiate the antinomies in a more heterogeneous way than would be possible in other shopping situations. It is to the individual experience of supermarket shopping that we now turn.

Care and love in the supermarket

As we have seen, Williams's account of supermarket shopping separates it from a 'fuller and more human' identity. We may reasonably ask whether this dismissal covers all behaviour in the supermarket. To sensitize Williams's account, we could look at those moments when people defy the goal-directed retail logic of the store in order to follow their own inclinations: to browse, sample, associate with friends and relatives, steal goods or look for romance amongst the exotic fruit and vegetables. Yet while we could undoubtedly find instances of such 'carnivalesque inversions and alternatives to rational social order' (Shields, 1991: 17), an approach premised on shopper's 'resistant' activities gives us limited purchase on the great majority of food shopping. The overriding impression of provisioning is indeed of a rational social order. It is, however, a social order dominated by the presence of women. We have noted that, at the level of goods, the supermarket typically homogenizes antinomies of taste. In his ethnographic study of supermarket shoppers, Daniel Miller (1998a) has pointed out that at another level, the level of feeling, women's supermarket shopping is overwhelmingly concerned with one particular antinomy, care and convenience. The practice and rhetoric of care, or in Miller's near-synonym, of love is, he observes, more than a claim to affection made during courtship. Instead 'it stands for a

much wider field of that to which life is seen as properly devoted ... a foundation for acts of shopping' (Miller, 1998a: 20).

This love is largely devoted (unreservedly) to children and (more equivocally) to male partners, though Miller sketches versions of love focused on other family members and on neighbours. The other key discourse employed by all the shoppers in his study, whatever their class or gender, is 'thrift'. In its links with respectability and working for the common good, thrift is also a manifestation of love. It is interesting to note how the values Miller's shoppers bring to their shopping both overlap with, and diverge from, the ways in which Warde's antinomies of taste shape food practices in the UK. In his analysis of the opposition between care and convenience, Warde finds a decreasing emphasis on care in women's magazines, yet Miller's shoppers employ a notion of care-love that appears relatively resistant to change. Likewise, in his analysis of the opposition between economy and extravagance, Warde finds that the value placed on thrift-economy is closely related to the unequal distribution of material resources, yet Miller's ethnography seems to reveal that thrift is much more widely valued.[1]

So while Miller's shoppers are undoubtedly working against their own best interests, his work demonstrates that structures of oppression are bound up with practices and emotions that are by no means the reflection of dominant interests. In the shopping situation, 'extravagance' is widely described as characteristic of contemporary shopping but finds expression only in the small treats that minimally affirm the individuality of the shopper against the needs of the family. While revealing shopping as a grind that sustains conservative structures of feeling, Miller's analysis therefore sensitizes Williams's proposition that fully human identities are incompatible with the space of the supermarket. Another way of saying this is that the *disembedding* mechanisms materialized in the supermarket – the alienating, massified aspects of the modern world which find form in arrangements of aisles, counters, trolleys and car parks – become *re-embedded* through the care and restraint that individuals bring to these mundane and fatiguing routines. As well as taking place at the level of the individual and group, embedding processes also take place spatially and culturally. It is to these levels that we now turn.

Disembedding and re-embedding

We have argued that one of the key features of the post-war period in the UK has been the dispersal of communities. Retailers and shoppers have adopted strategies to produce and negotiate new landscapes of food

provisioning. We need to question the implications this has for locality, for it is clear that a tendency towards suburbanization is not the same as a wholesale flight from the city. Not only have many people stayed relatively close to their pre-dispersed locales, but cities have also been reoccupied, often by different populations. In this section we use urban markets to suggest that the space of food shopping continues to be meaningfully 'textured'. This is not to argue that markets are necessarily 'better' than supermarkets – their texture might be more accessible to middle-class gentrifiers than to the relatively impoverished populations trapped in place – but we argue that a diversity of social groups share common orientations towards markets.

Although markets as a cultural form predate supermarkets, they are not always old. In some cases they are, indeed, responses to supermarkets. To capture this sense of unevenness, we use the work of the sociologist Anthony Giddens to explain urban change as a dynamic phenomenon. Modern institutions, Giddens observes, lift social relations out of local contexts and rearticulate them 'across indefinite tracts of time-space' (1991: 18). Calling this process 'disembedding', he argues that this lifting-out is accompanied by the growth of *abstract systems* that mediate between people and institutions. The exchange of money for goods and services, for example, has become vastly more sophisticated, while our day-to-day business relies on trust in technical and bureaucratic systems about which we have limited knowledge. In both cases the supermarket is a paradigmatic site of disembedding, involving innovations in travel, payment, quality control, packaging and self-service.

Giddens adds complexity to this historical process by noting that such developments are not simply linear. Instead, social institutions are subject to continual revision, or *reflexivity*. Expert knowledge and popular fears about the toxic characteristics of mass-produced food, for example, have generated critical judgements of supermarket produce which have been answered by the enhancement of supermarket organic ranges, which are themselves subject to reflexive consideration of their cost, taste and degree of conformity to organic precepts.

This reflexive orientation may manifest itself in practices of *re-embedding*. Giddens defines the term as the 'recasting of disembedded social relations so as to pin them down . . . to local conditions of time and place' (1990: 79–80). Although he has in mind the humanization of businesses and bureaucracies through face-to-face contact, we could equally observe that the disembedding of dispersed communities has been followed by a limited spatial re-embedding in which culinary institutions have returned to cities. Giddens tends to dismiss the idea that reflexivity

may achieve the maintenance or recovery of residual structures of feeling in local space. Although 'active attempts to re-embed the lifespan within a local milieu may be undertaken in various ways', he counters that such attempts 'are probably too vague to do more than recapture a glimmer of what used to be' (1991: 147).

Giddens's work therefore offers a useful way of thinking about the culinary management of dispersed populations. Modernity disembeds old face-to-face practices (market and high-street shopping) and reinstalls them elsewhere (in the supermarket) before re-embedding them affectively (by what we do in the supermarket) and topographically (as residual forms reassert themselves). Yet these re-embeddings remain unstable, and subject to reflexive evaluation. In order to analyse this, we examine different food market forms in contemporary UK cities. To situate this argument, however, we first consider the market as a site of meaning.

Market mythologies

Peter Stallybrass and Allon White have observed that 'a marketplace is the epitome of local identity (often indeed it is what defined a place as more significant than surrounding communities) and the unsettling of that identity by the trade and traffic of goods from elsewhere' (1986: 27). Rather than think of markets as purely local, therefore, we need to think of them as places in which competing processes of localization and globalization are always already operative. Nonetheless, in the face of the disembedding tendencies of contemporary food shopping, the local aspect of the market has, in recent years, become particularly meaningful. Discursive constructions of the city have routinely come to privilege the market and the meanings that surround and construct it: meanings such as historical depth, suspended relationships of class and ethnicity, organicism and ecology, familial continuity and rugged entrepreneurialism. Seattle's Pike Place Market, for example, stands at the centre of a reimagined city history in which benign market trading displaced more coercive versions of capitalism. This enchanted narrative records that following the 1897 Klondike Gold Rush, when middlemen were inflating prices for essential commodities, local producers came to the city in order to sell goods straight from barrows (Cook *et al.*, 1998: 990). The story instates the idea of Pike Place market as a site of communion between producers and consumers, rather than as a site of exploitation. This image is then reinforced through the production of a sense of continuity in which these values survive seamlessly into the present. The *Pike Place Market Seafood Cookbook* records that:

City Fish was started by the City Council of Seattle in 1918 when the price of salmon had skyrocketed to a whopping twenty-five cents per pound . . . David Levy . . . bought the business in 1922 and turned it into a Market institution. . . . It was always a family-run enterprise . . . 'Good Weight Dave's' descendants continued to run City Fish until February 1995, when former Alaska fisherman Jon Daniels, a strapping young man with eyes as blue-gray as the ocean and a vise-like handshake forged by years at sea, took over the business.

(Rex-Johnson, 1997: 7)

A 'mythology' is under construction here in which the normal operations of capitalism are suspended. If the experience of both shopping and shopworking is overwhelmingly mediated and alienating, then the narrative of City Fish returns us to a pre-capitalist world of locality, family, and face-to-face communion between buyers and sellers and between people and things. This market mythology is eminently transposable, and is itself liable to cycles of disembedding and reflexive response. In the case of Pike Place a variety of other leisure sites (delicatessens, restaurants making use of market produce and brewpubs) have emerged as satellites of the market. Amongst the most successful of these has been the Starbuck's chain of coffee houses, which originated nearby and has since expanded across North America and into Europe, Asia and Australasia. Starbuck's has so successfully traded on the connotations of quality attached to the market that Ritzer offers the franchise as a 'profound challenge to McDonaldization' (Ritzer, 1998: 178). Yet increasingly reflexive responses to the chain see it as itself homogenized and invasive (Blythman, 2001; Pendergrast, 2002).

While Giddens may therefore be right that re-embedding mechanisms only 'recapture a glimmer' of pre-modern modes of social behaviour, it is equally true that these mechanisms are widely practised and meaningfully participated in. Short ethnographies of the street market (McRobbie, 1989) and the car boot sale (Gregson and Crewe, 1994) reveal that this desire for 'traditional', 'authentic' and 'pre-industrial' gatherings are an important feature of the contemporary shopping landscape. But while McRobbie, Gregson and Crewe are at pains to emphasize the cross-class characteristics of their markets, it seems clear that not all markets are equally open to different populations. For that reason, we wish to briefly look at two UK food market forms with divergent class, gender and ethnic characteristics.

Elaborated markets

In his study of Australian supermarkets, Humphery has noted that one response to the increased homogenization of provisioning is to engage in shopping quests, in which routine shopping practices are 'elaborated' into a pleasurable search for edible goods. For his respondents, the use of delicatessens and markets is a more real experience because it is a more fully social one (a respondent expressed a preference for a form of shopping in which information is *exchanged* rather than simply transmitted). While Giddens's notion of modernity is predicated on predictability, Humphery's respondents claim to value the unpredictable, associating this characteristic with the past. While this unpredictability is inconsistent (predictability is generally desirable in food hygiene), it may be assumed that seasonal produce adds one valued layer of unpredictability.[2]

Seasonality is now an established aspect of UK food retailing in the form of the farmers' market. Although only appearing as a concept in 1997, by 2002 there were around 300 farmers' markets in the UK offering a range of goods marketed as local, seasonal and/or organic. These terms are attempts to re-embed food provisioning within *two* local landscapes – the immediate cityscape and an imagined rural hinterland – and to disrupt the homogeneity of 24-hour shopping time by producing a sense of temporal specificity. Note how the following newspaper feature holds the two localities together:

> [A] benefit of the market is that all of the food – which must come from within a radius of 100 miles of the M25 – is local and, therefore, seasonal . . . [also] . . . they bring a friendly, community spirit back to the area. Instead of rushing past one another, people buy at a more leisurely pace. They come out of their homes and offices to gossip as well as buy.
>
> (Linley, 2002: 3)

Rather than being crude exercises in rural nostalgia, the farmers' markets are indicative of a more complex structure of feeling which holds together imagined communities separated by distance. Indeed, part of the nostalgia is for a crucial trope of *modernity*: the ability of the individual to act as *flâneur*, strolling the consumption sites of the modern city in search of novelty (Tester, 1994). While the paradigmatic movement through twenty-first century urbanity is by car, '*flânerie* as a form of being in the modern metropolis seems to endure' (Smart, 1994:

161–2), this endurance lying in its ability to re-embed and re-enchant activities which have been geographically dispersed within and beyond the space of urban locality.

Despite this desire for a degree of unexpectedness, these temporary sites have the potential to themselves become sedimented and predictable. The rapidity with which this can happen is well illustrated by the development of London's Borough Market, a weekly organic farmers' market attached to a long-established wholesale fruit and vegetable market. Initially styling itself as a Food Lovers' Fair, the market became monthly in 1998 and weekly the following year. Although initially a relatively 'unpredictable' institution, at another level this sedimentation was profoundly *predictable* as a demonstration of how food may be used to re-enchant an urban area caught up in processes of regeneration. Zukin has noted that there are parallels between gourmet food consumption and 'the deep palate of gentrification' (1991: 206). We might go further and suggest that gentrification is now inconceivable without a concomitant commitment to gastronomic change. So while the market area was under threat from 'insensitive' redevelopment long before the establishment of the farmers' market, it was the arrival of the Food Lovers' Fair that gave impetus to a more 'sensitive' version of redevelopment, in which culinary and architectural conceptions of good taste could be articulated together.[3] What was initially offered as a temporary and unexpected site of food shopping is now a more entrenched phenomenon with the market surrounded by gourmet shops and plans for a car park.

It should be clear from the preceding discussion that farmers' markets are predominantly middle-class spaces, trading not simply in produce, but also in culturally rich values of authenticity, simplicity and 'heritage' (somewhat problematized by the traditions not always being British ones). Yet despite their rapid growth, such food markets continue to be relative rarities in the UK. More common are the covered and open-air markets largely serving the elderly, the relatively poor and ethnic minorities. Here too are features of the elaborated market: the exchange of information; some sense of historical groundedness; the play of temporary and permanent market status and the availability of rare or seasonal produce. Yet the character of these markets is clearly very different from that of the farmers' markets. Taylor *et al.*'s (1996) ethnography of the 'post-industrial' cities of Manchester and Sheffield argues that they inhabit the centre of a densely-articulated mental cartography of place and social position very different from that of Borough Market. They argue that there is an

important distinction between those people who visit the markets routinely and those who use them sporadically. The largely elderly regular visitors expressed their relationship with the markets in terms of their weekly routine, their proximity, the opportunities they afforded for sociability, and the cheapness of the goods. Tourists or newcomers to the city 'cast a very different gaze over the bustling market scene', sampling 'the social diversity, the cheap wares and the "pre-modern" quality of social relations benevolently, because it is not somewhere to which they will return' (Taylor *et al.*, 1996: 153). Taylor *et al.*'s purpose is to recognize the importance of economic necessity in the shopping behaviour of many working-class and ethnic minority respondents. It is an argument for the continuing centrality of wealth inequality in food provisioning (see also Warde, 1997: 175), deploying a spatialization of the economy and extravagance antinomy. As a number of respondents forcefully argue, economy is embedded within locality, while extravagance is disembedded along driveable lines to Sainsbury's and Tesco (Taylor *et al.*, 1996: 156).

Nonetheless, what is striking in Taylor *et al.*'s work is the shared sense of 'market values' between established and incomer groups. The market is a positively coded residual space unlike nearby cheapjack supermarkets such as Kwik Save or Discount Shopper. In these spaces the economy antinomy is clearly paramount, whereas in the market other taste issues might be more valued. This is most apparent in the brief reference to Asian and Afro-Caribbean Sheffielders' use of markets, where London's Southall and East End markets for Asians, and Brixton and Hackney markets for Afro-Caribbeans, provide rich imaginative cuisinal resources, to set against the perceived drabness of local markets in the North of England. In these cases, it is the role of markets in reproducing food traditions that outweighs economic motivations.

We have argued, therefore, that the dispersal of food shopping practices to the urban edge does not offer a complete picture of UK provisioning. Instead, markets continue to be used by different populations in different ways. There is strong evidence to suggest that, contrary to fears of homogenization, people possess sophisticated food cartographies in which unpredictability is a prominent trope. Analysis of the corner shop, the mini-mart, the high street shop and the delicatessen would also have shown the reflexive arrangement of disembedding and re-embedding practices amongst suppliers, sellers and shoppers, albeit in different ways. By way of a conclusion, we move from the continuing resonance of a residual space to an emergent shopping site that focuses the management of dispersal in new ways.

Home shopping

Williams's notion of mobile privatization, described earlier, was not an argument for a general retreat into isolation but 'a key tendency in urban and industrial society for homes to be physically and socially more distant and . . . to be the focus of consumption' (Mackay, 1997b: 264). For Williams, it was quite possible for people to participate fully in both the public and private spheres, for he insisted that people do not live 'in a cut-off way'. Yet in recent years home-based leisure and consumption have become significantly more intensified, leading to renewed fears of a general retreat into the private sphere. Central to this intensification has been the home computer and the emergence of the internet and e-mail. These developments offer to fundamentally change the nature of provisioning. If the car provided an important mediating technology between 'home' and the outside world, then the PC offers – or threatens – to promote a much more widespread withdrawal into privacy.

Yet like the discourse of 'supermarketization' outlined earlier, such a view of provisioning is incapable of dealing with the ambivalences and contradictions of UK food shopping. Although home computer ownership in the UK is fairly widespread (Mackay, 1997a: 307), the take-up of home shopping has been much slower than anticipated. While in 1996, economic forecasters were predicting that home shopping in 2002 would account for around 20 per cent of grocery retail; by that date the actual proportion was less than 1 per cent of the total (Rushe, 2001). Although this figure masks the relative success of some online UK retailers (Tesco and, for a time, Iceland), others amongst their competitors (notably Asda, Sainsbury's, Safeway and Budgens) have been forced to reassess and reinvent their online strategies and procedures. The proportion of provisioning represented by online shopping will undoubtedly increase, but the thumbnail history above is consistent with our earlier observation that food shopping has developed neither evenly nor entirely predictably in post-war Britain. From the preceding discussion, we can see that homogenization and technological determinism are insufficient responses to the emergence of a relatively novel form of selling and shopping. Instead, we would wish to offer three contingent propositions for PC home shopping:

1 Dominant, residual and emergent cultural levels are not discrete

We should be suspicious of claims that internet provisioning is something entirely new. There are obvious continuities with existing telephone and television shopping, even if the service has become more widespread

and notionally democratized. Equally, an emergent technological commodity, the PC, may grant access to residual cultural forms and modes: to 'authentic' goods unobtainable in nearby shops and to pre-dispersed modes of service such as home delivery. Kevin Robins (1996) has noted a fundamental nostalgia in this combination of the emergent and the residual, but we may observe that such attempts to weld different cultural levels into a meaningful formation are a consistent feature of the post-war food landscape.

They were certainly operative in the freezer supermarket chain Iceland's 1999 attempt to combine home shopping with a commitment to organic foods. Although widely seen as a downmarket brand, Iceland was initially successful in repositioning itself within an 'ethical' niche that combined low prices, resistance to genetically modified produce (the company claimed to have bought 40 per cent of the world's stock of organic vegetables) and an internet home delivery service targeted at shoppers without the means of getting to their stores. By 2001, however, this strategy collapsed in the face of falling profits (believed to be a reflexive consequence of customers' unwillingness to pay higher prices for organics and the withdrawal of multi-buy offers) and a reluctance amongst customers, many of whom were, in McGuigan's (1996) phrase, 'information-have-nots', to shop online (a halt was called to the re-branding of the chain's shops as Iceland.co.uk) (Bridge, 2002). Nonetheless, both the revamped Iceland website, and that of Sainsbury's, continues to grant organic produce a significance not reflective of its contribution to UK food sales. Internet food shopping is not so much, therefore, an emergent practice becoming dominant, as a practice that exists within a range of orientations towards the world.

2 Homogenization is negotiated

We have argued that simplistic accounts of UK food provisioning concentrate on the issue of homogeneity while a more nuanced account seeks to understand the play of homogenization and individuation in food shopping situations. While the emergence of internet shopping may be seen as homogenizing time by enabling people to shop 24 hours a day, individuals also attempt to reclaim temporal specificity by shifting the time of shopping in their favour. For this reason, the home computer is a form of what Warde (1999) has termed the 'hypermodern convenience device'. For relatively affluent sections of the population, the appearance of devices such as freezers and VCRs enables time to be reordered.

The development of new conceptions of convenience is associated with a re-evaluation of time, which increasingly encourages individuals to covet a capacity for the autonomous organization of the personal schedule. For at least some sections of the population . . . the ability to organize time use in the light of personal purposes [is] a mark of privilege.

(Warde, 1999: 522)

There is, therefore, an instructively imprecise fit between retailer and consumer 'intentions'. While online supermarkets using distribution centres typically demand that the customer books a delivery slot, consumer demand tends to concentrate within specific weekend times. Far from the food retailing industries imposing a patterned response upon a docile population, consumers have shown themselves willing to contest homogeneous time in favour of existing familial, working and leisure rhythms. Nonetheless, as we have seen in the case of markets, the section of the population best able to convert these discrepancies in their own interests are those who are high in the economic and educational capitals needed to own and use home computers.

3 Online shopping is an act of care-love

Although some consumers are better able to resist temporal and spatial homogenization than others, we have argued in favour of Miller's proposition that most consumers affectively re-embed the dispersal of shopping through acts of care-love. Journalistic responses to internet food shopping typically deal with this aspect of home shopping. One newspaper report argues that supermarkets work against care, generating an excess of maternal guilt. As one 'full-time mother' reports, this imbalance can be redressed through online shopping:

'The kids are arguing before we get out of the door. . . . When you arrive, things do not get better. I have a trolley to push and two children to look after. If I give them something to eat to keep them quiet, I start feeling guilty because someone might think I've nicked it. It's just as bad if they help themselves to something. Online shopping has been a lifesaver. I don't know how we would cope without it.'

(Rushe, 2001: 7)

The most reflexive, and therefore successful on-line retailer, Tesco, has based its strategy on rearticulating this antinomy of care. While

Sainsbury's and Asda–Walmart initially adopted a homogenizing strategy of opening widely dispersed distribution centres, Tesco chose a 'picking' strategy in which local stores would process on-line orders. The message was clearly that Tesco was demonstrating its commitment to care, even at the expense of profit. This was reinforced through a series of adverts focusing on a mother–daughter relationship, simultaneously establishing the centrality of women to provisioning and negotiating the problem of the home computer as a markedly male 'miraculous toy'. Revealingly, even while continuing to argue that picking is uneconomical, Sainsbury's, Safeway and Asda's online strategies subsequently combined picking with dispersed distribution.[4]

Conclusion

As we noted in Chapter 1, a recurrent criticism of cultural studies has been that it is little more than a celebration of consumption. While we would resist such a caricature, it is true that much research has analysed shopping activities very different from the predominantly banal activities of food-buying and food-selling. Shopping research has tended to emphasize 'high-status', or recreational shopping. This chapter, by contrast, has dwelt on a spectrum of shopping activities, most prominently routine provisioning. Rather than succumb to what is, ultimately, a form of economic and technological determinism, we have argued that food shopping spaces and practices are involved in reflexive processes of dis- and re-embedding. This is not to deny the formidable and increasing power of food retailers addressed in the previous chapter, but to argue instead that an understanding of the massifying power of capitalist industry at a national or global level misses the more negotiated sense of space, place and time that takes place locally, every time we shop. In the next chapter we explore how the foodstuffs we buy are consumed in a domestic context.

8 Eating in

What we eat, where we get it, how it is prepared, when we eat and with whom, what it means to us – all these depend on social [and cultural] arrangements.

(DeVault, 1991: 35)

Eating in is an everyday activity that we often take for granted. By analysing the activities that both produce and sustain eating in, this chapter aims to show the complex cultural processes that are involved. This involves a consideration of the ways in which ideas about the meaning of eating in the domestic sphere are produced by public discourses. It also involves a consideration of the complex negotiations that take place in the private sphere which produce the food which is prepared and the ways it is eaten, and identifies the power relations in which these activities take place. Debates about eating in raise a range of questions that are central in understanding food cultures. In particular, they raise questions about the role of food practices in producing, and reproducing the home, the family, gendered identities and the relationship between public and private spheres. Furthermore, the consumption practices discussed here are closely connected with other aspects of the circuit of culture, raising questions about changes in food production, policy and regulation, representation and identity.

It is unsurprising that much of the work on eating in has been motivated by feminism. Central to second-wave feminism in the late 1960s and the 1970s was the idea that 'the personal is political'. Whereas left-wing politics often distinguished between the 'public' sphere of politics and the 'private' sphere of the home and family, feminists came to see the home and family as a key source of women's oppression and, therefore, political. As Elizabeth Fox Genovese has argued, 'Feminism has led the way in demystifying personal relations, forcefully insisting they are personal to the core' (1991: 11).

While the home is often presented as a haven from the public sphere and associated with 'positive' qualities such as 'privacy, security, family, intimacy, comfort, [and] control' (Putnam, 1990: 8), feminist critics have pointed out that these positive qualities are often experienced by men rather than women. Furthermore, they have argued, it is unpaid female labour that not only services the home but also produces the positive experience of home for other people. It is for these reasons that discussions of eating in have been preoccupied with how female domestic (physical and emotional) labour produces and sustains the family through the provision of meals. The distinction between public and private spheres often rests on the assumption that the public sphere is the realm of production and the private sphere that of consumption. Not only does this reproduce a problematic notion of the relations between production and consumption, it also ignores the fact that female domestic labour *is* labour: 'women are typically the producers of goods and services of which men as husbands are the *consumers* or final users' (Lury, 1996: 123). Therefore, meals are produced by women from commodities that have been bought on behalf of other people (Warde, 1997).

Food practices need to be understood in relation to the ways in which they produce, negotiate and reproduce the nature of the relationship between public and private spheres. Indeed, in Anne Murcott's study of gender and cooking, she found that for her respondents eating in was a significant act because 'the cooked dinner marks the threshold between the public domains of work or school and the private sphere behind the closed front door' (1995: 92). 'Home-cooked' meals are seen as imbued with the warmth, intimacy and personal touch which are seen as markers of the private sphere and in opposition to foods which are the products of a public, industrialized and anonymous system of food production. It is for this reason that commercially produced foods often seek to add value to their foods by associating them with 'home', demonstrated in claims to 'home-cooked' food in pubs and diners and 'homestyle' ranges of ready-meals from supermarkets (Warde, 1997 and 1999).

Finally, the concept of the family is central to this chapter, a concept subject to extensive debate within sociology. There is little space here to follow the same route and, indeed, this chapter is more concerned with the meanings that become attached to the family as it is mobilized across a range of discourses and constituted through everyday practices (DeVault, 1991). However, it is worth noting from the outset the ways in which home and family frequently become synonymous in discussions of eating in. Furthermore, as the following section makes clear, in popular discourses and practices, 'the family meal' frequently comes to represent the

'proper' mode of eating which is central to the reproduction of national cultures.

'The proper meal' and 'the family meal'

Notions of 'a proper meal' are often linked to nutrition. These definitions often draw on a range of scientific discourses in which the 'goodness' of a meal is equated with whether or not it gives us the 'proper' nutrients. However, as was noted in Chapter 4, ideas about nutrition are often far from objective: what constitutes a nutritious meal in one decade will not be necessarily the same in the next as ideas about nutrition are often profoundly cultural (see Levenstein, 1993; Lupton, 1996; Crotty, 1999). This section explores how ideas about the proper meal extend far beyond questions about nutrition as they become attached to a wide range of symbolic and cultural meanings and to particular models of social relations.

Ideas about health are not only the product of scientific discourses. In the introduction to one of her bestselling books, British cookbook queen Delia Smith writes:

> I have an instinct (no more), that perhaps our current preoccupation with healthy eating has eclipsed what I consider to be a very health-giving joy of more traditional cooking, of eating gathered round a table enjoying conversation, good food and good wine.
>
> (1995: 7)

For Smith, a 'proper' meal becomes attached not only to ideas about tradition, but also to our emotional and spiritual health. Furthermore, this is not simply about what one eats but how we eat: the proper meal is at a table, shared and promotes sociality and talk. The proper meal is also home-cooked. She continues, 'let's not completely lose sight of our heritage: puddings steaming merrily on the stove, the smell of home baking and the evocative aroma and the sound of a joint sizzling in the oven after a long frosty walk' (ibid.). Here, the proper meal conforms closely to the home-cooked traditional family British Sunday lunch. These ideas about the proper meal are not unique to Delia Smith: they are reproduced institutionally, across a range of texts and in people's everyday practices.

In the UK, studies of domestic cooking have demonstrated how people conceptualize the proper meal in relation to particular foodstuffs. In Anne Murcott's study of food in South Wales in the 1980s, the proper meal was

equated with meat, potatoes, vegetables and gravy (1995: 91). Likewise, the respondents in Charles and Kerr's study of families and food in the 1980s came to a similar conclusion and they shared with Delia Smith the sense that Sunday lunch was 'the proper meal *par excellence*' (Charles and Kerr, 1988: 18–19). More recent studies of British perceptions of the proper meal, while showing some shift towards 'menu pluralism', nonetheless reiterate the meat/potatoes/vegetables model as central to British people's understanding of the proper meal, although the category can now be extended to include pasta (Mitchell, 1999).[1] If the proper meal in Britain is strongly bound up with ideas of nation as Chapter 5 demonstrates, then DeVault's study of food and families in the USA also found that people had their own fairly rigid understanding of what constituted the proper meal, even if notions of the proper meal were more ethnically diverse. Her respondents 'spoke of rules for the kinds of combinations they can make', and all these studies demonstrate that these rules provide a key point of reference and a 'cultural standard', even when they are being broken (DeVault, 1991: 45) In making this argument, DeVault draws on Mary Douglas's structuralist analysis of the codes which govern the ways in which elements are combined to produce a meal. For Douglas, 'syntagmatic relations between meals reveal a restrictive patterning by which the meal is identified as such, graded as a major or minor event of its own class, and then judged as a good or bad specimen of its kind' (1997: 42). The respondents in all the studies discussed above demonstrated a high level of adherence to a specific cultural code which delineated what could, or could not, be included in the proper meal.

However, in all these studies, the ingredients of a proper meal extend far beyond the foodstuffs that combine to make them. For Murcott's respondents, a proper meal was *home*-cooked: it must be a produced in the home and it must be a cooked dinner (1983 and 1995). Therefore, for these women, the proper meal is also a product of the female labour performed on food through the act of cooking. For this reason, convenience foods – despite the fact that they frequently require some form of preparation in the home – were not included inside the category of the proper meal (Charles and Kerr, 1988; Murcott, 1983). Finally, these studies suggest that people understand the proper meal as a 'social occasion' where all the family sit down together and there is conversation: it is therefore 'defined by the social relationships within which it is prepared, cooked and eaten' (Charles and Kerr, 1988: 23). It is perhaps not surprising given the expectations that accompany the proper meal that many of the women interviewed in these studies felt frustrated and depressed by their inability to always match their practice with this ideal.

DeVault's work (discussed in more depth below) argues that meals are a means of 'producing home and family' (1991: 79). Indeed, social policy in the UK rests on the assumption that particular meal arrangements are an index of family life. Shared meals between a man and a woman can make women ineligible for state benefits: meals are a sign of cohabitation and therefore that a woman can be economically dependent on a man rather than the state.

> The sharing of food is seen as indicating a close relationship. . . . Conversely, when petitioning for divorce one of the indications of separation is that meals are no longer being shared by marital partners. The sharing of food is therefore something that happens within family households and is an indication of their existence.
>
> (Charles, 1995: 101)

These perceptions are also reproduced in the practices of families after a divorce or separation: the rituals of mealtimes become a way in which separated partners communicate to their children that they still have a 'normal' family life (Burgoyne and Clarke, 1983)

Ideas about what constitutes a proper meal are also constructed through more public commentaries. A salient example in the UK was the amount of media debate generated by the news that the Oxo family, stars of a long-running series of advertisements for the Oxo stockcube, was to be axed. This would serve as a vehicle to discuss a whole range of issues about the significance of the family meal. Born in 1983 to replace an earlier incarnation of the Oxo family, the family in question had 'intended to give a more realistic insight into life around the kitchen table, including some bickering' (Barwick, 1999). However, by 1999, it was claimed, the Oxo family was no longer 'realistic': 'The Oxo family was a great British institution but times have changed and the new campaign holds up a mirror to life in Britain today', claimed one spokeswoman for the product (Gregoriadis, 1999).

The death of the Oxo family was taken as a sign that family meals were dead, even 'bickering' family meals, and fuelled a debate about the significance of its demise. While some critics noted how contemporary conceptions of the family meal were in fact a post-war product anyway and noted the stresses and strains produced by notions of the family meal (Coward, 1999; Jennings, 1999; Rowe, 1999), others pondered whether more fundamental cultural values were being lost. Many stressed the threat to communal eating: 'The Oxo ads reinforced the importance of eating together', claimed TV chef Nick Nairn, while columnist Bel Mooney advocated that 'Good food and good conversation matter.

Solitary grazing is depressing' (in Rowe, 1999). The decline of communal eating was not only bad for our mental health, it was claimed, but even our physical health: health columnist Joanna Blythman suggested that 'When people sit down together, children accept what everyone else is eating. We shouldn't give in to ideas of children's food as separate. We're creating the obese, unhealthy adults of the future' (in Jennings, 1999). In her response to the Oxo story, cookery writer Nigella Lawson went further: when families stop eating together, 'community is diminished . . . family without community . . . is the worst of all worlds.' She continued, 'I see the bottle-fed infant, the package-fed child and the alienated generation as a continuum . . . the contact, that thing which makes us learn to be human, and to value it, is missing' (Lawson, 1999).

Deborah Lupton has argued that 'The "family meal" and the "dinner table" are potent symbols, even metonyms, of the family itself' (1996: 39). Some of the commentators responding to the Oxo family 'crisis' made it clear that proper meals are family meals, that mealtimes are fundamental to the production of families and that, in this way, the proper meal is crucial to the nation's physical, mental, social and cultural health. For such commentators, the family meal is a practice through which we produce and reproduce human culture and through which we recognize ourselves as belonging to a culture. However, these reports also rely on a narrative of cultural decline in which there is a nostalgia for a 'golden age' of family meals that there is little evidence to suggest ever existed (Murcott, 1997). Yet this image of the family meal remains a forceful one, 'an ideal-typical model of the middle-class and (respectable) working-class family' (Murcott, 1997: 44). Practising the family meal becomes a means through which people not only recognize themselves as families, but as a particular 'class' of family. The family meal is a means through which respectability is signified through practice: in a context where respectability signifies 'moral authority', 'to not be respectable is to have little social value or legitimacy' (Skeggs, 1997: 3).[2] This image of the family meal will be felt as particularly coercive for households who have less chance of living up to them because 'the proper meal' is financially beyond their reach (DeVault, 1991). It will also act as a reference point for 'normal' practice for those who live outside 'conventional' family structures (Bell and Valentine, 1997).[3]

Women and the family meal

The discussion above has suggested that the production of the proper meal, which in turn produces the family, is rooted in a particular sexual

division of labour. Despite an increase in married women now being employed in paid work outside the home, research suggests that this has not had a significant impact on the distribution of domestic tasks between the sexes. This section explores these ideas further by examining research which looks at the extent to which women are still responsible for 'feeding the family'. Furthermore, it should be noted, that this happens in a context in which many women are positioned as the providers of food for others but maintain a difficult relationship to eating itself. Women frequently use food to offer family members pleasure yet have difficulty experiencing food as pleasurable themselves, particularly in a domestic context (Martens, 1997; Charles and Kerr, 1988).

The construction of women as mothers responsible for the health of their children begins even before the child is born. Lupton argues that during pregnancy, the mother-to-be is encouraged to see her food practices in terms of medicine and nutrition. Pregnant women are told they are 'eating for two', encouraged to evaluate their own intake in terms of the health of the foetus and to see 'the morality of their food choices' (Lupton, 1996: 41). As one advice book put it, 'before you bring a bit of food to your mouth, ask yourself: Is this the best bite I can give my baby? If it isn't, find a better one' (ibid.: 42). This emphasis on the responsibility of the mother for the physical health of the child is maintained after birth, including the pressure on women to breast-feed for the good of the child. 'The cultural construction of the infant–mother relationship when breast-feeding is that of a mystical union in which both nourishment and tender, loving feelings are passed from the mother to child' (ibid.). Both before and after birth, the construction of women as mothers involves putting the preferences and health of the child before their own. Feeding a child is not only seen as providing nutrition but demonstrating care and love as the proper disposition of the mother towards the child. Furthermore, the health of the baby is read as a product of good or bad mothering: 'the infant's body becomes a symbol of a mother's ability to feed and care for it well' (ibid.). For this reason, it becomes imperative that the child eats, and eats healthily: it is perhaps unsurprising that women's magazines and daytime television spend so much time both constructing and negotiating anxieties about disciplining children's eating and the problem of 'faddy eaters'. Furthermore, research indicates that mothers understand their decisions about infant-feeding as 'displays of morality and responsibility' which not only demonstrate their moral worth as a mother, but also, more generally, as a woman (Murphy *et al.*, 1999: 242).

Questions about disciplining eating relate back to ideas about the family meal and the idea that children should not only be taught the

right things to eat but, also should be taught how to eat, during their socialization. These ideas are reproduced in research into the meanings mothers attach to the proper meal. The family meal, for the women in Charles and Kerr's study, was 'the only way of ensuring that they [their children] were eating "properly" in terms of health as well as social acceptability' (1988: 93). More recent research carried out in Australia demonstrates that, despite an increasing emphasis on children being given autonomy, parents still feel a pressure to teach their children the difference between 'good' and 'bad' foods (Coveney, 1999).

While there are a number of works testifying to the ways in which responsibility for cooking falls to women as part of a wider sexual division of labour which reproduces gender inequalities, Marjorie DeVault's work highlights both women's role in producing the family and the female labour that goes into sustaining it. A range of social changes – including the rise of convenience foods, the provision of more foodstuffs and women's increasing participation in the (paid) labour market – means that 'family meals have become less necessary and a more volitional social form' (1991: 37). However, the increase in goods and services provided by the market has not reduced female labour: instead, DeVault argues, sustaining the family becomes the key form of labour. Preparing food for a family involves far more than cooking, it also involves invisible forms of labour which demonstrate caring. For DeVault, caring work is the 'undefined, unacknowledged activity central to women's identity' (ibid.: 4).

Her study of families in Chicago from a range of class, ethnic and 'racial' backgrounds, some of whom are full-time mothers and others who engage in paid labour, demonstrates the skilled planning and co-ordination that goes into providing food. This involves pleasing the family, producing the proper meal, making meals interesting and producing the meal as an event through which family life is created. In planning meals, women employ a large and diverse amount of tacit knowledge. Shopping is not simply an activity in which purchases are made, but involves 'screening and sorting' products, monitoring both the family and the market and making improvizations (see also Miller, 1998a and the discussion of his work in the previous chapter). DeVault's aim to give voice to, and hence make visible, women's experiences of providing for their families, is echoed in Luce Giard's work which captures the nuances of activities which go into 'doing-cooking':

> In cooking the activity is just as *mental* as it is manual; all the resources of memory and intelligence are thus mobilized. One has to

organize, decide and anticipate. One must memorize, adapt, modify, invent, combine and take into consideration Aunt Germaine's likes and little Francois's dislikes, satisfy the prescriptions for Catherine's temporary diet, and vary the menus at the risk of having the whole family cry out in indignation with the ease of those who benefit from the fruit of other people's labour.

(1998: 200)

For DeVault, women are also responsible for producing the 'quality' time that is necessary if family life is to be experienced:

Feeding work . . . reconciles the diverse schedules and projects of individuals so as to produce points of intersection when they come together for group events. Within the group that this kind of scheduling creates, attention to individual needs and preferences establishes the family as a social space that is personalized.

(1991: 90)

It is through providing this personalized attention that women produce the experience of eating in as distinctive from the experience of eating out. The labour involved in producing family life is never completed. While women have some opportunity to set their own standards and regulate their own labour, they experience 'anxiety and guilt' because they feel they will be judged for their failure to live up to the idealized images of family life which serve as reference points for how they conduct family life and themselves as women (ibid.: 133).

However, DeVault argues, the families that women produce through the practice of providing will differ according to the different material conditions in which women perform their labour. For example, while for middle-class women the family meal may symbolize love and care, for poor women putting a meal on the table is more likely to be an assertion of survival. Likewise, families are produced in different ways between social groups:

In families with more resources, food becomes an arena for self-expression, providing a chance to experience family as a reward for achievement; in poor families, feeding and eating are themselves the achievement. Since the ability to maintain family members cannot be taken for granted, all family members are recruited into interdependence through necessity.

(ibid.: 201)

Studies of the position of feeding work in the sexual division of labour are often met with suspicion because men are generally presumed to be taking more interest in, and responsibility for, cooking. Studies from the 1980s show men's participation in the family meal is largely confined to the fact that they eat it and, sometimes, 'help out' their wives (for example, Murcott, 1983 and 1995; Charles and Kerr, 1988). The ways in which cooking has been naturalized as a female activity is also well-illustrated by the ways in which failure to provide proper meals is a recurring theme in reasons cited for domestic violence (Ellis, 1983). Likewise, press coverage of the Greenham Common protesters focused on their 'rancid' and 'burnt' food, and their 'dirty' pots and pans, as a way of signifying that these women weren't 'properly' feminine (Cresswell in Morley, 2000: 70). While there has been relatively little interest in the meanings that men bring to their cooking (Kemmer, 1999; Roos *et al.*, 2001), more recent work suggests that while men do take more responsibility for cooking at certain stages of the lifecourse of the family, there still have not been significant changes (Warde, 1997; Warde and Hetherington, 1994). While publications aimed at the male cook may be less likely to treat him as an abnormal figure as was suggested in the 1980s (Coxon, 1983), and while contemporary men's magazines such as GQ and *FHM* may include recipe columns, the fact that the male cook is no longer envisaged as feminized, does not mean that he is envisaged as domesticated.[4] (See Chapter 11 for a more extended discussion of masculinity and cooking in relation to TV chefs.)

DeVault's study does address the issue of men's contribution to providing food. For some men in the households she studied, cooking is seen primarily as a leisure activity in which they produce a 'special', rather than an everyday, meal, reproducing the idea that the home is experienced as a place of leisure, rather than work, for men (see also Kemmer, 1999; Roos *et al.*, 2001). However, in the three households where men made a significant contribution towards cooking, they felt little of the anxiety and guilt that women associated with feeding the family. This, DeVault argues, is because while men certainly contributed through tasks to 'feeding the family', they did not 'feel the force of the morally charged ideal of deferential service that appears in so many women's reports' (1991: 149). This gendering of cooking as leisure or labour also permeates representations of cooking.[5]

Whereas some critics have explained the caring work women do in feeding the family in terms of an 'extraneous gender ideology' imposed on women (Warde, 1997: 130), for DeVault it is through the very practice of feeding the family that women reproduce gendered identities.

'It is not just that women do more of the work of feeding, but also that feeding work has become one of the primary ways women "do" gender. . . . By feeding the family, a woman conducts herself as recognizably womanly' (DeVault, 1991: 118). Through providing food for their families and 'doing' care, women reproduce gendered identities and inequalities. Because feeding the family is a caring practice and a feminine practice, this begins to explain why there has only been a partial shift in the sexual division of labour around cooking. While men may cook meals, and while cooking is no longer seen as an 'essentially' feminine activity – and, indeed, can take on masculine attributes of mastery and skill (Levenstein, 1993) – caring remains a femininized competence and disposition. As Skeggs argues, 'the link made between femininity, caring and motherhood contributes towards naturalizing and normalizing the social relations of caring' (1997: 67). Similar conclusions to DeVault's are drawn from research in the UK on shopping by Miller (1998a) who, as we've shown, notes the strong relationship between the practice of mothering, self-sacrifice and caring for others.

For DeVault, women learn to care, to practise attention and listening to the needs of others, from both their mothers and from wider images of family life and feminine practice. DeVault is at pains to distance herself from those feminist positions which suggest that women are 'essentially' more caring than men or that they are more 'naturally' virtuous.[6] Instead, she argues that feeding as a feminine practice is inculcated in childhood, produced through discourses of mothering and reinforced through the experience and practice of being a wife and mother. In this way, to draw on Bourdieu's terms, caring become a logic that underpins feminine practice. Put another way, to provide food is to reproduce a feminine habitus as 'a system of structured, structuring dispositions . . . which is constituted in practice' (Bourdieu, 1990: 52).[7]

Care and convenience

The significance attached to female labour – and, in particular, care – in producing the proper meal means that convenience foods are often constructed as a threat to the family meal and, hence, the family itself. This has been fuelled by reports that there has been a culinary deskilling in which people were frequently unsure of how to transform 'raw' foods into meals (Caraher *et al.*, 1999). Instead, it has been claimed, the responsibility for cooking has been taken out of the home and is provided by the market in the form of convenience foods which need only to be zapped in the microwave (Coward, 1999). In the UK, in the years between

1994 and 1999, sales of chilled ready-meals doubled, with 80 per cent of sales in single-portion sizes (Pook, 1999; see also Wrigley, 1998). It was claimed that Britain was becoming a nation of solitary eaters and that households were engaging in 'serial eating'. Even when people did eat together, it was reported, they were increasingly relying on the market rather than home-cooking: 'White lies served up at dinner parties' as one *Daily Telegraph* headline put it. The turn to convenience foods has also been linked to the rise of what Fischler calls 'an empire of snacks' (in Wood, 1995: 64) which constituted another threat to proper meals. Unsurprisingly, for some in the UK, this was seen as a sign of an insidious Americanization that threatened the British way of life: chef Sally Clarke would comment, 'The Americanized way of grazing creeping in here is terribly sad' (Jennings, 1999). Whether snacking is undermining the family, or simply changing the conditions under which families come together, is open to debate: Dare's study of people's food diaries found that most snacks were consumed as a family rather than as individuals (Wood, 1995: 66). Further research suggests that eating out also tends to be done with people from the same household (Warde and Martens, 1998b).

Warde notes that there remains an 'ambivalence' about convenience foods: people who use them are often seen as 'reprobates, people somehow failing in their duties. . . . The idea of convenience food is tinged with moral disapprobation' (Warde, 1999: 518). These images also inform food practices. In Charles and Kerr's study, 'good' food was home-cooked using 'raw' ingredients: it was women's labour that produced its 'moral goodness' (1988: 129–31). Indeed, for the women in their study, convenience seemed to be defined as 'any food which has had work performed on it outside the home' (ibid.: 130). From this perspective, convenience isn't just equated with 'instant' foods such as Pot Noodles but also with sausages. The only ways in which these women could achieve convenience without feeling guilty was to produce home-cooked meals for the freezer. This suggests that the concept of convenience is problematic because a range of different meanings have become attached to it (Warde 1999).

Convenience foods tend to be seen as illegitimate because they are seen to lack the care that produces 'proper' foods. As Warde (1997) argues, people are rarely convinced to buy foods simply because they are convenient because, as this chapter has shown, the meaning of food cannot be reduced to rational calculations about time. The opposition between care and convenience has at its heart ideas about the relationship between private and public spheres. These oppositions form the basis for a series of further antinomies including:

personalized provision against commodified produce; lavishing care against saving time; expressive against instrumental work; particularistic attention against mass provision; and so forth. In each case, the first element of the antithesis conjures up familiar and homely love, the second the cold and impersonal world of capitalist rationalization.

(ibid.: 133)

Warde's study of how advertising and women's magazines negotiate this tension reaffirms this point. Advertisers wishing to sell convenience foods must do so without suggesting that this implies a lack of care. One way of attempting to resolve this tension is by domestic rather than industrial production so as to suggest the product is 'home-made' by another family. For example, an advert for Sacla's Pasta Gusto Red Pesto claims that 'if you're looking for the authentic, home-made taste – with a real strength and depth of flavour to it – make sure you choose the one my family creates'.[8] Should this fail to convince, the advert also contains a simple recipe for 'Creamy Caramelized Onion and Red Pesto Pasta' to show how the sauce can be employed in a 'home-made' meal.

In his sample of recipes from women's magazines from 1968, Warde found that convenience foods were incorporated into recipes. While the magazines of the period showed a concern with the use of home-cooking to demonstrate care, convenience foods in the period came to symbolize 'the modern, the exciting and good' (Warde, 1997: 134). By the early 1990s, convenience became equated not with ready-prepared products but with simplicity, saving time and rationalizing time. This is evident in the *BBC Good Food Magazine* where alongside more labour-intensive recipes for special occasions and entertaining can be found a 'quick and easy' logo alongside some recipes. Each month, near the front of the magazine, and hence facilitating easy access, is the 'Make it Tonight' section offering fast 'midweek' family meals. Simplicity is also stressed in the monthly 'Take Five Ingredients'. By the 1990s, Warde argues, the recipes no longer placed as much evidence on care – 'Family meanings have, apparently escaped from home-made food' – but there is less evidence to suggest that this had translated into practice (Warde, 1997: 138). Nonetheless, while magazine columns stressed ways of saving or rearranging time, they still avoided the word 'convenient' 'lest it offend by implying insufficient care' (1997: 153)

As we argued in the previous chapter, Warde (1999) develops the idea that increasingly convenience is understood in terms of time-shifting through what he calls 'hypermodern convenience devices'. Just as we shift time by programming videos so as to watch a TV show at our

convenience, so we use the freezer to store food we prepare when we have time and reheat at a later date. This also draws attention to the ways in which changes in domestic technologies have an impact on the practice of food preparation. While these are often seen as 'labour-saving' and 'time-saving',[9] for Warde they are better understood in terms of how they allow us to reorganize and re-order time. While it would be a mistake to see technologies such as the freezer as determining how people use them, they do not simply respond to their user's requirements either. 'Although the freezer does allow its users to re-order shopping, cooking and eating practices, the processes of freezing, thawing and de-frosting impose demands of their own' (Shove and Southerton, 2000).

This concern with rationalizing time associated with hypermodern devices can be seen in magazine features such as 'fabulous home-made ready meals' prepared for the freezer in individual servings.[10] Warde argues that this is a response to the fact that the *idea* of the family meal 'retains it value . . . but . . . it is increasingly difficult to organize because of the de-routinization of everyday life' (1999: 520). In this context, the need to reorganize time is a response to the problems of bringing everyone together to eat because of competing schedules. Indeed, DeVault noted that this was one of the tasks women had to negotiate in order to produce the family meal. Warde concludes that the use of hypermodern devices and convenience foods is less a rejection of the idea of the family meal than an attempt to make communal eating possible: 'there is a tendency for far too many people to be too often in the wrong place. For as long as meals presuppose companions, an increasingly complex set of negotiations is required to achieve meeting around the table' (1999: 525–6).

Feminism and cooking

Cooking has an uneasy, and frequently underexplored, position in feminist theory and practice. Within second-wave feminism, cooking (and especially baking) could be pathologized as a sign of a 'traditional' domestic femininity that was at odds with the identity of 'the feminist'. In her recollections of her involvement in the women's movement in the UK, Janet Rée reflects on how she used to act as a 'hostess' in women's group meetings: 'I always made cakes. And tea and coffee, I've always loved making a kind of home. All the peripheral things like cooking and sewing. . . . I might as well have been hosting the Women's Institute' (cited in Brunsdon, 2000: 23). A similar opposition between 'feminist' and 'traditional' femininities – and feminism and cooking – structured

some of the press coverage in the UK of Nigella Lawson's (2000) cookbook *How to be a Domestic Goddess*. For example, Charlotte Raven was baffled by 'Nigella's apparent conviction that the only problem with domestic servitude was the time it took to perfect. Her nostalgia for the side-effects of female oppression – that atmospheric fug in the kitchen – would be offensive if it wasn't so curious' (2000: 5). Suzanne Moore managed to link the book to a call to return to a pre-feminist dark ages of 'back-street abortions, the average woman spending 14 years of her life pregnant or breast-feeding and 14 hours of the day slaving away, cleaning and washing' (2000: 31). If, as Charlotte Brunsdon has argued, 'the opposition feminist/housewife was polemically and historically formative for second-wave feminism' (2000: 216), then in this press coverage, it was quite clear where cooking was positioned (see Hollows, 2003a).

Within academic feminism, cooking has been most frequently discussed, as the contents of this chapter suggest, within sociological analyses of the sexual division of labour. The research by critics such as DeVault is useful because it demonstrates the meanings women bring to providing food and how the labour involved in feeding the family produces feminine cultural identities: the production of the caring subject is a mechanism through which femininity is constructed and lived. Furthermore, DeVault demonstrates how the caring subject is not a singular feminine identity because both the representation, and the practice, of feeding the family is cross-cut by class, ethnicity and 'race', as well as nation, generation and sexual orientation. While her work suggests that the strength of the relationship between femininity and caring makes current gender inequalities resistant to change, this is not to suggest that they are transhistorical or that they cannot be changed.[11]

One of the key features of DeVault's work is the way in which she makes women's labour visible as an economic, social and cultural practice, and demonstrates how it requires both creativity and skill. This is also a feature of French sociologist Luce Giard's work on 'doing-cooking'. Moreover, Giard begins to develop an analysis which sees cooking as a form of popular culture. This is a potentially useful basis from which to develop work on eating in within cultural studies, and, in the process, Giard seeks to reclaim cooking for feminism by rescuing the domestic cook from the image of her as a dominated drudge.

However, in doing so, she uses a narrative of cultural decline which employs some of the tropes of mass culture theory: women, she argues, are becoming de-skilled as more of everyday life becomes taken over by an industrial logic and a proliferation of new objects (blenders, coffee-

machines, microwaves) and pre-packaged labelled foods (complete with nutritional information, sell-by date and so on). For Giard, the skilled and inventive female cook is in danger of being transformed into an '*unskilled spectator* who watches the machine function in her place' (1998: 212). While Giard is critical of 'archaistic nostalgia', and notes that there is still some space for 'micro-inventions . . . to resist with sweet obstinance the contagion of confusion' (ibid.: 213), she ends up reproducing some of the problems of a culturalist form of analysis which ultimately rests on a distinction between an 'authentic' popular culture reproduced in a living tradition of women's culture and an 'inauthentic', mass-produced and industrialized culture produced 'for the people' but not by them (Hall, 1981; Bennett, 1986).

A similar position is adopted in Mary Drake McFeeley's (2001) history of American women's kitchen cultures. Fuelled by what Bourdieu has called a 'populist nostalgia' (1984: 58), the book uses a Missouri farming community of the 1920s to represent 'the world we have lost'. For Drake McFeeley, the 1950s represents a nadir in women's culinary history, a time when the creative and productive housewife in a living kitchen culture was replaced by a deskilled housewife-consumer, marooned in a kitchen where she prepared homogeneous and standardized dishes 'handed down, not from Great-grandmother, but from General Foods' (Drake McFeeley, 2001: 99). While Drake McFeeley's liberal feminism means that she ends on a rather more optimistic note than Giard when she claims that 'we do not need to lose our kitchens to keep our freedom' (ibid.: 169), both critics share a nostalgia for a time before capitalist rationalization and commerce destroyed a living tradition of feminine culinary culture. In this way, both critics' arguments are underpinned by what Rachel Laudan (1999) has called 'culinary Luddism'. As Elizabeth Silva puts it, 'I remain critical of notions of technological innovation in the home as expression of a conspiracy towards a devaluation of essentially womanly activities' (2000: 626).

For critics such as Giard and Drake McFeeley, the modern is presented as 'an alien, external force bearing down on an organic community of the disempowered' and, in the process, they tend to ignore the multiple ways 'the modern becomes real at the most intimate and mundane levels of experience and interaction' (Felski, 2000: 66). Cooking cannot simply be understood as something imposed on women as a result of patriarchal ideology nor can it be understood as the basis for an 'authentic' women's culture. Instead it is necessary to start by examining what cooking has been *made to mean*, exploring how these representations are *lived* and analysing how the relationships between gender and cooking are a site of

struggle and transformation in specific historical locations and power relations.

Feminist critics across a range of (inter)disciplinary fields have, in recent years, begun to reconsider the complex and contradictory meanings associated with gender and cooking, and to trace the continuities and discontinuities in the articulation of cooking, gender, class and ethnicity over time. Much of this work has focused on the relationship between representations of cooking and gendered practices, themes we develop in Chapters 10 and 11 (see, for example, Inness, 2000, 2001a, 2001b; Theophano, 2002). However, work by historians has also begun to trace how women's involvement in feeding the family has not only worked to confine women within the private sphere but also can form the basis for protest and resistance in the public sphere. These may take the form of refusing to consume certain products (see Chapter 12) or in food riots and protests which 'politicize . . . the networks of everyday life' (Kaplan, cited in Bentley, 1999: 42; see also Bentley, 1998; Davis, 2000).

This chapter has considered how the practices of eating in need to be understood in relation to the wider power relations within the domestic sphere. The privatized domestic sphere itself stands in a relation to the public sphere in which eating gains a whole range of different meanings. It is to these issues that we now turn.

9 Eating out

Upon entering one's local multiplex cinema, one might be forgiven for mistaking its primary function. There is a ticket sales area with a relatively inconspicuous listing of the films showing. It is only when one has progressed into the darkness of the auditorium that the main function becomes clear. Before that, in the very spacious and brightly lit foyer, frequently devoid of any cinema-specific paraphernalia, what one is most aware of is food. Ice-cream and pick 'n' mix sweets and soft drinks, and hot dogs and nachos and, of course, popcorn, lots of popcorn. Indeed lots of everything – all of the food seems to be served in gigantic containers – even the 'regular Pepsi'. A striking feature of the contemporary landscape is the endless provision of food outlets which supplement the main activity or purpose of a whole raft of commercial premises. Thus the sports stadium and the leisure and health club, the airport, bus or train station, the museum and the art gallery, the bookshop, the supermarket and the shopping mall may all be placed alongside the workplace and the cinema we began with, to give a strong sense of the range of options currently available for eating outside the home.

Any commercial enterprise of any size today would appear to need to offer some form of sustenance – it is apparently not possible to survive for more than a very short time without snacking. Indeed, Fischler (1980) has claimed that we now inhabit an 'empire of snacks'. Although this is not an entirely recent development, there clearly has been an increase in the volume of foods consumed outside the home. In 1989, Finkelstein predicted that by the end of the twentieth century two in three meals in the USA would be purchased and consumed outside the home (Finkelstein, 1989: 1). A few years later Christina Hardyment, drawing on surveys of food consumption in Britain, estimated that 'meals consumed out of the home' constituted 'almost half of the average household's meal occasions' (1995: 193).

The purpose of this chapter is to explore the meanings and practices of eating out. The particular focus is on restaurant cultures, reflecting popular understandings of the term 'eating out' reported in Warde and Martens's (2000) major research project, in which British respondents very clearly prioritized the restaurant or bar meal over all other away-from-home locations of food consumption. Nonetheless, at this point we should register the wide divergence of eating places available to the consumer, from the Michelin-starred country house restaurant, to the fast-food outlet, to the workplace refectory.

For most people who can afford to dine outside the home, the experience is generally articulated as a source of pleasure, often expressed in contrast to the drudgeries that we have shown regularly attend domestic responsibility. It is an initial premise of this chapter that eating out is a source of pleasure and a favoured leisure pursuit for increasing numbers of people, and much of what follows will be concerned with exploring the pleasures and some of the complex meanings attaching to it. A further premise, however, is that pleasure is neither universally nor evenly associated with the experience of eating out, and we shall therefore proceed to consider some of the tensions and anxieties experienced when eating out is not an unmitigated source of pleasure. This chapter also gives us an opportunity to reflect back on debates about eating in, and evaluate the claim that an increase in eating out might threaten to undermine family values. In the process, we explore Warde and Martens's suggestion that conviviality need not simply be a product of domestic food consumption, but can also be produced in commodified eating situations (2000: 217).

Patterns of eating out

Most people in the UK eat out at least occasionally. The Mintel report *Eating Out* (1999) concluded that 95 per cent of the British population has experience of eating out and/or purchasing takeaway food. Only 5 per cent claimed never to have eaten out, though there was a significant 18 per cent who ate out 'only occasionally'. The report anticipated a total market value of around £20.6 billion by the end of 1999. The restaurant share of this is estimated at £4.5 billion. The report indicates substantial recent growth in the popularity of eating out, with an increase in the restaurant market value of some 23 per cent against the 1994 total of £3.6 billion. Expressing the growth another way, in 1999 the average annual expenditure on eating out per head in the UK was £361, or £6.94 per week, compared to the 1994 weekly figure of £5.83. Steingarten

reports that the average household expenditure on dining out in the USA is around $1,650 per year (1997: 29). (For a history of eating out in the USA, see Levenstein, 1993.) The Mintel survey systematically breaks down respondents into demographic subgroups and indicates very distinctive variations correlating with gender, age, lifestage, regional and socio-economic categories, and the academic work published in this under-researched area draws attention to similar bases for variations in eating-out behaviour (Warde and Hetherington, 1994; Warde, 1997; Warde and Martens, 2000). As Warde and Martens's study suggests, 'the factors most strongly predisposing high frequency of access [to eating out] were, in order of importance, being young, having sufficient household income, having a degree, not being a housewife and not having children under sixteen at home' (2000: 71).

A similar survey conducted thirty years ago would have produced very different results. Eating out as a widely practised leisure activity in the UK is very much a post-1950s phenomenon. Incidence increased gradually during the 1960s and 1970s and then with the 1980s came dramatic expansion. Between the mid-1980s and the mid-1990s it is estimated that the number of cafés and restaurants in London doubled from around 3,000 to around 6,000. During the late 1990s around 50 new outlets were opening each week, and some 33 per cent more meals were served in 1995 than in 1985 (Author Unknown, 1988).

Restaurants are not there simply to feed people. Bell and Valentine refer to restaurant dining as 'a total consumption package – not just food and drink but a whole "experience"' (1997: 125). Atmosphere is arguably as important in the promoting of restaurants as is the food itself. This is reflected in feedback cards in restaurants, where customers are asked to respond to a range of indicators very much wider than mere culinary ones. At the same time, eating spaces have become increasingly striking in design and are staffed by carefully selected people who look and sound just right as proprietors compete to outdo each other in redefining ways in which the restaurant becomes a new way of spending an evening. The increased emphasis on design, style and the consumer experience can be understood in relation to shifts in consumption associated with the move from Fordism to post-Fordism (see Chapter 1). In particular, the rise of the themed restaurant aimed at niche markets; the compounding of food pleasures with other consumer activities; and the increased emphasis on 'experiential' rather than material commodities tie changes in restaurant culture to wider shifts in production and consumption (Lee, 1993). An interesting example, innovatory when it opened in 1997, is an establishment called Dave and Buster's, in Solihull. Part of an attempt by a chain

successful in the USA to enter the British market, the food is essentially burgers and fries and the eating takes place in a large central area. Around the edges of the table are amusement arcades, a 'play for fun' casino, golf simulators, virtual reality systems and championship-style shuffleboard. In short, Dave and Buster's is not simply a restaurant, but, as its own marketing proclaimed, a 'food and fun experience' the 'ultimate restaurant entertainment complex'.

Performance has long been a feature of the restaurant experience. Initially, this resided in the activities of waiting staff. Witness, for example, the flourish with which the cover was removed from the customer's plate in traditional *haute cuisine* restaurants, or the manner in which the cork from the bottle was theatrically sniffed by the wine waiter. More recently, in the UK at least, it has spilled over to include the activities of the chef, where the open kitchen, offering diners the option of observing the preparation process, has become increasingly popular. This could be understood as part of a process by which the visual aesthetics of food have become increasingly important, and the chef increasingly thought of as an artist (Ferguson and Zukin, 1998). At the Connaught in London, for example, there is now a 'Chef's table in the kitchen', enabling those fortunate enough to secure the much-in-demand table to feel very much at the centre of the proceedings presided over by super-chef Gordon Ramsay. This aspect of performance is also discursively constructed: theatrical metaphors have long been a feature of restaurant reviews. The restaurant of the Sharrow Bay Hotel in the Lake District was, for example, in 1995, reviewed as 'a well-oiled machine, stimulating and theatrical . . . the stage-managing is done with tact and grace' (Ainsworth, 1995: 506). The 'total experience' of Sharrow Bay is of course very different from that of Dave and Buster's. The elaborate food is complemented by traditional English country house style. The dining room is formal, with starched tablecloths and high quality tableware. Service is attentive, though not oppressive; there are comfortable lounges with chintzy furnishing for post-dinner coffee; the prices are high. Alan Warde calculated that the average price of dinner for one at Sharrow Bay in 1992 was, at £42, more or less equal to the average household's weekly food expenditure. It was considerably in excess of that of less than averagely wealthy households. In an interesting historical cross-reference, he compares 1992 prices with those of 1968, when dinner in the same establishment cost about £3 per head. In that year the average household spent £6.59 on food, making the cost relative to total food expenditure much lower in the 1960s (Warde, 1997: 107). This indication of what amounts in real terms to more than

a doubling of price provides a further perspective on the upsurge in popularity of eating out.

Roy C. Wood has argued that an increasing emphasis on ambience, design and performance masks the fact that the food in restaurants has become increasingly standardized. 'Any sense of novelty and innovation, or "real" difference, derives from non-food factors, the contexts in which foods are served, and the value to consumers of these contexts' (1994: 12). He continues, 'dining out is increasingly standardized and routinized . . . "Choice", in any meaningful sense of the word, is an illusion, and . . . the very act of dining out is emptied of meaning beyond the passive acceptance of the demands of fashion and convention' (ibid.: 13). As we shall see in the next section, however, there is rather more complexity to the meanings that people bring to eating out than this suggests, and standardization is perhaps less endemic than Wood assumes.

Pleasures of eating out

One of the problems with Wood's approach is that it confers ultimate power upon those who control the restaurant industry and assumes that this determines how people consume the restaurant experience. We can identify a similar tension at work in theoretical debates within cultural studies in the 1970s and 1980s. Up until that point, we would argue, cultural studies tended to concern itself with an analysis of dominant forms of power and their expression in popular cultural forms. After that, however, there was increased recognition that people might employ some degree of autonomy in their choice of cultural forms and that the pleasures they derived from such practices could not be fully accounted for in terms of the transmission of dominant ideas. Feminist scholars carried out much of this re-evaluation, notably in engagements with the pleasures of female consumers of popular romances and soap opera (Ang, 1985; Radway, 1987). In respect of food, there are a number of studies, drawn from disciplines other than cultural studies, that expressly address the pleasures of eating out (Finkelstein, 1989; Hardyment, 1995; Lupton, 1996; Martens and Warde, 1997; Warde, 1997; Warde and Martens, 2000). These studies have an affinity with the cultural studies tradition which treats the issue of pleasure as meaningful, and in doing so allow us to question Wood's analysis. It will be useful here to explore the work of Lydia Martens and Alan Warde who have carried out a series of qualitative and quantitative empirical studies of dining out in three English cities.

Their underlying contention is that the practices of eating out are marked by 'social divisions', 'cultural complexity' and a sense of the

dynamic interplay of meanings around food as a luxury and food as a necessity (Warde and Martens, 2000). Their earlier analysis (1997) of eating-out habits in Preston, in North West England, allowed them to separate out a number of sources of pleasure. Many were to do with simple hedonism: the apparently uncomplicated pleasures of immediate gratification. This places eating alongside certain other activities such as play, sex, singing and dancing which would appear to figure among the most basic sources of pleasure in most cultures. Other pleasures were very closely linked to the perceived quality of the food: prominent amongst these are 'foodie' pleasures; the response of the 'educated', 'discriminating' palate.

For many respondents, the social dimension of eating out is almost always important and would appear to be the most readily articulated source of pleasure. Very few people in Britain eat alone in restaurants – except when they are unavoidably away from home – and it is clear that social contact and quality of conversation are as important as sources of pleasure as is the quality of food. Linked to this, a 'sense of occasion' was routinely reported as important. For many people, eating out is an occasional treat, a special occasion, to be enjoyed as a departure from run-of-the-mill, everyday experience. Frequently it is an event that is saved for, and in this context, the expense of upmarket dining may contribute to the sense of occasion and thus the pleasure. Many restaurants conspire to enhance this sense of occasion.

From a gendered dimension, many women respondents cited a sense of release from normal domestic responsibilities. Not to have to shop, prepare and clean up afterwards, and being served by someone else, are all important contributors to this form of pleasure. Finally, the range and novelty of available choices was a key factor. Again, the reference point is food at home, and the departure from a limited and predictable range of choices was a source of pleasure for many respondents.

One of the strengths of Martens and Warde's work is that they provide detailed empirical evidence of the precise forms of pleasure experienced by diners. Their stress on the importance of eating out as an event suggests that 'the meal symbolizes a socially-significant, temporally-specific occasion' (Warde and Martens, 2000: 217) to their respondents. Furthermore, their research suggests that the conviviality enjoyed in the restaurant is doing little to threaten the communal experience of eating together produced by the family meal. 'There is,' they conclude, 'no necessary conflict between commodified provision and conviviality' (ibid.). These findings not only problematize the work of Wood but also pose questions about the work of Joanne Finkelstein, which we now go on to discuss.

The restaurant as site of incivility

Finkelstein's central and counter-intuitive argument is that, rather than being a source of pleasure, 'the practice of dining out is a rich source of incivility' (1989: 5). An underlying premise is that a condition of 'civility' is one in which people relate to each other openly, spontaneously and 'meaningfully', and are genuinely attentive and responsive to each other's personalities and needs. Finkelstein argues that the coded nature of eating out precludes this kind of engagement. 'The styles of inter-action encouraged in the restaurant', she claims, 'produce an uncivilized sociality. The artifice of the restaurant makes dining out a mannered exercise disciplined by customs that locate us in a framework of prefigured actions' (ibid.). When we follow the rules of eating out we are in effect role-playing, and the roles have been fixed in advance for us to slot into. We then engage in the complex ritual or performance which eating out in sophisticated western cultures has become. Such is the attention demanded by the performance that to relate properly to our companions is impossible, and the end product is the incivility Finkelstein diagnoses.

Clearly then, Finkelstein's argument seriously undermines one of the key pleasures intuitively associated with eating out: the social interaction cited by the diners in Martens and Warde's study is interrogated in a very fundamental way. However, it is surely the case that meaningful inter-action may exist despite, and perhaps even because of, the coded nature of restaurant behaviour. While the presence of a waiter dusting up crumbs at the table might inhibit conversation, it is also possible that once they have departed, their activities might serve to generate new topics of conversation which themselves lead on to meaningful forms of communication. In this respect, those who associate the experience of dining out with pleasurable social interaction are not necessarily deluding themselves in the ways Finkelstein's analysis insists they are. Critiques of Finkelstein's work have suggested that her principal focus is less on the culture of the restaurant than on the formulation of a theory of identity and self (Mennell *et al.*, 1992; Wood, 1994; Beardsworth and Keil, 1997; Martens and Warde, 1997), and certainly we can see connections between her project and Elias's wide-ranging account of the civilizing process, discussed in Chapter 3. For example, as Finkelstein's book proceeds from a case study of dining out into a more general account of 'The Manners of Modernity', it becomes increasingly clear that the analysis is driven by a largely negative reading of the condition of human interaction in advanced western society. Moreover, as Warde and Martens argue, her

'thesis might be criticized for its scant empirical basis, its construction of customers as passive and misguided, and its indifference to the sub-cultural differences of advanced societies' (2000: 6).

While Warde and Martens argue that in general the restaurant is a site of 'conviviality and co-operation' rather than incivility (ibid.: 277), their work nonetheless acknowledges some of the tribulations of dining out. They observe, for example, that 'people at different tables rarely engage in conversation with one another' (1997: 147). More often, the behaviour of people on adjacent tables is perceived as disruptive of pleasurable interaction, when, for example 'their' intrusively noisy con-versation or their cigar smoke is disruptive of 'our' pleasure. One might argue indeed that intrusions of this kind approximate to Finkelstein's incivility and threaten to undermine the fully interactive sociality to which we aspire. Perspectives on civility or otherwise may be a question of the position from which they are made. It may be that in the theatre of dining out others are welcome to observe our performances, but there is no suggestion whatsoever that we take any pleasure from witnessing theirs.

Eating out and 'distinction'

Many of the pleasures discussed above derive from perceived differences between eating out and eating at home, from the occasional release from familiar, everyday, potentially tedious behaviour patterns. In this sense, eating out is the 'exotic other' of eating at home. Another set of mean-ings which depend crucially on perceived contrasts surround the role of eating out in the consolidating of the diner's sense of self and social status. This embraces a range of nuances, from the fact of being seen in the appropriately fashionable restaurant to the display of savoir-faire implicit in being confidently at ease in upmarket establishments. The insights offered by Bourdieu into the role of food culture in relation to distinction have already been discussed in Chapter 4. Warde and Martens conclude that eating out 'continues to operate as a field of distinction, marking boundaries of status through the display of taste' (2000: 226). Indeed, others have argued that contemporary patterns of eating out (particularly within the new middle classes) frequently include strategies of cultural omnivorousness, which value 'variety for its own sake, equat-ing knowledge and experience of the widest possible range of alternatives with a cultural sophistication' (ibid.: 79).

Media discourses concerning those who privilege gastronomic pleasures frequently cohere around the figure of 'the foodie'. For example, *The*

Official Foodie Handbook contrasts the foodie with the gourmet. The latter 'was typically a rich male amateur to whom food was a passion. Foodies are typically an aspiring professional couple to whom food is a fashion. A fashion? *The* Fashion' (Barr and Levy, 1984: 7). While agreeing that foodie-ism was prone to the whims of fashion, Diana Simmonds argues that 'to be a foodie requires self-absorption, self-love, self-delusion, self-confidence; in other words selfishness to a degree unsurpassed in modern times' (1990: 130–1). Although differing in their conclusions, such observers therefore agree that the foodie was a new middle-class figure who reshaped class boundaries in the pursuit of fun and hedonism.

Newspaper restaurant reviews provide a fruitful site for understanding the construction of the foodie. Amongst the most stylized of the restaurant reviewers in the British press is Michael Winner, whose 'Winner's Dinners' column appears in the *Sunday Times*. On 19 April 1998, the restaurant was the Oak Room Marco Pierre White in London's Meridien Hotel, and the review demonstrates some of the ways in which 'foodie' expertise may contribute to the deployment of cultural capital. One notes first the nature of the food cooked by the superstar chef: Winner's first two courses, seafood mariniere with caramelized squid and Cornish blue lobster, represent, especially at lunch time, a level of exoticism more than adequate to distinguish this diner from most others. The main course, pig's head with mash and various types of pork, is robust peasant food, typifying one recent shift in taste whereby rustic food based on inexpensive cuts of meat has become the height of chic. Price is a factor too. Having spurned the set menu, and chosen a half bottle of Mouton Rothschild 1986 from the wine list, Winner unflinchingly forks out £496 for lunch for two. While this may be interpreted as an ostentatious display of economic capital, the review also endorses the purity of Winner's taste in food, thus demonstrating his reserves of cultural capital. The majority of the review, however, is unconcerned with food and, instead, advertises Winner's social capital through discussion of his close relationships with the chef and other celebrities. The article, then, would seem to principally address a readership with aspirations to join an inner circle of foodies (although many readers may refuse Winner's pretensions). In a world in which food culture looms increasingly large in the processes of accumulating cultural capital through the display of a discriminating palate, this review demonstrates vividly some of the mechanisms at work.

Another area where these mechanisms are played out is in the manner in which people behave when dining out. As we saw in Chapter 3, table manners and social etiquette can be important means of conveying

distinction and these codes operate within restaurants just as they do in dinner parties. When eating out we tend to observe conventions governing the order in which we eat different kinds of food, the pace at which we eat, the ways in which we behave towards other diners and to restaurant staff. As Bell and Valentine put it 'every move you make is covered by some sort of restaurant norm, making eating out an intensely structured affair' (1997: 131). Some of Warde and Martens's respondents identified this structuring (being given a menu, sitting down to a meal, eating later than at home) as a source of pleasure (2000: 46).

In the Oak Room review referred to earlier, it is clear that Winner understands the pleasures generated by the codes of eating out. However, Winner's pleasure also comes from the subversion of these rules. He recounts that 'I had dressed in a black jacket and an old silk kipper tie for the occasion. Marco [the proprietor] sat back and looked me up and down. "It's a good job we don't have a dress code or you wouldn't get in," he observed' (1998). Winner is able to dress casually only because he is so absolutely confident of his privileged postion in relation to the codes attaching to dining in smart restaurants.

There is a world of difference between departures of this kind and those grounded in ignorance. Not everybody is as confident when eating out as is Mr Winner, and for many there is considerable anxiety lest one appear to be ignorant of restaurant codes. This is the obverse of the reassuring function of familiar structures. For some people in some circumstances, such structures become tyrannous as they are transformed into minefields of potential embarassment. Warde and Martens's (2000) research identifies non-white minorities as particularly susceptible to this discomfort. Though the general trend in eating out is towards informality and increasingly relaxed regimes, an easy unmitigated pleasure is not the inevitable outcome of an evening eating out for all people on all occasions. The anxieties around dining out take a number of forms, many of which will change over time. Some of these may concern formal and apparently anachronistic aspects of dining. Before arriving in the restaurant, for example, one has to decide what to wear: 'Is there a dress code?' Once in the restaurant: 'Do I have to eat three courses?'; 'Which glass is for red wine, which for white?'; 'Which is the fork for the middle course?' And at the end of the meal: 'How much should I tip?'; or, 'Should I ask if service is included?' Above all, perhaps, how to respond when asked if one enjoyed the meal? To complain or not to complain?

Equally, however, the informalization of manners and dining codes imposes its own anxieties. We might wonder whether we will be over-dressed in suit and tie; if there is bench seating, whether we should sit

next to a stranger; and whether to pour the wine or leave it to the waiter. Informalization is often associated with new cuisines and this can raise a new range of anxieties: for example, over the use of chopsticks, the correct sequence of courses, or what to drink. This explains why Warde and Martens's (2000) research suggests that middle-class diners are far more comfortable in ethnic restaurants than their working-class peers. Distinction, or its absence, is thus conveyed in a number of aspects of the eating-out experience. As the example of the ethnic restaurant shows, it is also predicated on questions of authenticity.

Authenticity and standardization

We have already seen, in Chapters 5, 6 and 7, that issues of authenticity and standardization are central to contemporary food cultures. This extends to restaurant cultures, where the idea of the 'one-off', the 'little gem of a place' which somehow manages to transport a slice of rural Spain, Provence or Tuscany into a British city centre is a recurrent marker of excellence. The quality of the one-off trattoria or bistro is defined by its distance from the standardized offerings of McDonald's or Pizza Hut, and the diner with a sure nose for such quality is making an important statement about his or her good taste. Within this frame of reference, the search is on to continually produce a sense of authenticity. However, the pursuit of new business opportunities is frequently at odds with the demands of 'authenticity'. Two UK examples worth citing here are Belgo, a *moules-frites* and Belgian beer establishment, and La Tasca, a chain of tapas bar. For all their claims to authenticity (the waiting staff dressed as Trappist monks in Belgo, the painstakingly-recreated interiors and music in La Tasca), both are very strongly shaped by the standardization which many of their customers would affect to despise. Although Belgo began life in 1992 as an independent one-off in North London, rapid success and expansion followed and the chain of Belgo branches is now part of a rapidly expanding group which owns several of the more exclusive restaurants in London. Its chairman, Luke Johnson, was himself recruited from the Pizza Express chain. La Tasca has also expanded into a large chain of restaurants throughout the UK. These are just two examples of a growing trend in British restaurant culture. 'The days of the owner-chef are long gone', claims Laurence Isaacson, head of the Chez Gerard chain of 'authentic' French brasserie style establishments, though as we discuss in Chapter 10, this has been met by a counter-trend in which star chefs are increasingly proprietors of their own restaurant. It is probably the case that establishments run along increasingly standard-

ized lines are well placed to deliver their definition of 'authenticity'. It is equally clear, however, that such packages neccessarily divorce authenticity from the sense of the one-off so influential in definitions of restaurant appeal.

In pursuing a somewhat different take on authenticity, the restaurant critic Hugh Fearnley-Whittingstall (1999) provocatively suggests that 'the pleasure derived from dining out decreases in direct proportion to the rising standards of restaurant food generally.' His argument hangs on the pervasiveness of the influence of a small number of influential chefs at the top end of the restaurant business who were substantially responsible for revising both standards and attitudes to food during the 1980s. Subsequently their pupils and later generations of chefs have taken up and refined their styles, so that we now have 'close to 200 chefs running British restaurant kitchens who can trace their tutelage, directly or indirectly back' to a handful of chefs (ibid.). For Fearnley-Whittingstall, the result is standardization, albeit at a high level of achievement – a kind of homogenized excellence leading invariably to disappointment in the diner seeking something striking and distinctive. However, such views need to be approached with caution: Warde and Martens's (2000) research actually suggests that disappointment is rare among diners and Ritzer defends the relationship between pleasure and homogenized excellence (1998: 178). As much of the discussion in this book suggests, not only is authenticity a complex and problematic term, but also consumers' own negotiations of authenticity need to be included in a full account of the phenomenon.

At the start of this chapter we raised the question of whether the commodification of eating threatened the sociality of dining traditionally associated with the family meal. For some critics, this commodification is associated with individualistic grazing, solitary dining and the decline of the family. However, this chapter has argued that the practices of eating out are rather more complex than this pessimistic view would allow. We have argued instead that dining out offers a full range of social meanings, prominent amongst which are the conviviality and sociality that Warde and Martens set against Finkelstein's notion of incivility.

10 Food writing

Representation is a central issue within cultural studies. As John Fiske suggests, 'all representations must have a politics', and it is the task of cultural studies to interrogate the nature of these politics (1989: 191). As we argued in Chapter 4, cultural studies has identified a 'cultural circuit' through which any analysis of cultural forms and practices must pass. We have already demonstrated the significance of processes of consumption and identity to this circuit. Here we concern ourselves with practices of signification. Over the course of the next two chapters, we will be concerned with the manner in which food is represented in two textual forms: in the following chapter, television representations of cooking; and in this chapter, food in print.

The most comprehensive analysis of food writing appears in the work of Stephen Mennell. Mennell draws a distinction between two forms of food writing: gastronomic literature and cookery books (Mennell, 1996). While he associates the latter category principally with domesticity, and therefore with the feminine, he conceives of the former as an expression of a developing public sphere, and therefore as masculine. In what follows, we organize our discussion around these two categories, and address the representational politics which they generate. Following Mennell, we see questions of gender as being central to the textual politics of food writing, but we also identify politics of class and nationality as significant.

Cookery books

It is thought that the first cookery book to be printed was *Kuchenmeisterey*, first published in 1485 in Nuremberg. The innovation soon took off. For example, the first cookbook to be published in France, *Le Viandier*, loosely based on a fourteenth-century manuscript, 'was reprinted twenty-three times by thirteen different publishers in Paris, Lyons, and Toulouse' between 1486 and 1615 (Hyman and Hyman, 1999: 394). As Mennell

explains, by 'the mid-sixteenth century, books of cookery had been printed in most of the main languages of Western Europe' (1996: 65). By the end of the seventeenth century, cookery books were including illustrations of table plans, while *La Nouvelle Instruction pour les confitures, les liquers et les fruits* (1692) incorporated a picture of a fully set table. By the mid-eighteenth century, illustrations of the dishes themselves began to be incorporated (Hyman and Hyman, 1999: 397–9). In today's publishing industry, cookery books occupy a prominent position and often deploy sophisticated design and photographic techniques. As food publisher Anne Dolamore explains, 'most of the large publishers . . . are looking for seasonal blockbusters with chefs or TV personalities who will generate huge sales that will cover advances that can reach up to £100,000' (Kapoor, 2001: 17). When Delia Smith's *How to Cook: Book Two* was published in December 1999 it sold over 110,000 copies in the UK in its first three days (Ezard, 2000). Its precursor, Smith's *How to Cook*, had already topped the Christmas bestseller lists in 1998. Both of these books were launched on the back of accompanying television series, a fact which suggests an important position for cookery books is not simply within the book trade, but within the broader structures of contemporary media industries (see Chapter 11).

Arjun Appadurai has suggested that, in so far as cookery books 'reflect the kind of technical and cultural elaboration we grace with the term *cuisine*, they are likely . . . to be representations not only of structures of production and distribution and of social and cosmological schemes, but of class and hierarchy' (Appadurai, 1988: 3). In order to understand the historical origins of this relationship between cookery books, class and hierarchy, it is worth turning to the development of cookbooks before the publication of *Kuchenmeisterey*. A number of medieval cookery manuscripts are still in existence. Geared towards the diet of the upper classes, the surviving texts have much in common. As Mennell notes, 'the picture is of a common style of cookery, with many of the recipes occurring with little change in several of the texts' (1996: 50). Thus the English manuscript *The Forme of Cury* (1390) includes recipes also found in two French texts, the *Ménagier de Paris* (compiled between 1392 and 1394) and *Le Viandier de Taillevent* (compiled between 1373 and 1380). 'In short,' Mennell concludes, 'there is abundant evidence that upper-class tables in Italy, France and England were furnished according to a common style, with dishes prepared by methods and according to recipes which were common property across the continent' (1996: 50–1).

The advent of print technology assisted in the strengthening of these common culinary traditions. Recipes could now be transmitted more

widely as a set of prescriptive, culinary rules. At the same time, however, as Mennell points out, printed cookbooks also helped to usher in a process of change, allowing improved or improvized versions of traditional recipes to be passed on more rapidly. And since the early development of such books coincided with the emergence of 'a professional elite of cooks in the service of members of the upper class', the pressure to improve and improvize was itself increasing (ibid.: 67). From this point onwards, Mennell argues, we can identify a clear difference between the development of French and English cookery books. 'Cookery seems to have been socially stratified much less markedly in England than in France', he notes (ibid.: 100). As a result, English cookery books tended to have a domestic, female target audience (ibid.: 200). Thus, while French cookbooks tended to be aimed primarily at the professional male chef, the nobility and the upper-middle classes, English books were aimed more at female housekeepers, and more often at lower social strata than their French counterparts.

Mennell's account identifies a connection in English culinary history between cookery books and female domesticity. Other critics have examined the form this relationship has taken in American culture. Jessamyn Neuhaus, for example, provides us with an analysis of the cookery sections found in marital sex manuals between 1920 and 1963, noting how 'they regularly asserted that an important part of being a married woman was cooking and serving the daily meals' (Neuhas, 2001: 96–7). Sherrie Innes has examined the extent to which similar assertions found their way into cookbooks aimed at children. *The Betty Betz Teenage Cookbook*, for example, published in 1953, reminds its readers 'that the good-looking girl who's also a "good-cooking Girl" stands more of a chance of sniffing orange blossoms!' (2001: 37). Jennifer Horner's study of *Betty Crocker's Picture Cookbook*, which was published in the USA in 1950 and remains the second best-selling cookbook of all time, also identifies a traditional construction of women's domestic role. Horner argues that we need to understand this particular cookbook in relation to the postwar realignment of gender roles.[1] The end of the Second World War saw men returning home from battle, and women, many of whom had entered the workforce for the first time as part of the war effort, returning to their domestic duties. In the light of this, argues Horner, the *Betty Crocker* book can be read as an attempt to redefine gender roles in the wake of the upheaval, reaffirming women's domestic role in the kitchen. More than this, however, Horner argues that, in its 'celebration of uniquely American foods and practices' (2000: 338), the book 'symbolically connects the domestic practice of modern women's cookery

to the birth of the United States and, in turn, to the postwar renewal of the nation' (ibid.: 332). In constructing this sense of a renewed, culinary national identity, the recipes to which Horner refers regularly invoke George Washington and the Fourth of July. The book also seeks to incorporate certain forms of immigrant cuisine into this construction, such as Scandinavian and German dishes. The partial, and problematic, nature of this construction is shown by the absence of any African-American recipes, a fact which Horner attributes to a desire to deny the 'problem' of slavery.

As Horner's argument suggests, cookery books can operate as vehicles for constructing an image of the nation, just as they are capable of negotiating certain forms of female domesticity. Appadurai's study of English-language Indian cookbooks published through the 1970s and 1980s provides a detailed analysis of the manner in which an image of 'Indian cuisine' has been constructed. Many of these books celebrate regional culinary traditions. However, they often do so by drawing on 'ethnic cameos'. The author of *Delicious Bengali Dishes* (1975), for example, tells us that 'a true Bengali will eat fish at least once daily and no celebration is said to be complete unless there are a few dishes of fish served in it' (Appadurai, 1988: 16). Alternatively, cookbooks 'invent and codify new, overarching categories which make sense only from a cosmo-politan perspective' (ibid.). Here, Appadurai cites the manner in which books on 'South Indian' cookery are written from a 'northern perspective', collapsing 'the distinctions between Tamil, Telugu, Kannada, and Malayali cuisines', and lumping 'them together as South Indian cuisine' (ibid.). At the same time, a number of techniques have emerged for projecting a sense of a unified, Indian cuisine. Some authors, for example, inflate a particular culinary tradition 'and make it serve, metonymously, for the whole' (ibid.: 18–19). Increasingly, Appadurai argues, books on Indian cuisine also seek to impose a menu-like structure on the recipes they offer. This helps to codify and organize Indian food in a systematic manner but, in so far as 'Indian meals do not normally have a significant sequential dimension', it provides a clear example of the constructed nature of 'Indian' cuisine (ibid.: 20). Appadurai's analysis thus reveals cookery books to be important sites in the establishment of culinary national identities.

What we have seen in this section is that cookery books frequently negotiate issues such as female domesticity and national identity. We now want to turn to two specific cookery writers, Eliza Acton and Delia Smith, in order to examine the manner in which their work might broach similar issues.

From Eliza Acton to Delia Smith

Eliza Acton (1799–1859) published *Modern Cookery for Private Families* in 1845. Claimed by Elizabeth David as 'the greatest cookery book in our language', it remained in print until 1918 (David, 1968: xxx). With Mrs Beeton's *Household Management*, published in 1861, it is one of the key cookbooks of Victorian England, although unlike Mrs Beeton, whose book spans all domestic tasks, Acton concentrates solely on cooking. The recipes in the book are organized into chapters representing different categories of foodstuffs (for example, cakes, bread, pork, baked puddings, and so on), but the final chapter is devoted to foreign and Jewish cookery. Advice on technical skills, such as boning turkeys, cleaning vegetables and making preserves, are offered throughout, and the book breaks new ground by providing precise quantities and detailed instructions for each recipe (David, 1986: 303). Acton also includes a range of recommendations which she applies to particular recipes – 'An excellent receipt', 'Very Good', 'Delicious', 'Cheap and Good', 'An admirable receipt'.

Mennell has suggested that, in eighteenth-century England, cookery books typically drew on a notion of the '"farmhouse" kitchen' for their repertoire; they were written by women, and 'addressed to the gentry and middle class' (1996: 202). As David notes, by the time Acton's *Modern Cookery* was published, 'this rural England was fast vanishing' (1968: xxix). While the title of Acton's book laid claim to the modern, the launch of Bird's Custard Powder in 1840 signalled a development which was to become more representative of modern cookery than the recipes served up by Acton (ibid.).

Mennell identifies two features of food culture among the middle and upper-middle classes in Victorian England. First, there is an increasing taste for French food as a means of expressing social distinction. Acton's book certainly draws widely on a range of French culinary traditions, and she herself had spent some time in France as a child. However, it is also concerned with renewing English traditions. Of the potato, for example, Acton claims 'we can easily comprehend the predilection of an entire people for a tuber' (1968: 135), particularly given its nutritious qualities and its versatility. Nevertheless, she despairs of

> the wretched manner in which it is dressed in many English houses [which] renders it comparatively valueless, and accounts in a measure for the prodigality with which it is thrown away when cold, even in seasons when its price is highest.
>
> (ibid.)

'Why', she asks, 'should the English, as people, remain more ignorant than their continental neighbours of so simple a matter as that of preparing . . . [nourishing food] for themselves?' (ibid.: xxii).

The second aspect of the social elite's food culture identified by Mennell was a trend for 'ladies with social pretensions to remove themselves from any practical involvement in the kitchen' (1996: 211). While this was undoubtedly a possibility for members of the upper class, Patricia Branca has estimated that, by 1871, only a third of middle-class families would have employed a cook, and so the majority of middle-class women were still required to cook for themselves (1975: 55). Acton herself lived among the sophistication of Tonbridge and Hampstead, an unmarried, aspiring poet (Ray, 1968: xxi). In agreeing to publish a cookery book in place of poetry, Elizabeth Ray has argued (ibid.), Acton conferred upon herself the domesticity that was central to notions of respectable femininity in Victorian England (Nead, 1988). *Modern Cookery* is dedicated to 'the young housekeepers of England' (Acton, 1968: xxii), and would have had a broadly middle-class readership, emerging, as John Burnett notes, as 'the accepted recipe book for those of moderate means' (1989: 206). In this light, perhaps its strongest theme is an emphasis upon economy. The 'Elegant Economist's Pudding', for example, is a recipe using up left-over Christmas pudding (Acton, 1968: 244). Elsewhere the book provides recipes for a 'Superlative Hare Soup' (ibid.: 13), alongside 'A Less Expensive Hare Soup' (ibid.: 14), and a range of cheap stews. In spite of this, as Burnett argues, the book also includes a number of rather more luxurious recipes, such as 'truffles boiled in a half bottle of champagne', which would have put 'them beyond the reach of all but a tiny minority' (Burnett, 1989: 207).

If Acton's *Modern Cookery* proved to be a bestseller in Victorian England, then Delia Smith's books have similarly dominated the market in the UK since the 1980s. Indeed, such has been Smith's rise to prominence since she published her first book, *Family Fare*, in 1973, that by 2002 the word 'Delia' had been included in a new edition of *Collins English Dictionary*, referring to 'a style of sensible, perhaps unambitious, English cooking' (Mullan, 2001). Those of Smith's books which most obviously belong to the tradition of Acton and Beeton are the *Complete Cookery Course* (1982, first published in three parts between 1978 and 1981), and the three-volume *How to Cook* (1998, 1999 and 2001), which seek to cover a comprehensive range of kitchen skills and a wide range of recipes. As with Acton's emphasis on economy, Smith is often to be found stressing the importance of moderation, and, along with *Delia Smith's Christmas* (1990), the *Complete Cookery Course* also includes a chapter on

left-overs. The reasons for this emphasis owe as much to questions of health and diet, though, as they do to financial considerations (Smith, 1982: 8). At the same time, Smith defends the use of ingredients such as cream, wine and butter on special occasions (1982: 8). As we have already seen in Chapter 8, by 1995 she is to be found suggesting that 'our current preoccupation with healthy eating has eclipsed . . . [the] very health-giving joy of more traditional cooking, of eating gathered round a table enjoying conversation, good food and good wine' (1995: 7).

In a number of ways, Smith seeks to negotiate the changing nature of domesticity. She explicitly acknowledges the increasing presence of men in the kitchen (1982: 7), for example, while *One is Fun!* (1980) pays heed to the growth in single-living. Meanwhile, Smith's Christmas book notes the difficulties of preparing for Christmas given the pressures of contemporary life (1990: 6). Her repertoire also attempts to synthesize tradition with novelty. This is emphatically so in her *Summer Collection*, which, while emphasizing the seasonal importance of nature, which 'varies our diet beautifully', also advises that 'we are not confined to specifically British recipes: we are tracking summer round the world for new ideas and inspirations' (1993: 7).

For all that there are a number of continuities between Acton and Smith, probably the most important departure is the location of Smith's book in relation to her other culinary enterprises. Most of her texts have been launched to accompany BBC television series, and Smith also writes regularly for *Sainsbury's Magazine*. Along with her website, which provides links to items about kitchen equipment, recipes, menu-planning and online shopping, Smith's books form part of an integrated media package. David Bell and Gill Valentine quote Smith talking about her role in *Sainsbury's Magazine*: 'You can now go into the supermarket and shop globally . . . now, seeing that that's all been made available to us, we can take it one stage further and find out what to do with these ingredients' (Bell and Valentine, 1997: 203). As Bell and Valentine argue, given the prominence of figures such as Smith, whose work spans several media forms, the 'food media's role is thus absolutely central' to the construction of taste and the marketing of particular foodstuffs and kitchen items (ibid.) (see Chapter 11).

As we have seen, then, both Acton's and Smith's work broaches issues of domesticity, economy and tradition. Given Smith's media profile, however, we have obviously come some way from the more humble achievements of Eliza Acton, and we will give further thought to these dynamics in the following chapter. We now turn to the second of Mennell's categories.

Gastronomic literature

For Mennell, gastronomic literature is a predominantly French textual form emerging in the early nineteenth century. At its heart, he identifies a mixture of four elements. First is the discussion of correct practice, the composition of menus and the sequence of courses. Second is a nutritional discourse setting out the health benefits and penalties of particular foodstuffs and modes of preparation. Third is a nostalgic 'evocation of memorable meals' and fourth is food writing which 'is a brew of history, myth and history serving as myth' (1996: 271).

We may ask of Mennell's rather arbitrary schema why he chooses to describe this form of writing as gastronomic *literature*. The theme of correct practice may be found in cookery books and carving manuals as far back as the Middle Ages, while the dietetic component is common also to domestic manuals and medical textbooks. It is therefore unclear how these texts may be usefully distinguished from the cookery book. The third and fourth categories, however, deploy a more evaluative assessment: gastronomic literature is imaginative writing, a genre within the broader literary field which was emerging as a privileged site of creativity during the late eighteenth and early nineteenth centuries (Eagleton, 1983). In this section we therefore consider the characteristics of imaginative food writing in post-Revolutionary France: its deployment of specific aesthetic strategies, the growth of a culinary public whose food choices could be legitimated through discriminatory food writing and the emergence of the gastronome as a masculine type. To ground these issues we analyse the most celebrated work of early gastronomic literature, Brillat-Savarin's *Physiologie du Goût*, first published in 1825. While Mennell's schema offers us ways of interpreting gastronomic literature at its moment of origin, however, it tells us little about the genre's subsequent development. In the later part of the section we therefore consider contemporary versions of the form, focusing on the culinary travelogue exemplified by *A Cook's Tour* (Bourdain, 2001).

We can contextualize the emergence of gastronomic literature through the culinary changes that followed the French Revolution. In particular we note the acceleration of three processes. First, aristocratic kitchens were closed and the guild system of food retailing dismantled. This led many cooks to seek work in the novel space of the restaurant, where they could compete for the custom of a population of diners. Second, Paris consolidated its position as a culinary and cultural centre. The influx of provincial deputies to the National Assembly, and a dramatic increase in the size of the city's population, combined to greatly increase the number

of dining sites. Finally, the nature of the dining public was recomposed into a predominantly bourgeois one. While bourgeois tastes before the Revolution were largely formed in imitation of the nobility, the increased political authority of the middle class after 1789 was complemented by a greater autonomy in their taste-making practices. New food tastes were publicized and diffused through the restaurant, an arena which 'simultaneously defined nondiners as nonelite and marked all diners as members of the elite' (Ferguson, 2001: 13).[2]

How were these developments mediated? Priscilla Parkhurst Ferguson argues that it was essential for 'culinary texts of indirection' to redefine the prosaic activity of dining out as a phenomenon of a higher moral and intellectual order. Texts such as Grimod's *Almanach des Gourmands* (1803) and *Manuel des Amphitryons* (1808), and Carême's *L'Art de la Cuisine* (1833–5) offered themselves as authoritative, universal accounts of cuisine, abstracted from their immediate contexts of production. Let us therefore examine the cultural values at play in an influential text of indirection, *Physiologie du Goût*, a work whose subtitle, revealingly, is *méditations de gastronomie transcendante*.

Jean-Anthelme Brillat-Savarin's life overlapped with the events described above. In 1789 he was elected as a deputy to the National Assembly. After being forced into exile, he lived in Switzerland and the USA until his return to France in 1796. The rest of his life was spent in Paris, with annual visits to his provincial home in the French Alps. Much of this time was spent writing *Physiologie*, a work published only a few weeks before his death in 1826. *Physiologie* may be comfortably accommodated within Mennell's schema and consists of a series of gastronomic meditations with a prologue of twenty provocative aphorisms, most famously the injunction to 'tell me what you eat: I will tell you what you are' (Brillat-Savarin, 1976: 13). It is a work of digression, allusion and shifting tone whose unity is generated through a consistent attitude towards gourmandism, here removed from low-status connotations of gluttony and elevated to a matter of discrimination. While 'animals feed', Brillat-Savarin writes, and 'man eats, only the man of intellect knows how to eat' (ibid.). As we shall argue shortly, the gender of the gourmand is marked, but more prominent here is the correlation between discrimination and class. The culinary values of the gourmand, like the social position of the middle class, are defined against both working-class excess and aristocratic superfluity. In Meditation 19, 'The Dangerous Effects of Strong Liquor', Brillat-Savarin reports a conversation with a merchant complaining of the brandy drinking of workmen. Unable to discipline themselves, the workmen slip from a small glass

each morning through a double dose until they 'are drinking at all hours, and will have nothing but brandy flavoured with infusion of cloves' (ibid.: 351). Death soon follows. By contrast, the true connoisseur practices restraint, for he '*sips* his wine. As he pauses after each mouthful, he obtains the sum total of pleasure he would have experienced if he had emptied his glass at a single draught' (ibid.: 43).

Just as restraint distinguishes the gourmand from working-class debauchery, so simplicity distinguishes him from aristocratic frippery. Brillat-Savarin complains of the culinary refinements which have assumed greater and greater importance 'until they now threaten to exceed all bounds and to become utterly ridiculous' (ibid.: 263). Such extravagances were closely associated with Brillat-Savarin's contemporary, Antonin Carême. Although Mennell makes the case for Carême's simplification of French cuisine, he is better known as the codifier of *grande cuisine*, an aristocratic mode of dining which necessitated the most costly and ornate methods of preparation and display. Brillat-Savarin, by contrast, has little to say on the decorative aspects of cuisine, concentrating instead on basic components of French cuisine (*pot-au-feu, bouillon, potage, fondue*) and ingredients which, even when they are luxurious – such as truffles – are unrefined. Typifying this emphasis on simplicity is Brillat-Savarin's memoire of a turkey hunting trip in the United States. He offers the reader a pastoral image of the bourgeois as a virtuous rural citizen satisfied by simplicity, domesticity and contact with nature. Describing a meal taken during the trip, he limits his comments on the visual appeal of the table to the generosity of the spread and its homely ingredients, 'a superb piece of corned beef, a stewed goose, a magnificent leg of mutton, a vast selection of vegetables, and . . . two huge jugs of a cider so excellent I could have gone on drinking it forever' (ibid.: 77–8).[3]

Physiologie is not, however, a simple refusal of other tastes. Brillat-Savarin makes the case for the gastronome's ownership of the quality of sensuality. The gastronome can devote intellectual and sensory attention to simple food in a way that is unthinkable or objectionable to the mass of people. In describing the correct way to eat a small bird he dictates that one should 'thrust him boldly into your mouth, bite him off close to your fingers and chew hard; this will produce enough juice to wet the whole organ, and you will taste a delight unknown to the common herd' (ibid.: 83). There are parallels here with Bourdieu's work on new middle-class taste, in which bourgeois taste leaders attempt to transgress the cultural boundaries of edibility. The parallels extend to the sensualist's transitional status, caught between a celebration of carnality and a full-

blown aestheticization of food. Yet the class characteristics of this discourse are, for much of *Physiologie*, indistinguishable from its marked masculinity. Although Brillat-Savarin makes occasional reference to female gastronomes, he more commonly elides men's culinary and sexual desires: women are the objects of sensuality as much as is food. Mennell has argued that this sensual approach to the world is comparable to that of the dandy, a new type of public masculinity emerging in the early nineteenth century who was able to take a non-instrumental approach to his consumption choices. He observes that such a figure could only appear in a period of social flux in which residual social codes are still in operation, but emergent codes have not become established as orthodoxy. We have shown that Brillat-Savarin negotiated this moment in post-Revolutionary France, establishing gastronomic literature as a textual form in which the taste judgements and cultural authority of bourgeois men were legitimated and reproduced. In turning our attention to contemporary forms of the genre, we suggest that these forms of social stratification continue to be meaningful, even as they are differently negotiated.

Contemporary gastronomic literature

Gastronomic literature was a rarity in the early nineteenth century, but recent years have seen the genre expand and diversify. Although Mennell's schema continues to be meaningful in those textual forms in which imaginative values cement a range of food-writing styles (for example the magazines *Observer Food Monthly* in the UK and *Gourmet*, *Saveur* and *Gastronomica* in the USA), more significant has been the hybridization of gastronomic literature with other literary forms. A hybrid of romantic fiction and food writing, best evidenced by the work of Joanne Harris[4] has been addressed to a predominantly female audience (Harris, 2000, 2001, 2002), but we concentrate here on culinary adventure writing typified by *A Cook's Tour* (Bourdain, 2000; see also Steingarten, 1999; Richardson, 2000; Stevens, 2001) which seeks out a primarily male reader. We argue that the pleasures and rewards of gastronomic writing have become closely linked with those of travel. Indeed, the two forms of literature have become mutually supportive in representing the cultural dispositions of the new middle class. While this is also true for the food romance, the cultivation of a highly stylized masculine mode of address in *A Cook's Tour* separates it from the feminine traditions of the cookbook and associates it with gastronomic literature.

In recent years a number of authors have argued that travel has been subject to major trasformations based on the rise of a new middle class (see especially Urry, 1990a, 1990b; Munt, 1994; May, 1996). For the new middle class, travel – as opposed to mass tourism – acts as a key means of acquiring cultural capital. Yet this acquisition is not guaranteed, for unique travel experiences are constantly under threat from the incursions of an ever-expanding tourist industry. Jon May points out that independent travel is therefore predicated on a quest for a 'backstage encounter' with 'authentic' people, things and places. Similarly, John Urry has argued that travel is dependent upon the cultivation of a 'tourist gaze' which contrasts the visual and sensual aspects of travel with those of everyday life (1990b: 33).

Anthony Bourdain achieved popular success with *Kitchen Confidential* (2000), a restaurant memoir and occasional travelogue that presents itself as a backstage encounter with 'the culinary underbelly'. The book offers the reader an exposé of business practices and restaurant slang, setting up an opposition between this authentic encounter and the inauthenticity offered by the 'frontstage' world of restaurant dining and television chefs (Bourdain, 2000: 5). The backstage encounter here is closely linked to the emphasis placed on professionalization and accreditation amongst the new middle class. As we shall see in the next chapter, the legitimation of professional practice is a key feature of contemporary culinary culture. Not only does Bourdain legitimate his own professional status through its rough-edged integrity, but *Kitchen Confidential* also offers the reader tips-of-the-trade ('How to Cook Like a Pro') which promise to professionalize the reader.

His follow-up book, *A Cook's Tour*, takes this backstage encounter further by having the author travel to a variety of largely pre-modern locales in search of his own backstage encounter with culinary forms resistant to the assumed homogeneity of American cuisine. Authenticity is doubled as Bourdain's professional integrity is mapped onto the authenticity of others' locality. Speaking to his *sous-chef*, he asks 'to meet everybody's families. I want your mum to cook for me . . . I want to drink *pulque* and *mezcal* and eat *menudo* and *pozole* and real *mole poblano*' (2001: 203). The threat of inauthenticity is dramatized by the Food Network television crew which accompanies Bourdain, making a series of inappropriate taste judgements. Although Urry (1990a) proposes that advance knowledge of a place via its appearance in the media accentuates the sense of sensual pleasure and difference from the everyday, Bourdain disavows this in favour of a celebration of presence and action. Visual representation alone cannot achieve the necessarily

sensual response to cuisine for which the professional gastronome is properly accredited.

As with Brillat-Savarin, this sensuality involves a productive confusion of culinary and sexual pleasures ('It was certainly the best testicle I'd ever had in my mouth. Also the first, I should hasten to say' (Bourdain, 2000: 126)) and a cross-cutting between categories of class and gender. As we argue in the next chapter, professionalization is itself masculinized as well as classed. Similarly, *A Cook's Tour* sutures markedly new middle-class and masculine associations between cuisine, the pleasures of risk and a discourse of action: most of the book's foreign journeys are structured around potentially dangerous encounters with local people, environments and produce (eating potentially toxic *fugu* sashimi or drinking in a Russian Mafia bar), the overcoming of the threat validating Bourdain's edgy masculinity. This masculine coding is further emphasized through the book's deployment of thriller and travel conventions, both of which are predicated on a rejection of domesticity. Just as the title of *Kitchen Confidential* established links between gastronomic literature and noir fiction, so the cultural frame of *A Cook's Tour* is formed by 'Graham Greene, Joseph Conrad, Francis Coppola, and Michael Cimino' (ibid.: 5). Such a masculinization of reference cements gastronomic literature's separation from domestic and feminine traditions.

In this section we have shown that gastronomic literature's marked class characteristics are often indistinguishable from a masculinized structure of feeling. A binary opposition between feminine cookbooks and masculine gastronomic literature is, however, somewhat simplistic. We now address this in relation to a third category of food writing discussed by Mennell.

The 'ill-defined margin'

We have argued that Mennell sets up an opposition between two categories of food writing, gastronomic literature and cookery books. However, he proceeds to identify a certain problem with the scope of these categories:

> there is an ill-defined margin at which the gastronomic essay gradually shades into the cookery book. The more learned sort of cookery book, such as those of Dumas and Ali-Bab, or more recently of Elizabeth David or Jane Grigson might be considered gastronomic literature as much as cookery books. In either case, they seem to be intended to be read as literature.
>
> (1996: 271)

We want to pick up on two of the examples cited here, Elizabeth David and Jane Grigson, in order to explore this observation further. David first came to the public's attention with the publication of *A Book of Mediterranean Food* in 1950. Written during the period of post-war austerity, the book celebrates the food of the Mediterranean, with its 'variety of flavour and colour, and the warm, rich, stimulating smells of genuine food' (1991: 3), as an antidote to rationing. She soon established herself as one of the foremost food writers in Britain, publishing *French Country Cooking* in 1951, *Italian Food* in 1954 and *Summer Cooking* in 1955, to be followed by *French Provincial Cooking* in 1960. She also wrote regularly for *Vogue*, *House and Garden* and the *Sunday Times* in the late 1950s, before working for *The Spectator* in the early 1960s. Invited to write for *The Observer* in 1968, she declined, but recommended instead Jane Grigson, having been impressed by the latter's *Charcuterie and French Pork Cookery* which had appeared the previous year. Over the course of the 1970s, Jane Grigson published a series of critically acclaimed titles, among them *Good Things* (1971), *Fish Cookery* (1973), *The Mushroom Feast* (1975), the *Vegetable Book* (1978) and *English Food* (1974).

Although David and Grigson's writings have been marketed in the form of the cookery book, there is doubtless a considerable erudition to them: many of their books can indeed be read not simply as cookery manuals, but as a form of culinary, historical literature. Such texts seem to fulfil at least two of the criteria Mennell uses in his definition of gastronomic litertature, those of providing a brew of history and myth, and of evoking memorable meals. The chapter on pasta in Elizabeth David's *Italian Food*, for example, not only includes an account of the origins of pasta, but also a lengthy discussion of Marinetti's discourse on futurist cooking (1989: 65). Like David, Grigson's work is suffused with memories: of culinary habits in Northumbria, Wiltshire and Touraine, of apple tart with Wensleydale and hunting for snails (1991: 87, 1992: 26). Their books tend to contain not only extensive annotated bibliographies about their respective subjects, but are also peppered with a diverse range of literary and historical references.

What should be made of this erudite written style? The first point to make concerns the social background of David and Grigson, which in both cases provided them with a high degree of cultural capital, and access to a diverse range of culinary traditions. Both authors enjoyed frequent access to continental cuisine, and inhabited a social milieu where literary pursuits were of central importance. Perhaps of more importance, however, was their position as women writers. Mennell's

analysis of gastronomic literature is particularly striking in so far as all of his examples of its exponents are men. David and Grigson's position in the 'ill-defined margin' is perhaps best explained in relation to the historical development of professional cookery. By the start of the eighteenth century, professional cookery was essentially a male domain, while domestic cookery was considered to be women's work. As we have seen, the authorship of gastronomic literature on the one hand, and of domestic cookery books on the other, reflected this gendered division of labour. Those who pronounced on the finer points of *haute cuisine* were men, while those who wrote cookery manuals for other domestic cooks were women. Further, Mennell suggests, 'it does not seem unfair to describe the food of the nineteenth-century English domestic cookery as rather monotonous, and above all lacking in any sense of the *enjoyment* of food' (1996: 214). Culinary *joie de vivre*, in other words, was articulated in the writing of the gastronome.

While both David and Grigson were able, in the course of their work to combine cookery writing with gastronomic literature, it was not a transition that was straightforwardly accomplished, as a glance at David's reflections on her own food journalism bears out. From 1955 until 1961, David wrote regular articles for the *Sunday Times*, *Vogue* and *House and Garden*. While these frequently revolved around her chief preoccupations in the period – French and Italian food, for example – she nevertheless felt constrained by the format which was expected of her. Having contributed her introductory piece about her chosen subject, she complained, 'you filled the rest of your space with appropriate recipes and that was that' (David, 1986: 9). There was an expectation, in other words, to provide recipes for the domestic cook. Grigson similarly complained that 'the English, like the Americans, are always demanding "recipes"' (Grigson, 1992: xiv). That the ideal recipient of these recipes was a woman was evidenced by their publishing location. *Vogue* and *House and Garden* were specifically aimed at a female readership. Meanwhile, in the *Sunday Times*, David's fortnightly column initially appeared on a page typically surrounded by adverts for women's fashions, a gendering device which became more explicit after the magazine section was launched in 1958, from which point on her columns appeared in the subsection headed 'Mainly for Women'. Grigson also published in the colour supplement section of *The Observer*, distanced from the news section.

It was not until David went to work for *The Spectator* in 1961, that she was able to indulge her interests fully, writing pieces on food issues and food histories where the provision of recipes was not necessarily a

requirement. It is noticeable, then, that it is a publication with a primarily male readership which allowed her to be 'liberated . . . from the straitjacket of the conventional cookery article as decreed by custom' (1986: 9). What this demonstrates is that, even by the early 1960s, the gender divide between cookery writing and gastronomic literature remained institutionalized.

We would argue that this situation can be usefully explored in relation to Alison Light's account of the changing nature of middle-class female domesticity between the two world wars (Light, 1991). Light contends that fiction of the period generated a creeping anxiety about the stultifying effects of the domestic sphere, accompanied by a rejection of traditional, feminine, romanticized forms of discourse in favour of more reticent, masculine discourses of self-control (1991: 209–18). For those writing about food, however, to have represented the domestic sphere in entirely pejorative terms was not an option: this was, after all, the space within which culinary interests could be fully realized. Instead, alternative forms of female domesticity had to be sought. One strategy for achieving this was to dissociate culinary domesticity from other kinds of domesticity. In the Introduction to *Good Things*, for example, Grigson noted that 'intelligent housewives feel they've a duty to be bored by domesticity. A fair reaction to dusting and bedmaking perhaps, but not, I think, to cooking' (1991: 11).

Of interest here is both David's and Grigson's hostility to the manner in which female domesticity is evoked in Mrs Beeton's *Household Management*. The problem with such images of domesticity is that they are too genteel, too frail and too suburban, and this is reflected in the prissiness of the food and the fussiness of the table decorations ('On crisp white hemstitched cloths we see the plated toast racks and crystal butter dishes, the starched napkins and tall *cloisonné* vases' (David, 1986: 306–7)). Mrs Beeton is also chastised for her parsimony. In a recipe for 'white soup', a concoction of fresh veal stock and almonds, Grigson notes Mrs Beeton's suggestion for a 'more economical version . . . using common veal stock, and thickening with rice, flour and milk'. As Grigson complains, 'the decline in English food through meanness is summed up in that remark' (quoted in Castell and Griffin, 1993: 71).

By contrast with Mrs Beeton's fussy domesticity, David defines 'good cooking' as 'honest, sincere and simple' (1966: 8). For her part, Grigson claims that 'simplicity and high quality [are] the standards of a good dinner' (1992: 3). Furthermore, both writers represent the kitchen as a space both public and private, 'the most comforting and comfortable room in the house' (David, 1966: 23), a 'space for talking, playing,

bringing up children, sewing, having a meal, reading, sitting and think-ing' (Grigson, 1991: 13). Cookery, then, is salvaged not only from the frills of nineteenth-century taste, but also from the dull compulsion of domestic labour. It is this desire to take food seriously, an appetite to explore the culture of food beyond the confines of domesticity, which enabled David and Grigson so successfully to occupy the 'ill-defined margin' between gastronomic literature and the cookery book, and to gesture towards the myths, histories and memorable meals which lay beyond the home.

In the course of this chapter, we have examined three traditions of food writing. We have argued that, from medieval cookery manuscripts, to culinary travel writing, to the latest blockbuster television tie-in, issues of gender, class and domesticity remain crucial to a thorough account. We now turn to another form of representing food with a briefer historical trajectory.

11 Television chefs

Following on from our discussion of food writing, this chapter considers how food, and, in particular, the meaning of cookery, is represented on TV. This takes place in a context in which there is a strong relationship between the cookbooks that become bestsellers and television cookery shows: many of the bestselling cookbooks in the UK are written by television chefs. However, as this chapter goes on to explore, if television now plays an important role in mediating how we understand food, cookery also makes an important contribution to contemporary television culture as part of the expansion of lifestyle programming. Therefore, the first part of this chapter examines the relationship between television cookery shows, the television industry and the restaurant business. In the process, we explore how celebrity chefs become 'brands' and how their cultural significance is also related to industrial concerns. The second part of the chapter examines some of the ways in which cookery shows mediate food knowledges and the implications this may have for everyday food practices.

Before proceeding to these issues, it is worth noting that this chapter is written in the context of the boom in television cookery which occurred in the 1990s, amidst a wider boom in lifestyle programming. In the UK, not only are there numerous cookery shows on both daytime and prime-time television on the five terrestrial channels, but there are also non-terrestrial channels devoted to food such as UK Food. Nor is the UK alone in this trend: many countries now have cable channels devoted to food such as the Food Network in the USA and Cuisine TV in France. In this apparent explosion of interest in television cookery, a number of chefs, fuelled by extensive newspaper coverage, have gained 'celebrity status', featuring in magazines such as *Hello* and *OK*. Likewise, just as a feud between rock stars is deemed newsworthy, so was a public disagreement among celebrity chefs as the following report from the 'quality' UK newspaper, *The Guardian*, shows:

Carving knives were drawn again yesterday in the row that has engulfed celebrity chefs. Once again the target was the doyenne of traditional cooking, Delia Smith, while her accuser was Anthony Worrall Thompson. . . . Appearing as an expert witness in a court case, Mr Worrall Thompson said the runny omelette Ms Smith made on her latest television show looked disgusting.

(Wilson, 1999)

In the UK, the press not only fuelled public fascination with celebrity chefs but also attempted to explain the significance of this fascination. Many food commentators incorporated television cookery shows into a wider narrative of culinary decline in which the industrially produced ready-meal had replaced the home-cooked 'proper meal' (see Chapter 8). As *The Guardian*'s food critic, Matthew Fort (1999a), put it, 'We watch the TV series. We buy the book of the series. And to sustain us while we watch or read, we go to the freezer, take out a frozen pizza, bung it in the microwave and make do.' Food, it was claimed, had lost its attachment to a 'living culture' and had become merely 'entertainment': as Nigella Lawson (1998b) explained, cooking 'is the new rock 'n' roll. But despite this, we can't cook . . . food and cooking has become a spectator sport'. (Nigella would launch her own TV series in 2000.) Food commentators drew on the tropes of mass culture theory to condemn the national obsession with television cookery: two products of an industrialized 'mass culture' – television and the ready-meal – were not only guilty by association, but in combination could work to signify an inauthentic culture passively ingested by consumers which threatened Britain's cultural, and culinary, heritage. This narrative also drew on more long-standing negative associations between television and food which had been established in critiques of the 'TV dinner' and TV cookery was condemned by contrasting it to the literary qualities of the types of food writing discussed in the previous chapter.

While the remainder of this chapter examines alternative ways of understanding the economic, social and cultural significance of television cookery shows today, the boom in cookery shows which these articles address is certainly real. A crucial element in this boom is the expansion of these shows in prime-time. While there is a long tradition of prime-time cookery in the UK (and this distinguishes it from the USA), these shows have been primarily thought of as a daytime format, dealing in those 'spaces and discourses conventionally gendered as "feminine" – the personal, the private, the everyday' (Moseley, 2001: 32). The boom in TV cookery – alongside other forms of 'lifestyle' programming such as

gardening, fashion and interiors shows – represents what Moseley characterizes as a '"daytime-ization" of prime-time'. A further feature of the proliferation of shows is an increased genre hybridity in which the cookery show has been incorporated into other formats including the travel show, game show and fly-on-the-wall documentary. As will be discussed later in the chapter, these characteristics have an impact on the ways in which food is mediated on television.

Cookery shows and the television industry

This section, and the one which follows, examine two key processes underpinning the recent boom in television cooks and celebrity chefs. In this section, we locate this boom in the context of shifts in the television industry in the UK and consider the significance of TV cooks as 'brands'. The following section examines how this branding has also become an increasingly important factor within a highly competitive restaurant scene in which there is an increased emphasis on marketing and public relations in order to produce 'celebrity' chefs associated with a 'unique' culinary style.

While this chapter is primarily concerned with contemporary TV cookery, this is not to suggest that the celebrity television chef is a new phenomenon. While cooking was first introduced on British TV in the 1930s, Mennell (1996) suggests that Phillip Harben became the first fully-fledged television chef in the 1950s. Harben, who also wrote for *Woman's Own*, shares a number of characteristics with later celebrity chefs. First, he had a distinctive visual style, a trademark striped butcher's apron. Second, like many later chefs, as a TV celebrity he moved across into other light entertainment formats such as panel shows. Third, as well as writing a string of cookbooks, he also traded on the Harben brand-name when he launched Harbenware, one of the first ranges of non-stick pans in the UK. Finally, Mennell notes, he played a role in expanding food knowledges by introducing internationalized dishes, technological developments such as frozen foods and new ingredients such as scampi (less appetizingly known as nephrops' tails at the time!).[1] In this way, Harben provided a model for later celebrity chefs.

The relationship between television and cookery in the UK has been partly shaped by the public service ethos which has structured the historical development of British broadcasting – 'to inform, educate and entertain'. Cookery has been tied into this ethos in a number of ways. For example, Strange notes how cookery shows have been produced to fulfil specific aspects of the public service ideal: in the 1980s and 1990s,

Rhodes Around Britain was produced by the BBC Education Department and Madhur Jaffrey's *Flavours of India* by the BBC Multicultural Programmes Unit, departments 'working to educational, racial and cultural remits' (Strange, 1998: 306). In a different way, Delia Smith's series, *How to Cook* was promoted by the BBC as a solution to the problem that the British couldn't really cook any more. The show was presented as an act of public responsibility by the BBC: as one spokesman put it, 'A lot of people out there can chargrill a bit of monkfish but have never baked a loaf of bread. We think it will help people who didn't get to do Domestic Science and didn't learn from their mothers' (cited in Boshoff, 1998). Press commentary also worked to cement the public service aspects of *How to Cook*: one critic called her 'the nation's official domestic science teacher' (Lane, 1999) and another noted how Delia was the only TV chef who sought to 'inform and edify' (Fort, 1999a).[2]

However, as was suggested in the introduction to this chapter, the explosion of TV cookery needs to be understood in relation to the more general expansion of lifestyle programming and the 'makeover' format. As Moseley (2001) explains, companies such as Bazal (responsible for programmes such as the UK cookery game show *Ready Steady Cook*) describe their products as

> 'infotainment' and are aiming for ratings, rather than Reithian principles. Nevertheless, in relation to the ethos 'to inform, educate and entertain', public service broadcasting now extends to the care of the self, the home and the garden, addressing its audience through a combination of consumer competence and do-it-yourself-on-a-shoestring-budget.
>
> (ibid.)

While the cultural significance of these shifts is addressed later in the chapter, it is also worth examining the implications they have for the economics of the television industry. First, even prime-time lifestyle programming with high production values is relatively cheap to produce compared to most TV drama (Boshoff, 1997). Second, lifestyle programmes have been used by the BBC to create predictable schedules within prime-time, especially in what the Midlands Television Research Group have dubbed the '8–9 slot' (Moseley, 2001). This kind of scheduling helps to 'stimulate fixed viewer habits' and allows new shows to be launched in close proximity to existing favourites (De Bens, 1998: 33). More recently, Channel 4 has drawn on a similar strategy to sell its lifestyle programming. Third, cookery shows are also produced with a

global market in mind: not only can the global sales of shows be a valuable source of profit, but also increased genre hybridity creates the opportunity to sell light entertainment formats. For example, the format for Bazal's *Ready Steady Cook*, in which two celebrity chefs compete to produce a meal in twenty minutes using ingredients brought in by contestants, has been sold to over ten other countries.

However, cookery shows also offer the television industry the opportunity to create profits from spin-offs across a range of media forms such as books, videos, magazines and CD-ROMs. In such a climate, top TV chefs such as Delia Smith, Gary Rhodes and Rick Stein are increasingly thought of as 'brands'. The BBC has recently shifted from licensing its merchandising to other companies into more actively merchandising its own 'brands' through BBC Worldwide. Delia Smith, the UK's best-selling TV cook, provides a useful case study. As well as producing Delia's TV series, the BBC also publishes her books and videos. In this way, Delia has become an important BBC brand; as Gavin Rupert, head of BBC Worldwide has commented, 'part of the success is having the TV programme going, the book pushed out in every outlet, *Radio Times* featuring her heavily week after week, and *Good Food* magazine featuring her heavily. We were able to market Delia through the [BBC-owned] media' (Barrie, 1999). In this way, the role of TV chefs within contemporary British television needs to be understood in terms of increased media synergy, a term which refers to the way in which, through diversification, media industries can increase the exposure of a celebrity or star: TV chefs become an 'entertainment package' across media forms (Negus, 1992: 5).

This ability to sell TV chefs across a range of media increasingly relies on them having a distinctive brand image which distinguishes from their peers. Some chefs are equated with a distinctive visual trademark style (Gary Rhodes has gelled spiky hair, James Martens wears a bandana), others are identified by an association with nation or region (Jean-Christophe Novelli plays the 'dishy' Frenchman and Bryan Turner the 'blunt' Yorkshireman). However, Jamie Oliver represents the most successful branding of a TV chef to date. Given his first series, *The Naked Chef*, at the age of 23, Jamie is first distinguished by his youth. Indeed, this youthfulness, is signified across a range of elements of his star image: his Britpop clothes, his accessories (mobile phone, Vespa, friends) and, perhaps most crucially, his Essex-boy patter in which food is 'pukka' and 'wicked'. Jamie's style of cooking (unfussy – hence naked) combined with a boundless childlike enthusiasm and excitement reinforce this image: in his words, 'It's not just food, it's socializing, it's having a laugh'

(Lane, 2000). The visual style of the programme also works to cement the image of youthful laddishness: there are '"hard" aesthetic strategies of documentary realism in the kitchen, combined with pop video style outside. The camerawork is rough, edgy, out of focus and continually trying to keep up with events' (Moseley, 2001: 38–9).

In this way, *The Naked Chef* could be described as a 'high concept' programme. Justin Wyatt argues that the high concept movie in contemporary Hollywood is characterized by 'an emphasis on style and through an integration with marketing. . . . The tie between marketing and high concept is centred on a concept that is marketable . . . advertising as a medium of expression is fundamental to the very construction of high concept films' (1994: 23). Indeed, the youthful lifestyle that Jamie Oliver embodies – in scenes outside the kitchen where he parties with friends, drinks cappuccino in a Soho coffee bar, rides his Vespa, brings friends and family into his industrially styled apartment – closely resembles contemporary lifestyle advertising. If advertising encourages consumers 'to employ products in an expressive display of lifestyle' (Lury, 1996: 65), then *The Naked Chef* invites its audience to take a similar disposition towards food and cooking (and presumably the spin-off cookbooks) (see Hollows, 2003b). Indeed, the UK supermarket chain Sainsbury's has since drawn on the visual style of the programme in a series of adverts featuring Jamie and features in-store chiller cabinets where you can acquire all the ingredients for one of Jamie's meals without having to cruise the aisles. In this respect, Jamie Oliver has become a powerful media brand.

Television, restaurants and celebrity chefs

While not all television cooks are also restaurant chefs, the recent boom in cookery shows has seen a far higher presence of the restaurant chef on television screens in the UK. This section examines how the high-level branding of chefs within the television industry is paralleled by a need for chefs to produce themselves as a recognizable brand within a competitive restaurant trade.

Marketing and public relations have become increasingly important within the contemporary restaurant scene as the possession of a 'unique' style and concept has become a hallmark of the successful restaurant chef. The creation of celebrity or star chefs is, in part, a product of the shifts which took place in the work cultures of restaurants in the late 1960s with the emergence in France of *nouvelle cuisine*, a form of cooking which put greater emphasis on the 'visual aesthetics' of dishes (Gillespie,

1994: 21), an emphasis which would also make food more televisual. The rise of *nouvelle cuisine*, Gillespie argues, is also associated with the idea of the chef as an 'artist' who has a distinctive, signature style often linked to a specific concept or market niche. Finally, *nouvelle cuisine* is also associated with the rise of the chef-proprietor: whilst previously top chefs would work for a restaurant owner, they have increasingly opened their own restaurants (see also Mennell, 1996).

For these reasons, Gillespie argues, the new wave of chef-proprietors have 'to juggle to resolve artistic, marketing (especially branding) and financial imperatives' (1994: 21). Given the high capital investment required to launch a new restaurant, celebrity and publicity are necessary to commercial success in a highly competitive restaurant trade. Consumers, on the other hand, are taught to 'understand restaurants as social and cultural markers if they can associate them with the "signature" styles of individual chefs' (Ferguson and Zukin, 1998: 92). This means that chefs must become media personalities in order to gain a high profile and distinctive identity. This has been enabled by 'an explosive expansion of "lifestyle" media and other "critical infrastructure" that disseminate, evaluate and compare experiences of cultural consumption' (ibid.).

The branding of chefs in the television industry is, therefore, also paralleled by the branding of chefs in the restaurant trade. The high-profile prime-time series associated with BBC chefs such as Antonio Carluccio, Rick Stein and Gary Rhodes probably offer the best opportunities to capitalize on celebrity. For example, Rick Stein's TV series promotes the Rick Stein product range: not only does the show sell his restaurant but also

> two hotels, a bistro, a café and a delicatessen which sells Stein jams, Stein chutneys, Stein you-name-it. And for those who want to relive the Stein experience in the comfort of their own home, there are piles of his books and videos, even a CD of the music from his TV series – on sale at all his outlets.
>
> (Middleton, 1997)

Gary Rhodes also provides an excellent case study of the branded restaurant and television chef. While Rhodes is unusual in that he is not a chef-proprietor of his flagship restaurant, City Rhodes, he has been the co-owner of a small chain of Rhodes-brand restaurants. As well as having his trademark spiky hairstyle, Rhodes also has a distinctive and easily identified signature culinary style – he cooks 'modern' British 'classics'.

However, it is not only Rhodes's dishes – modern twists on 'traditional British' fare such as the scone, the shepherd's pie and the Scotch egg – but his entire star image which is built around an attempt to reconcile the opposition between tradition and modernity (Strange, 1998). In this way, the set for the TV series combines traditional wooden beams and a colourful SMEG fridge. Elements of this star image are also reaffirmed through a series of endorsements. His range of 'gourmet' ready-meals were traditional domestic dishes in industrialized form. Sugar manufacturers Tate & Lyle used Rhodes in quirky, poppy adverts to sell a 'classic' British product which he used to produce 'classic' British puds. Rhodes's image was also used by Richardson Sheffield knives, a long-standing company associated with craftsmanship who employ modern technologies in their products. However, despite his association with tradition, Rhodes's image is carefully distanced from the 'boring' and 'domestic' connotations of traditional British cookery: Rhodes has updated the cookery demonstration in a rock-style tour, Rhodes on the Road, accompanied by music, lights and video screens, which give additional opportunities for sponsorship and the merchandising of 'Rhodes-branded cookabilia' (Vaughan, 1997). These factors all contribute to the construction of an identifiable star image which promotes the style of food served up in the Rhodes restaurants and produces Gary Rhodes as an 'entertainment package' over a range of sites.

Other chefs have used television to not only market themselves but to explicitly market the culinary and consumption experiences offered by their restaurants. Channel 4's *The Italian Kitchen* may have featured chefs Rose Gray and Ruth Rogers introducing elements of their brand of Italian cookery but, by locating their series in their restaurant, The River Café, also marketed the experience of dining in their restaurant. The audience saw the chefs at work and customers eating their meals; they also saw the vast amount of effort that went into sourcing the 'best' ingredients in Italy, 'quality' ingredients largely unavailable to the domestic cook attempting to recreate their recipes at home. However, the interest in chefs as celebrities, and the need for chefs to create a 'cult of personality' (Gillespie, 1994: 19), has also resulted in shows which go beyond the cookery format. Channel 4's *Gordon Ramsay's Boiling Point* was a documentary series which followed Ramsay setting up a new restaurant as a chef-proprietor in 1998 having left his previous employment in a blaze of publicity and law-suits.

However, the pursuit of celebrity can also be problematic for the chef. Some TV chefs have used their success as TV cooks to launch careers primarily as TV celebrities rather than as chefs. For example, Kevin

Woodford who is primarily associated with daytime cookery gameshows became a regular feature on travel shows and has co-hosted the BBC's *The Sunday Show*, a religious programme. Too much television exposure, especially in the feminized space of daytime, may increase opportunities for economic profit but can also reduce their legitimacy as a 'serious' chef. Indeed, many of the chefs who achieve prime-time status have refused to appear on *Ready Steady Cook*. This leads to a situation in which television chefs assert that they are 'not a television chef'. Hence, Jamie Oliver claims that 'he's probably spent more time in the kitchen than most of the "slightly wanky, cheffy circle of TV chefs"' (cited in Lane, 2000), and 'I don't want to be seen as a TV chef' (Fort, 1999b). If chefs are to cultivate an image of themselves as an 'artist' (crucial to the legitimacy of the top chefs after the rise of *nouvelle cuisine*) whilst still courting television and book contracts, they must attempt to 'distance themselves from "media sell-outs" like Ainsley Harriott, who, they have been assuring themselves for years, is not a real chef at all' (ibid.). For this reason, they are often keen to play down the economic profits that their celebrity produces: 'I dream of winning the lottery', claims Gary Rhodes, 'I am not a millionaire' (De Bertodano, 1997).

The attempt by television chefs to disassociate themselves from both the medium in which they have achieved celebrity, and the economic profits they have gained from it, is an attempt to assert their cultural legitimacy within the culinary field. The rise of *nouvelle cuisine* was, as we have seen, an attempt to transform the culinary field into one associated with the legitimacy of 'art' rather than 'craft' to produce 'a newly prominent cultural field' (Ferguson and Zukin, 1998: 93). Chefs are people who have invested heavily in the culinary field because of a heavy investment in what Bell (2002) calls 'culinary cultural capital': their legitimacy as arbiters of culinary taste comes from the cultural capital they possess within a specific field. However, as Bourdieu (1971 and 1993) argues, cultural capital does not have the same stable value as economic capital and there is a pressure to convert culinary prestige into economic wealth. Yet at the same time, if the chef shows too much desire for economic profit, this can lead to cultural delegitimization. Since it is the relative scarcity of the chef's skills, imagination and artistry which gives top chefs their legitimacy within the culinary field, they also risk losing their legitimacy if they 'sell out' to 'mass' tastes and the demands of popular entertainment. 'Selling out' can lose them their positional legitimacy within the culinary field which is the source of their cultural power. In this way, a chef's search for a 'mass' audience and economic profit through television in order to increase their celebrity

and economic success as chefs always contains the risk that they will lose respect for their work as 'artists'.[3]

Mediating food knowledges

This section discusses the impact of this new breed of celebrity chefs on the forms of food knowledge, and dispositions towards cooking, which are mediated through television cookery. Television is, of course, not the only source of food knowledge and the discourses about, and dispositions towards, food promoted in television compete with other sources such as family, cookbooks, advertising and women's magazines. For this reason, it would be misleading to attribute any direct effects or impact to television cookery shows (Dickinson, 1998). Indeed, the preferred meaning of food in TV cookery shows may be actively rejected or met with incomprehension as Caplan *et al.*'s research into food choice reveals: as one Welsh farmer put it, 'on the television [food programmes] always they show these things – [they get a saucepan] and they turn it and they pour this in and pour that in – and the only question I always ask is "has the stomach been made to cope with things like that?"' (Caplan *et al.*, 1998: 181). Nonetheless, we can still think of cookery shows as a 'resource', offering 'possibilities, guides and recommendations' about what and how to eat (Dickinson, 1998: 267). Furthermore, as Warde argues, food media may fuel 'the imagination about food, style and pleasure' (1997: 44) and while this might have little impact on cooking practices, it may shape more generally our dispositions towards new ingredients, eating out and the meaning of food in everyday life.

David Bell (2002) has argued that television chefs act as 'cultural intermediaries' who democratize food knowledges and give us opportunities to acquire 'culinary cultural capital' while also displaying their own distinction. However, the ways in which the meaning of cooking is mediated in television shows varies. Niki Strange distinguishes between chefs for whom 'cooking is contextualized as a practical and social skill' such as Delia Smith and others such as Gary Rhodes who present cooking as 'sensual and pleasurable' (Strange, 1998: 310; see also Bell, 2000). This distinction provides a useful way of conceptualizing some of the shifts that have occurred in recent television cookery. This section examines how the presentation of cooking as 'a practical and social skill' maintains a relationship between cooking, labour and the domestic context. However, we want to suggest that this disposition towards cooking has been overshadowed in recent television cookery, associated with the increased visibility of the star professional chef, in which the

meaning of cooking is equated with the 'sensual and pleasurable' and becomes associated with leisure and lifestyle.

Both Strange and Bell associate Delia Smith with the former category and, as was suggested earlier, she is also 'perhaps the ultimate instance of a public service-oriented television chef' (Moseley, 2001: 36). Using her characteristic didactic style of presentation, Delia presents cooking as a skill which her audience can acquire through patience and hard work. For example, in the TV series *How to Cook: Book Two*, she advises the viewer on the necessity of an appropriate store cupboard as one of the foundations of good cooking:

> If you want to drive in life, one thing you have to do is make a commitment to having driving lessons and then you've got spend a little bit of money on paying for the driving lessons. Well, if you want to learn how to cook, in a way the same applies. So welcome to part two of *How to Cook*, how to start off by spending a little time and money on getting the right store cupboard.

In this way, cooking is not only something that, like driving, requires proper supervision, but is also 'contextualized as a practical and social skill'. The comparison with driving also marks cooking out as a mundane, everyday skill, albeit one which should be approached with care and responsibility. Furthermore, Delia suggests that not only are money, time, 'commitment', and labour necessary to acquire these skills, but also that they are indeed 'fundamental to cookery' (Strange, 1998: 302).

Ultimately, Delia's *How to Cook* also emphasizes that these skills will be used in a domestic context: the labour involved is a means of enriching ourselves and those around us through the production and consumption of good food. This respect for 'quality' and doing things in the right manner is linked to a sense of moral responsibility. The following extract from the episode of *How to Cook* focused on bread makes this relationship explicit:

> If you want to improve the quality of your life overnight I can tell you how to do it, quite simply, quite inexpensively, and that is treat yourself everyday to some really good bread: the very best bread you can buy or, even better, home-made bread. Now this [holds up piece of sliced white bread], which is what a lot of people consume, sadly, nowadays, is not really bread: it's damp, it's clammy, erm, it's got no lovely crisp crunchy crust that belongs to good bread . . . and do you really want to eat it? No, you don't. What you really want to do is

value yourself enough to think that you deserve to eat good bread every day.

Not only is the consumption of 'good' bread which is physically, and morally, nutritious presented as a duty, but Delia also uses one of the key motifs of lifestyle programming more generally, the promise that, through making-over our lives, we can also improve the self.

If cooking is presented in Delia's shows as a moral obligation, it is linked to a very different moral obligation in some of the cookery shows associated with the new breed of television chefs: the moral duty to extract fun and pleasure from all aspects of everyday life which is associated in Bourdieu's work with the new middle classes (see Chapter 4). Niki Strange uses Gary Rhodes as an example of a chef who emphasizes the 'sensual and pleasurable' aspects of cooking, commenting on how 'the sensuality of his verbal and gestural registers (he often kisses his fingers and caresses the produce) serves to eroticize the recipes' (1998: 310). Unlike Delia, Gary Rhodes bites into his creations and demonstrates his overwhelming delight at the taste. He assures us of the pleasures of the textures of foods as we feel them in the mixing bowl, the smells that arise from a sizzling pan: it is not just that eating is a pleasure we can give to ourselves and others, but cooking is a pleasure we can indulge on our own. This, along with his constant reminders about 'how easy this is', serve to assure us that cooking is leisure, not labour. In the process, he distinguishes himself from a feminine domestic tradition and, as a professional chef, demonstrates his superiority to it.

This emphasis on the pleasures of food is reaffirmed by emphasis on the importance of the visual aesthetics of food. As we saw earlier, the rise of *nouvelle cuisine* is associated with an increased emphasis on visual aesthetics and this becomes another way in which the television chef can assert their distinction from the domestic cook: rather than looking like plain domestic fare, or the highly decorative fancies associated with a feminine tradition, these new television chefs create highly elaborate creations in which they display their artistry and sense of style by visually demonstrating how each element contributes to a dazzling culinary spectacle. Dishes are 'plated up' or arranged on the plate rather than displayed in the gratin dish or on a plate with an ornamental garnish. Even a simple dish can be used to demonstrate distinction. In his series *New British Classics*, Gary Rhodes makes cheese on toast and transforms it through a display of wit and artistic imagination into a dish which combines stilton with a home-made port and shallot marmalade served on walnut bread with a watercress, grape and apple salad. He then draws

our attention to the importance of the visual as a source of pleasure, inviting the viewer to compose it in a 'rustic style', yet arranging the ingredients with extreme care 'so that we can see every single flavour happening on the plate'.

Just as food programmes have merged with other entertainment formats, so too cookery itself is presented as entertaining. The entertainment and pleasure produced through cooking practices is no longer about producing food that is entertaining for others as a means of demonstrating care: as we saw in Chapter 8, the feminine domestic cook described by feminist theory is one whose food practices conflate 'caring *for* with caring *about*' (Skeggs, 1997: 56). Instead, cooking is presented as pleasurable and entertaining for the cooks themselves, a means of caring for the self. If the care performed by the new television chefs is based around a self that finds food a source of pleasure and entertainment, then this also works to suggest that the care invested in the meal is not a product of domestic labour but 'aestheticized leisure'. Research suggests that this disposition towards cookery is more commonly associated with men who tend to treat cooking as a hobby and turn their meals into 'special events' (Adler, cited in Bell and Valentine, 1997: 73). The self that 'cares for and about' through cooking practices tends to be replaced in the new television cookery by what Mike Featherstone calls a '"performing self" [which] places greater emphasis upon appearance, display and the management of impressions', a self which he sees as associated with the rise of the new middle classes (Featherstone, 1991b: 187) (see also Chapter 4).

This emphasis on cooking as a 'sensual and pleasurable' practice also links in with wider debates about how identities and distinction are increasingly performed through leisure, consumption practices and an investment in the art of everyday life rather than simply through work. This trend can be seen most clearly in Jamie Oliver's *The Naked Chef*. The emphasis on cooking as leisure and about lifestyle can be seen in Jamie's assertion that 'I don't consider the programme a job. I'm just letting people into my life' (Fort, 1999b), despite the fact that he not only is employed as a television chef but during the first series was also working as a chef at the River Café. As was suggested earlier, the imagery in *The Naked Chef* suggests how we can use food, cooking and eating to construct, and display, a particular lifestyle. Indeed, this was picked up in the press's fascination with Jamie: 'He supplies a persona, a way of presenting yourself, an entire package. Jamie's great innovation is to sell people not only recipes but an entire lifestyle' (Maxton Walker, cited in Bell, 2000). Unlike Delia where the food is prepared for no one (except

maybe the camera crew) and remains uneaten and divorced from everyday life, *The Naked Chef* encourages the viewer to think of cooking and eating as part of a wider art of lifestyle. It sells ' a whole lifestyle through a discourse of accessibility and achievability, of a way to be through clothes, looks, domestic space and ways of being a man' (Moseley, 2001: 39). By creating domestic life as sphere of leisure and lifestyle rather than labour, *The Naked Chef* also legitimates cooking as a masculine practice.[4]

Many of today's cookery shows do 'educate and inform' but in a very different way to Delia Smith. TV chefs such as Jamie Oliver and Nigella Lawson do not so much offer primers on *How to Cook*, but instead on how to live. Acting as cultural intermediaries or 'new intellectuals', these television chefs make 'available to *almost* everyone the distinctive poses, the distinctive games and other signs of inner riches' which were previously only associated with an intellectual elite (Bourdieu, 1984: 371). In this way, these shows still 'inform and educate' but the audience is no longer acquiring a basic skill, but is receiving an education in 'the art of lifestyle', on how to perform distinction by gaining pleasure and fun from all aspects of everyday life. The transformation or makeover of the self promised by these shows is significantly different to the traditional forms of moral improvement associated with Delia.

Conclusion

There remains little evidence to date that this emphasis on cooking, lifestyle and distinction in television cookery has much impact on the majority of people's cooking practices. Warde's (1997) research found that, despite class differences in food consumption, the majority of people did not understand their food practices in terms of distinction. Furthermore, while on the one hand, television cookery offers the invitation to make ourselves over into better selves, it may be the fantasy of transformation, the knowledge that we might or could makeover the self, that is itself pleasurable. As Lesley Stern puts it, 'gratification is to be achieved not through the acting out of fantasies but through the activity of fantasizing itself' (cited in Ang, 1990: 86). Given that the kitchen is not only a site of satisfaction but of labour, tension and anxiety, the pleasure of these shows is that they offer a glimpse of a world in which cooking could be a pleasurable activity. To some extent then, television cookery shows need to be understood as 'food fictions, . . . kitchen dreams never actually meant to come true' (Marling, 1994: 231). This is not to suggest that these shows have no impact on everyday food

practices but their significance may well lie in the ways in which they offer new answers 'to the questions "what and how shall we eat?"' (Warde, 1997: 44).

Finally, it is worth noting a contradiction at the heart of these shows for, as David Bell notes, TV chefs encourage us 'to acquire and then deploy culinary cultural capital ... while simultaneously *blowing it*, by giving away those secret knowledges that are used to mark their status' (2000). Fattorini, discussing the case of food journalism, argues that this can cause conflict between restaurant chefs and their customers: lifestyle media construct their audience as 'expert consumers' or 'pseudo-professionals' who believe that their knowledge of food is equal to that of the professional chef (1994: 24–6). This causes resentment within the restaurant trade, Fattorini argues, because the 'motives of the domestic cook (pleasure, enjoyment of the end product, cooking as a leisure activity) are different from those of the professional, for whom food is just one part of the job' (ibid.: 27).[5] Furthermore, without a sense of distinction from the domestic cook, professional chefs not only lose their claims to legitimacy and expertise in culinary matters, but are also threatened by the feminine associations of domestic cookery which, for most women, is also ultimately, work.

12 Food ethics and anxieties

During the last two chapters we have dealt extensively with aesthetic responses to food. However, just as aesthetic aspects of food mediate between people and foodstuffs, so there is a strongly marked moral and ethical dimension to food culture. We have already touched upon this in our discussions of how global food provisioning disadvantages people in the developing world, how domestic food preparation disadvantages women and how certain foodstuffs are distasteful for particular social groups. In this chapter we explore further the ethical dimensions of both consumption and non-consumption, focusing on the example of vegetarianism.

Contemporary ethical consumption is often closely related to heightened perceptions of the risks attached to food. Recent years have seen an accelerated sense of panic as fresh anxieties appear to proliferate. Amongst the most conspicuous scares in the UK have been those concerning salmonella in eggs, listeria in cheese, meat and ice cream, Bovine Spongiform Encephalopothy (BSE, or 'mad cow disease') in beef, and genetically modified foods. In this chapter we consider these high-profile examples in relation to theories of moral panics and their representation in the news media. However, we also consider how concerns about less spectacular issues such as organicism and nutrition need to be understood within wider cultural processes. Central to our analysis will be a critical estimation of the extent to which cultural meanings are dominated by perceptions of risk and anxiety.

What is good to eat, bad to eat, wrong to eat and impossible to eat are, therefore, profoundly cultural questions. In dealing with the nature of food taboos, Mary Douglas has proposed that such phenomena establish cultural boundaries, thereby providing an important means by which a culture maintains or polices its integrity. 'Cultural intolerance of ambiguity', she writes, 'is expressed by avoidance, by discrimination and by pressure to conform' (Douglas, 1975: 53). Beyond the established

limits, foodstuffs and food practices embody danger and otherness. And while there are often legitimate health reasons for the initial establishment of a taboo (see Harris, 1997), such physiological explanations do not account for taboos once they become embedded within a culture: long after foodstuffs cease to pose a medical risk, they continue to operate as a cultural risk. As Douglas states, 'whenever a people are aware of encroachment and danger, dietary rules controlling what goes into the body would serve as a vivid analogy of the corpus of their cultural categories at risk' (1997: 52). This chapter considers the relationship between cultural risks, dietary prescriptions and bodily risks. To examine a particularly widespread practice which cuts across these categories, we turn now to the subject of vegetarianism.

The meanings of vegetarianism

While vegetarianism has frequently been seen as an ethical approach to food consumption, it has also been seen as 'an exercise in the management of anxiety' (Beardsworth and Keil, 1992: 290). Similar points could also be made about an ethical preference for organic or locally produced food. The discussion of vegetarianism as a specific example of moral and ethical food consumption therefore needs to be understood within a wider context of food scares and anxieties. We also focus here on vegetarianism, because across cultures, meat is 'by far the most common focus of taboo, regulation and avoidance' (Twigg, 1983: 18). We note, for example, that even when no proscription is in place against meat eating *per se*, it operates as the focus of moral interdiction: witness, for example, the focus of much dietary advice on the avoidance of 'saturated' (animal) fats.

Nonetheless, a rigorous avoidance of meat or the avoidance of particular meats has a long history. There are deeply embedded associations between religion and the complete avoidance of meat (for example, in Brahminism, Buddhism and Zoroastrianism) while other religions such as Christianity and Islam have imposed proscriptions upon specific meats. Avoidance of meat was typically premised on its connotations, amongst which, reports Twigg, were 'carnality' and 'pollution' (1983: 19). Thus, the tradition drawn from Greek philosophy of 'vegetarian "pacifism"' identified by Montanari (1996: 78) established a relationship between meat-eating and violence, while in Christian religions, this connotation became tied to the idea of meat as pagan and 'leading to an excess of sexuality' (ibid.). As we observed in relation to Douglas's work, these religious taboos have to some extent survived beyond the demise of religion as the principal set of values by which most westerners live.

However, in other respects, the transition from pre-modernity to modernity marks a break with older attitudes towards meat-eating. The *formal* beginnings of vegetarianism in the UK, for example, are traceable to the year 1847 with the foundation of the Vegetarian Society. This institutional development needs to be understood in the context of four key transformations in animal–human relations which Adrian Franklin has identified during the nineteenth century; these being: 'The sentimentalization of animals; the role of the modern state in regulating appropriate civilized behaviour to animals . . .; the demand for animal rights; and the growing significance of animals in human leisure' (1999: 34). For some critics, these changes were themselves the product of a variety of broader social and cultural changes, including the growth of bourgeois culture and the development of the civilizing process during the nineteenth century. For example, Montanari argues that the new bourgeois urban culture had a transformed relationship to animals: as meat became available to a wider proportion of the population, meat-eating could no longer be seen as a sign of distinction. Similarly, Mennell (1996) relates the appeal of meat avoidance in nineteenth-century Britain to the rise of the urban middle classes and identifies it as part of a civilizing process in which there was a trend towards 'animalic human activities . . . [being] progressively thrust behind the scenes of men's communal life and invested with feelings of shame' (Elias, cited in Mennell, 1996: 307). We might cast our minds back at this point to Engels's critical parallels between the Irish and their pigs introduced in Chapter 1. (For a critique of Mennell's position, see Franklin, 1999.)

Franklin argues that the early twentieth century saw a sentimentalization of animals, accompanied by a widespread faith in 'progress', which we can see as a key constituent of the project of modernity. However, from the 1960s, he argues, there was increasing loss of confidence in this teleological and optimistic view of the world. Not only is this period characterized by a number of high-intensity food scares, as we go on to discuss below, combined with increasing perceptions of anxiety about food, but it also coincides with the increased popularity of vegetarianism. In the UK, the Vegetarian Society claims major growth in the movement since the 1970s. Between 1980 and 1995 membership increased from 7,500 to 18,550, and the Society estimated the number of vegetarians in the UK in early 2001 at around 3.5 million.[1]

One of the key ways in which food politics and food ethics became increasingly visible during this period stems from the political radicalism associated with the counter-cultures of the late 1960s and 1970s. Stuart

Hall and Tony Jefferson have noted how the middle-class counter-cultures 'spearheaded a dissent from their own, dominant, "parent" culture' (1976: 62) primarily through ideological and cultural means, amongst which was a resistance to the patterns of cooking, eating, provisioning and thinking about food associated with the 'mainstream'. Levenstein (1993) analyses how, from the late 1960s onwards, there was increasing convergence between the New Left and a growing environmental movement in the USA, centring around a critique of food industry practices. These concerns also reached the mainstream through new media channels: books such as Frances Lappé's *Diet for a Small Planet* (1971) which identified the relationship between US food practices and 'Third World' malnutrition, centred on the pivotal role played by the meat industry (Levenstein, 1993: 179–80). Such representations of food were frequently married to new projects for its production and consumption, many of which were vegetarian, projects such as wholefood shops and vegetarian or vegan cafés, a renewed interest in growing vegetables on allotments and at home, and a 'food-for-free' movement harvesting wild-growing fruit, vegetables and fungi (Mabey, 1972).

If 'health and moral concerns often complemented one another' (Levenstein, 1993: 182) within the food politics of the counter-culture, the growth in macro-biotic and organic diets in the 1960s and 1970s needs to be related to 'a very American nerve', an 'obsession with food and filth' (ibid.: 183). Here, the validation of natural and wholefoods, often linked to 'folk' culinary traditions, was part of a trend to see the body as a temple that should not be polluted by the artificial products of corporate capitalism. In this way they invoked the opposition between culture and nature to sanction the distinction between the edible and the inedible (for more on which see Chapter 2).

It should be pointed out here that not all sections of the population had equal access to these cuisines: 'radical culinary chic' was largely confined to the middle class. (For a critique of the counter-culture's pretensions to 'folk' authenticity, and the connections between 'wholefood' and middle-class African-American 'soul food', see Ross, 1989.) Nonetheless, Klaus Eder (1996) has argued for vegetarianism's anti-bourgeois character, claiming that:

> The carnivorous culture, which has differentiated in modernity into a high gastronomic culture and an industrial food culture, is doubly negated by the vegetarian way of life, which is both anti-industrial and anti-bourgeois. . . . The renaturalization of society contradicts the industrial culture and classed structure of modern societies.

Vegetarian culture articulates a collective need for 'back to nature' against this industrial class culture.

(1996: 136)

However, if, as we have suggested, the shift to vegetarianism in the nineteenth century can be understood in class terms, then so can the dispositions associated with the counter-culture, many of which are now more widely reproduced within sections of the new middle class. Mike Savage has argued that this 'ascetic' lifestyle has been translated from its strong association with the 'alternative lifestyle' of a fraction of the new middle class and has now 'been adopted on a large scale by those with much greater economic resources' (Savage *et al.*, 1992: 113; see also Franklin, 1999). If, in 1937, the English essayist George Orwell, could dismiss the 'food crank' by their association with 'every fruit-juice drinker, nudist, sandal-wearer, sex-maniac, Quaker, "Nature-cure" quack, pacifist and feminist in England' (1937: 152), then our discussion of vegetarianism's recent history has demonstrated how the 'crank' has become part of the mainstream through its association with new middle-class lifestyles. This development bears out the truth of Hall and his co-authors' view that the counter-culture was a vanguard for changes in middle-class production and consumption rather than a fully-blown alternative to bourgeois culture (Hall *et al.*, 1978). In making this observation, however, we do not wish to homogenize all vegetarianism. It is to the friction between different vegetarianisms that we now turn.

The practice of vegetarianism

Vegetarianism is a slippery concept that has different meanings for different people. Such an acknowledgement is implicit in Beardsworth and Keil's claim that, 'it is reasonable to estimate the proportion of self-defined vegetarians in the UK population (excluding young children) at between 4 per cent and 7 per cent' (Beardsworth and Keil, 1997: 225). These authors therefore draw attention to the problem of defining and measuring the extent of vegetarianism. In attempting a count, are we simply to accept the word of those who consider themselves to be vegetarians, or should we seek some objective definition against which to categorize people's eating behaviour? Even if a definition were found, it is difficult to envisage a reliable process of data collection on any substantial scale. If we resort to self-definition, anomalies abound. Many people who think of themselves as vegetarians eat fish, dairy products and even, occasionally, chicken. In a survey conducted by Anna Willetts,

'66 per cent of self-defined vegetarians incorporated meat into their diet' (Willetts, 1997:116), while, for the USA, Steingarten records that around 10 per cent of 'vegetarians eat red meat at least once a week' (Steingarten, 1997: 112). Furthermore, Willetts argues that:

> questions of identity cannot be reduced to the presence or absence of meat in the diet. What is clear is there are no set rules for being a vegetarian, rather individuals define and enact this identity each in their own way.

(Willetts, 1997: 128)

Willetts's study suggests that to assume that 'meat-eating and vegetarianism are representative of two unique and oppositional world views' (ibid.: 112), as was suggested by Eder, amongst others, doesn't necessarily account for everyday practices.

In the light of such diversity we should not be surprised by the range of reasons vegetarians give for their preferred style of eating. As Beardsworth and Keil (1997: 226) point out, few discussions of vegetarians' motivations and convictions distinguish between the reasons people may have had for taking up vegetarianism in the first instance, and those 'rhetorical idioms' they summon in justification of their continuing practice. Donna Maurer has gone some way towards analysing this distinction. She identifies two key rhetorical idioms in vegetarian discourse, 'entitlement' and 'endangerment', although the two may overlap. She argues that entitlement 'emphasizes freedom, choice and liberation while it condemns attitudes and actions that are discriminatory and unjust' (Maurer, 1995: 146). Claims for vegetarianism that emphasize animal rights frequently fit within such an approach, although entitlement also emphasizes the wider enhancement of human life. This is the moral position at the centre of the argument of the animal liberation movement since the 1970s. Philosophically, it questions the assumption that human rights must always prevail over those of animals and argues that basic ideas of equality and justice apply to all species. For example, Singer (1975) draws an analogy between animal liberation and other liberation movements such as Women's Liberation. Indeed, this is taken further in Carol Adams's (1990) feminist defence of vegetarianism, where she argues that the consumption of meat is an essentially masculine activity connoting a dominance of animals analogous to that exerted in patriarchy over women.

A variant of this position focuses not on animals as moral agents in their own right, but on the moral obligation on humans to treat animals

with respect and to desist from the kind of behaviour that regards them simply as things to be exploited. For example, Singer argues that the 'case of vegetarianism is at its strongest when we see it as a moral protest against our use of animals as mere things, to be exploited for our convenience in whatever way makes them most cheaply available to us' (1998: 77).

Maurer's second rhetorical idiom, 'endangerment', tends to concentrate on health, 'adopting a more scientific style, these claims focus on the potentially health-damaging claims of meat consumption and on the increased number of people who can be healthily fed when few resources go to animal agriculture' (1995: 147). There is a clear connection in contemporary society between vegetarianism and the health food movement premised on an assumption that the vegetarian diet is intrinsically healthier than non-vegetarian alternatives. Reference is made to medical research which links the consumption of red meat to heart disease and various cancers. It is further argued that the highly processed quality of many meat products renders them less 'natural', and therefore by common association less healthy, than the relatively unadulterated fruit and vegetable alternatives. Finally, the susceptibility of meat products to bacterial contamination (as in recent E. coli outbreaks in the UK) further endorses the links between vegetarianism and healthy eating and becomes linked to healthy lifestyles and the management of anxiety.

Just as there is a bodily dimension to the endangerment argument for vegetarianism, so there is a link to broader questions of ecological health. Vegetarians frequently argue that the rearing of animals for meat is wasteful of the planet's natural resources. Singer observes:

> Animals raised in sheds or on feedlots eat grains or soy beans. . . . To convert eight or nine kilos of grain protein into a single kilo of animal protein wastes land energy and water. On a crowded planet with a growing human population, that is a luxury we are becoming increasingly unable to afford.
>
> (1998: 78)

The argument is one about the distribution of wealth and resources. While the underprivileged have insufficient to eat, wealthy westerners waste food on feeding the animals which are destined to become the food of the privileged nations. Endangerment here overlaps substantially with entitlement.

But just as there are many overlapping concerns, so there are also many tensions between these contrasting justifications of vegetarianism.

Keith Tester (1999) points to important contradictions in his distinction between 'ethical' and 'lifestyle' versions of vegetarianism.' Lifestyle vegetarianism shifts the emphasis away from the integrity of individual moral choice on to the rational assessment of the risks to health and well-being that underpin many of our food choices. Clearly such assessments are themselves not entirely without integrity: Tester draws on Anna Thomas's formulation 'enlightened self-interest' (cited in Tester, 1999) in distancing this version from self-interest of a more crudely materialistic nature. And yet at the heart of versions of vegetarianism which aspire to eat healthily is a set of concerns which focus on the self rather than the social. This partly explains the ease with which vegetarianism has entered the mainstream in recent years. Beardsworth and Keil coin the useful phrase 'menu pluralism' to characterize a food culture in which increased variety, choice and flexibility have been key markers of developments in recent decades, and in which vegetarian foods take their place among the range of options open to consumers (1997: 239). Increasingly we need to register the existence alongside *the vegetarian* (of varying levels of strictness) of *the individual who frequently eats vegetarian food*.

Tester contrasts the purity and integrity of the ethical strand with the relative easiness and popularity of the lifestyle version. There is a close relationship between this proposition and our earlier observation that what once appeared marginal within middle-class culture has become an established feature of new middle-class lifestyles. However, Tester draws our attention to the fact that this transition has not been a seamless and conflict-free process:

> The argument which stresses enlightened self-interest is perhaps the aspect of vegetarianism least close to any criteria of an ethical standard of life . . . the ethical dimension . . . is cut away and all that remains is a dietary form which promises to offer some kind of insurance against the risks generated by factory farming and other technological processes.
>
> (1999: 217)

Such debates return us to wider questions about the role of food in relation to a widespread loss of faith in the project of modernity. Focusing on this issue, Nick Fiddes (1997) locates the discourse of vegetarianism within debates about the relationship between humankind and the natural world. Fiddes suggests that meat eating has operated as a symbol of people's domination over animals and the rest of the material world.

The current vegetarian and animal rights debates, he believes, reflect increasing contemporary uncertainty about this relationship of mastery:

> Animal concern has been always at least partly a metaphor for other social discourses . . . Beneath the modern animal exploitation debate lies another hugely unresolved but increasingly pressing issue which concerns the entire basis on which humanity should behave in relation not only to the rest of the human species, but also towards the natural world as a whole. This debate . . . is essentially the cultural crisis of the late industrial era.
>
> (1997: 259–60)

Fiddes's argument suggests that the current climate is not simply one in which fundamental reappraisal of this relationship is in progress, but that actual transformations have occurred. One example he explores is a shift in public attitudes to science. Formerly a prime agent of human mastery of the planet, and as such generally held in high regard, science no longer enjoys such unconditional esteem. Fiddes points to the para-doxical situation in which heightened levels of suspicion and distrust of scientists seem to have developed alongside the increasingly comfortable lifestyles delivered by science and technology. He observes that:

> A new scepticism . . . may not reject science wholesale, but does recognize that its self-serving and self-referential agendas and distorted representations belie its claims to objectivity, and have contributed to some of its . . . catastrophic consequences.
>
> (ibid.: 260)

In this section, we have therefore argued that the meanings brought to vegetarianism are complex and not always compatible with one another. Where they *do* cohere is in their suspicions of the price paid for society's investment in modernity. In the following section we will consider the implications of ideas analogous to those of Fiddes for the broader food culture. We therefore move our discussion away from vegetarianism towards wider food anxieties.

Food and risk

This section builds on the ideas above about scepticism concerning the impact of the project of modernity, to explore the notion that we are now living in a 'risk society' in which anxieties about food are endemic.

However, anxieties about food are not new. Claude Fischler (1980) argues for the physiological basis for food tastes. He notes an 'omnivore's paradox' in which humans maintain a wide-ranging diet by searching for new forms of food but are equally aware of the potential dangers posed by this quest for novelty. While Fischler identifies 'neophilia' as a favourable reaction to unfamiliar foods, this is accompanied by 'neophobia', which sees the new in terms of danger, rejects the unfamiliar, and falls back on familiar and 'safe' foods. Current examples of neophobia are frequently seen in holiday-makers' rejection of indigenous foods as 'dangerous'. Here, safety invariably equates with familiarity and may well be at odds with more scientific definitions of terms. Anxieties about food and safety do not always follow rational trajectories as we will subsequently discuss in our analysis of media food scares.

As the example above demonstrates, globalization, with its attendant increase in travel and movement of exotic foodstuffs, may be seen to have heightened our perception of food risks. As we argued in Chapter 6, globalization is associated with an increasingly expansive and mobile mode of production and consumption; with an intensified sense of interconnectedness and interdependence between places; with environmental changes; and with the increasing saturation of societies with scientific and technological change. These developments have been seen by the sociologist Ulrich Beck as forming a qualitative shift from previous patterns of risk to produce a new social condition, what he terms a risk society. Beck notes three reasons behind this shift. First, modern risks are largely invisible. Second, they have their basis in industrial overproduction. Third, they jeopardize all life on earth (see Caplan, 2000a). However, neither the experience nor the understanding of risk is homogeneous. Not only are some subordinate social groups more 'at risk' than others, but it is frequently the highly educated middle-classes who experience themselves as being most at risk and who have a heightened sense of anxiety. 'Risk society is characterized by the contradiction that the privileged have greater access to knowledge, but not enough, so that they become anxious without being able to reconcile or act upon their anxiety' (Lupton, 1999: 69).

An example of these processes in action is given in Pat Caplan's (2000b) analysis of the two 'mad cow disease' crises in the UK. Though the first occurrence of BSE was as early as 1984, significant public concern was not apparent until late Autumn 1987 when both the press and television news ran stories relating to 'a mystery brain disease'. It was during 1988 that the possibility of transference of the disease to humans was first mooted, and although the majority of expert opinion at this

stage was reassuring, concern intensified to crisis levels in 1989–90 when Germany banned the importing of British beef products and in the UK many kitchens in schools, hospitals and other institutions removed British beef from their menus. In an attempt to restore public confidence, the Agriculture Minister of the day was shown on television feeding his four-year-old daughter a hamburger. Between 1991 and 1996, media interest lessened considerably and the official line remained that there was no danger to humans. In 1996, however, the Health Minister announced formally that a new strain of Creutzfeldt–Jakob Disease (CJD) had been discovered and that there was a strong likelihood of a link with BSE: this provoked a more intense scare lasting several years, and spilling outside the UK to the cattle herds of other countries.

Caplan records that different regional populations experience these crises in diverse ways. In line with Beck's thesis, informants from London appeared to regard risk as a 'universalized' condition in which social factors such as ethnicity, gender, age and class had little impact (although wealthy middle-class respondents were the group most likely to change to an organic meat diet) (Caplan, 2000a: 190). This corresponds with Bhattacharyya's argument about European attitudes to BSE where 'public fears demanded that this fresh evil be exorcized at source. People began to doubt the power of science and instead looked to magic for protection' (Bhattahcharyya, 1998: 59). However, Caplan's informants from West Wales had a much more specific sense of risk. Rather than the threat of BSE being a general one, these respondents could find certainty in a local knowledge of 'where the meat had come from, under what conditions it had been produced, and, above all, knowing the person who sold it' (Caplan, 2000b: 193). Caplan's empirical research therefore casts into some doubt the universal character of Beck's thesis. As Caplan herself notes, however, individual perceptions are only one element of a food scare. Her respondents identified the media as playing a major, often untrustworthy, role in the production of the scare and it is to this that we now turn.

Media panics and food scares

Beardsworth and Keil (1997: 163) attribute to the food scare a recurring shape, in which a sequence of events unfolds in a more or less standardized sequence. They argue that the typical food scare follows five stages. First, an '"equilibrium" state' exists where there is little sense of any potential risk amongst the public. Second, the public become aware of a potential food risk. Third, concern mounts as 'various arenas of

public debate' highlight the risk. Fourth, the public react to this newly heightened sense of risk and this may impact on their food practices. Their reactions may be out of proportion to the 'real' threat posed by the foodstuff. Finally, interest wanes and the food scare is no longer potent (although, 'chronic low-level anxiety may persist, and can give rise to a resurgence of the issue at a later date') (ibid.).

This attempt to identify a common structuring of food scares resembles attempts by sociologists to characterize such related cultural phenomena as 'moral panics'. Stan Cohen defines a moral panic as a periodic event in which specific issues or groups 'become defined as a threat to societal values and interests' (1993: 9). Central to this process, is the role of the media. Cohen observes that the media presents the panic in 'a stylized and stereotypical fashion'. By defining and shaping the nature of the threat, the media have frequently been seen to not only create but also amplify the sense of panic. These panics are never entirely isolated: as Kenneth Thompson argues, 'moral panics tend to appear in groups rather than singly, and . . . are related to wider anxieties and social contextual factors' (1998: 20). A sense of these 'wider anxieties' is essential if we are fully to understand the cultural significance of scares about beef.

There is a growing body of literature addressing the media's coverage of food scares (Mitchell and Greatorex, 1990; Beardsworth and Keil, 1997; Reilly and Miller, 1997; Macintyre *et al.*, 1998; Reilly, 1999; Eldridge, 1999). Though much in this work confirms the role of the media in both reporting and shaping food scares, there is little to support the proposition that food scares are *primarily* media constructions. More typical is the view that several agencies are involved and that the scare is the product of a four-sided dialogue involving media professionals, food producers, regulators and the public. Nonetheless, the role of the media is an important one and may be approached from two points of view: that of the *production*, and the *reception* of media messages.

Though it is clearly the case that primary responsibility for the production of news content rests with media professionals, one should not overlook the influential role played by their sources. In relation to food scares in the UK, key sources of information have included such government departments as the Department of Health (DoH) and the Ministry of Agriculture, Food and Fisheries (MAFF) (subsequently the Department for Environment, Food and Rural Affairs, DEFRA). For some years, MAFF was able to excercise substantial control on the flow of news. During the first BSE crisis, MAFF retained substantial control of the appointments to the various committees of inquiry that were established, and these in turn supplied a good number of the experts

consulted by the news media (Reilly and Miller, 1997). This is not to argue that news flow was determined exclusively by MAFF. The significance of its role is clear, however, and reminds us that it was not the media professionals alone who shaped the coverage of the BSE scare. Indeed, other agencies had a role to play, including the National Farmers' Union and, during later scares, the Countryside Agency.

The representation of food scares is also mediated by the media's own internal practices (although there may be differences between media forms). There is very clear evidence that media coverage of food scares is shaped by press and television perceptions of 'news values'. Macintyre *et al.* (1998) noted five news values which were very strongly present in the coverage of the salmonella and BSE scares and also in coverage of the connections between diet and coronary heart disease. The values identified were 'scientific advances', 'divisions among experts', 'matters of state', 'division in the government' and 'government suppression' and the research identified differing levels of prominence attaching to individual news values across media outlets. Thus, in coverage of heart disease, the tabloid press favours those story lines featuring disagreement between experts, as in the headline 'Fatty food not a killer' (*Daily Express*, 23 December 1991) and the implied reader addressed is the ordinary person impatient at being offered no consistently reliable guidance by the experts. In the liberal broadsheets, on the other hand, government suppression has been especially prominent, as in 'Scientists do an about-turn over polyunsaturates' (*Sunday Times*, 3 September 1989). Again, the point of view adopted is that of the public 'let down', but this time by a government whose political agenda, divided loyalties or indecision impedes the conducting of exhaustive and objective scientific enquiry (Macintyre *et al.*, 1998: 236–7).

We now go on to explore the study of the reception of media reporting of food scares. Rather than assuming that audiences are passive recipients of media messages, Macintyre *et al.* (1998) explore how audiences negotiate responses to media reporting of food-related issues. Most respondents in their study supported the suggestion that it was primarily media coverage which alerted people to issues of food risk and safety. However, like Caplan, they found considerable diversity among people's perceptions of the role of the media and the nature of the risk.

The research noted a higher level of sensitivity to dangers among women than men; a tendency for those whose work was food-related to be critical of 'media-induced panics'; and a link between responses and personal experience of food related health problems. The researchers also drew attention to the high incidence of scepticism about the advice

offered by experts in relation to food scares. There is evidence of a stage beyond the confusion experienced in the face of conflicting messages, in which people become impatient with all expert advice and rely instead on personal decisions based on familiar eating practices.

An analysis of the *Independent on Sunday*'s portrayal of responses to fears about genetically modified (GM) foods offers further understanding of some of the discourses through which people make sense of food scares. On 14 February 1999, the newspaper devoted a whole page to readers' letters on the subject and five major themes could be identified. First, choice emerged as a key theme: 'I demand the choice to be able to protect my family', one reader claimed. This concern about choice relates to both a wider suspicion of expert knowledge and a lack of autonomy. Second, one reader's request for 'easy identification' and proper labelling reflected a desire to be informed. Third, these anxieties were linked to a call for environmental responsibility: as one reader put it, 'For nature's sake a total ban is the only acceptable outcome'. Fourth, this closely relates to fears about 'meddling with nature'. Two familiar assumptions are implicit in this theme: that foods that are unmodified are 'natural' and therefore inherently preferable to manufactured products and that science unrestrained is not wholly beneficial. Finally, readers demonstrated suspicion of multinational food corporations like Monsanto (the biotech giant heavily involved in GM research and at the centre of the scare during 1999): 'Will the big food corporations run the world?' one reader asked. These issues raised by readers relate back to some of the key debates underpinning vegetarianism and ethical consumption. As Matless argues, 'as the status of Nature and the distinction of organism and mechanism, human and machine, becomes ever less certain, organicist thinking gains popular appeal by offering a solid, natural, moral ground' (1998: 281).

In this section, we have demonstrated that media representations contribute to a climate of anxiety and risk but do not determine how people understand it. Indeed, people bring a range of complex food meanings to situations of risk. While some of these responses intensify the experience of anxiety, more typical is the attempt to re-embed knowledge through experience. As Stassart and Whatmore argue, 'in "hot" situations like food scares, when the landscape of competing knowledge claims is at its most molten, consumers rely heavily on experiential knowledge that reinforces ontological continuities between human bodies and those we eat' (2003: 460). In this way, the discourses through which people make sense of risk bear a close resemblance to those discourses underpinning the rejection of meat.

Dieting, anxiety and the body

If theories of risk suggest that people increasingly experience a sense that they lack control over the food they eat, then questions about dieting raise other issues about the desire to control food intake. Anxieties about eating have traditionally been associated with women, and the increased visibility of eating disorders has frequently been the focus of moral panic. While the media has been demonized for its portrayal of excessively thin female body shapes, the mechanisms by which representations of femininity translate into embodied identities are clearly more sophisticated than this would suggest. As Susan Benson argues, disordered eating needs to be understood as 'a complex response to the demands and constraints of contemporary femininity, involving both complicity with, and rebellion against, cultural norms around the gendered body' (1997: 124). So, for example, while eating disorders have often been seen as a *loss* of control over the body, Lupton argues that anorexia is better understood as 'a technology of self-control and purification' where eating represents a descent into chaos (1996: 133). Drawing on the work of Susan Bordo, Lupton suggests that 'Hunger is experienced as a temptation to lose control. ... The denial of hunger' becomes a 'sign of triumph of the will over the body' (ibid.: 135).

Nonetheless, if gender has been an understandable focus for discussions of dieting and body image, gendered bodies are cut across by other forms of social differentiation. While issues of control and discipline are central to understanding eating disorders, they also underpin wider anxieties about the body. These anxieties cohere around a widespread concern with dieting and exercise in contemporary society. The body has increasingly become an important means 'for conveying self-identity, for it is deeply implicated in the performative and cognitive aspects of class, gender and generation' (and one might also add 'race') (Warde, 1997: 96). Therefore, if the slim body equates with an idealized feminine body, our bodies are also sites where class habitus is given a material form. If the fat and 'excessive' body signifies a self which is out of control, then this inability to control the body has frequently been associated with lower social classes. By contrast, the middle-class body is associated with the restraint and control that both Bourdieu and Bakhtin identify with bourgeois eating practices.

As a number of critics have noted, however, this does not necessarily mean that dieting indicates asceticism. Indeed, as Joanne Entwistle notes, dieting is increasingly seen in terms of increasing, rather than denying, pleasure: 'Asceticism has been replaced by hedonism ...

discipline of the body through dieting and exercise has become one of the keys to *achieve* a sexy, desirable body which in turn will bring you pleasure' (2000: 20). For Mike Featherstone (1991b), who describes such an approach to diet as 'calculated hedonism', these dispositions are particularly associated with the new middle classes who refuse both the asceticism associated with the traditional bourgeoisie and the indulgence associated with the traditional working class. These groups are characterized by their ability to swing from the restraint and discipline associated with diet and exercise to the hedonistic pleasures of self-indulgence.

Although Featherstone is surely right to highlight the pleasures of self-discipline, such body projects are rarely entirely satisfying: the constant self-regulation and policing needed to maintain the sexy body are sources of displeasure and unease. Benson argues that this 'self-regulating self' is further caught up in anxious contradiction with the values of contemporary capitalism, which she describes as 'wanting it all, having it all, acting on impulse' (1997: 137): the disciplined body is at odds with a hedonistic body that is constantly consuming. For Susan Bordo, the disordered body then becomes a means of managing these contradictions.

Yet while some critics see these contradictions as irreconcilable, the promise of many diets is precisely to resolve such ambiguities. One of the most high-profile diets is the Atkins Diet, which first found success in the 1970s, and resurfaced in the 1990s, replete with a rash of celebrity endorsement. The diet eschews much conventional nutritional wisdom, waging war on carbohydrates rather than fats and encouraging the consumption of protein. In this way it condones many indulgent foodstuffs such as bacon, steak and cheese, which other diets vilify. However, the diet, along with similar programmes such as the Montignac Regime and the South Beach Diet, has been portrayed as one for rich westerners: the consumption of luxury foodstuffs is not morally censured and meat production is environmentally wasteful and disadvantages the developing world. Nonetheless, Atkins and similar diets enable indulgent and hedonistic food consumption to be married to the fantasy of achieving an attractive body. As a result, the rise of these diets sits alongside the rise of the new middle classes with an aesthetic based on calculated hedonism.

More generally, Warde's antinomy between health and indulgence gives some sense of the more widespread contradictions in cultural constructions of contemporary eating. His analysis of British women's magazines identifies how they recommend 'dishes both because they promise good health and because they indulge physical and emotional cravings' (1997: 96). Therefore, it is unsurprising that self-control over

eating can generate a great deal of anxiety. If the desire for a slim body, 'may constitute a source of anxiety and self-disgust on the part of some people in some contexts', the examples we have discussed earlier also suggest 'the successful exercise of control over one's diet may also provide a source of satisfaction' and pleasure (Lupton, 1996: 142).

In this final section, we have highlighted how food anxieties are brought to bear on the body; how they are experienced intimately and as part of our sense of self. But these issues too might be seen as reflexively related to broader categories of risk. Our example of the Atkins Diet, which promises the appearance of a healthy body, has also been seen as a threat to health and is associated with a range of symptoms from halitosis to colon cancer, kidney disease and calcium excretion. As Benson points out, while we are encouraged to 'defend ourselves against "health risks" the spectre of loss of self-control, as well as of "risks" in our social and physical environment that we *cannot* control, become an increasing source of anxiety' (1997: 124). In making sense of changing food cultures in the twenty-first century, these may become increasingly important issues.

Notes

1 Food-cultural studies: three paradigms

1 The family is not the only structure impacting upon the children's consumption practices. James considers the relationship between kets and more fully capitalized and mediated forms of sweets.
2 Canned food appears in another key work of 'mass culture theory', Adorno and Horkheimer's *Dialectic of Enlightenment* (1944) as the touchstone against which other forms of cultural depredation might be measured. Surveying the Californian landscape, they note that, 'the older houses just outside the concrete city center look like slums, and the new bungalows on the outskirts . . . demand to be discarded after a short while like empty food cans' (cited in During, 1993: 30). Not only are the cans and buildings matter out of place, threatening a form of pollution, but both are also 'hygienic' emblems of a cultural sterility at odds with authentic food and authentic culture.
3 This situation is not, of course, beyond 'structural' constraints. In particular we can identify the values and products of the British Empire as having a central position in the teashop. Writing of the history of black people in Britain, Stuart Hall notes that:

> People like me who came to England in the 1950s have been there for centuries. I was coming home. I am the sugar at the bottom of the English cup of tea. I am the sweet tooth, the sugar plantations that rotted generations of English children's teeth. There are thousands of others beside me that are . . . the cup of tea itself.
>
> (1991: 48–9)

4 See also Gillespie (1995) and Classon (1996) for alternative accounts of the uses to which Coke is put by groups in Britain and Argentina respectively.

2 The raw and the cooked

1 As we have seen in Chapter 1, in *Mythologies* Barthes himself deploys a structuralist form of cultural analysis, albeit with rather different objectives to Lévi-Strauss.

4 Consumption and taste

1 For a more thorough critical appreciation of Mennell's work, see Warde (1997).

2 However, these gendered bodies and tastes are also cross-cut by class. Bourdieu's research suggests that gender differences are particularly acute within working-class culture in which the body that performs manual labour is associated with bulk and strength. Food consumption works to reaffirm this conception of the masculine body: working-class men have a taste for meat which is 'strong and strong-making'. As Bourdieu argues, 'It behooves a man to drink and eat more, and to eat and drink stronger things' (1984: 192). For middle-class men who are not only associated with mental labour but who are increasingly subject to new bodily disciplines as they are required to be groomed and stylish within the workplace (Adkins, 2002), there may be a closer association with what have been seen as feminine tastes.

5 The national diet

1 For a sample of responses to this question see Bell and Valentine (1997: 170).

2 See also the discussion in Chapter 10 of Elizabeth Acton's Victorian cookery book providing further insights into nineteenth-century perceptions of the inferiority of English to French methods of food preparation.

3 In 'Bhaji's in Britain', part 4 of *Slice of Life*, BBC 2, 1995.

4 The iconic status of beef is not of course exclusive to British food. The USA and France are two obvious further examples. The prodigious quantities of beef consumed by Texans have mythic status and the reader is referred to Chapter 1 for discussion of Barthes's reading of steak and Frenchness.

5 Fish was the focus of the three 'cod wars' waged by Britain and Iceland in 1958, 1972 and 1975. Though feelings ran high, and there were frequent skirmishes and damage to nets and ships, the intensity of national feeling fell short of that generated by BSE.

6 See especially Murcott (1998). This volume reports the findings of a number of ESRC funded research projects, running from 1992 to 1998, which aimed to improve understanding of the processes of food choice.

7 While we don't have space to discuss this further here, for an overview see Matless (1998).

7 Shopping for food

1 We should remember here that the two authors' methods – Warde's textual analysis of magazines and Miller's fieldwork – are very different, yielding different outcomes.

2 There are undoubted contradictions between modern and traditional forms of foodstuff within markets. Kneafsey and Ilbery (2001) note that producers of 'traditional' regional produce in the UK are often reluctant to use 'heritage' images because they think they are at odds with consumer demands for 'modern' values such as hygiene.

3 The architects responsible for the redevelopment, Greig and Stephenson, also engaged in the discourse of 'textured space', noting with approval Borough Market's 'anarchic and conflicting geometries'; see: <http://www.boroughmarket.org.uk> (accessed 10 July 2002).

4 This practice is subject to reflexive estimations. Newspapers have reported widespread frustration with the practice of replacement, whereby pickers automatically replace missing goods with goods that may, or may not be, similar. The online trader Ocado, working with the UK Waitrose chain, has based its marketing campaign on this reflexivity.

8 Eating in

1 Given the structural differences between a pasta dish and more traditionally British fare, this might seem something of a radical departure. Levenstein (1993) has noted the role that pasta played in reshaping the national diet in the postwar USA.

2 Although historically out of place in this discussion, the following characterization of the British housewife, from 1904, from the government's Interdepartmental Committee on Physical Deterioration makes interesting reading:

> If, as one witness emphatically stated, with the support more or less marked of others, a large proportion of British housewives are tainted with incurable laziness and distaste for the obligations of domestic life, they will naturally have recourse to such expedients in providing food for their families as involves them in least trouble.
>
> (cited in Mennell, 1996: 263)

Such comments also accentuate the tension between care and convenience for women discussed later in this chapter.

3 By 2002, the Oxo family was resuscitated after Unilever, who had acquired Oxo, decided that the Oxo family was central to the brand. The rebirth of the Oxo family received far less press coverage (Archer, 2002).

4 Indeed, this is not a new phenomenon as the pages of US magazines *Esquire* and *Playboy* in the 1940s and 1950s demonstrate (Hollows, 2002). For more on masculinity and domesticity in relation to cooking, see Moseley (2001) and Hollows (2003b).

5 The gendering of cooking as leisure or labour is frequently negotiated in television cookery shows, especially those that emphasize cooking as lifestyle such as *The Naked Chef* and *Nigella Bites*.

6 A useful assessment of these debates is provided by Segal (1987).

7 There is considerable debate about the usefulness of Bourdieu for analysing gender inequalities: see, for example, Moi (1991), McCall (1992) and Laberge (1995).
8 From *BBC Good Food Magazine*, August 1999.
9 For other critiques of this position, see Cowan (1983) and Forty (1986: 207–21).
10 From *BBC Good Food Magazine*, November 1999.
11 See Skeggs (1997) for an account of how the caring subject in the UK has been open to historical transformation.

10 Food writing

1 More recently, we might identify the emergence of cookery books which emphasize either male culinary incompetence or a masculine unease with the domestic kitchen (see Anderson and Walls, 1996; Bastyra, 1996; Zen, 2000).
2 This development bears comparison with the emergence of coffee houses more than a century earlier. Both sites undermined the social hierarchy of feudalism and extended laws of decency and civility into new sections of the middle class. Stallybrass and White observe that 'although it was an "addition" to the cultural map, the coffee house presented itself not so much as an addition as a replacement, an alternative site and part of an alternative and superior stratification of the city' (1986: 99), and we see this analysis as holding true in the post-revolutionary restaurant.
3 This emphasis upon the domestic scene is surprising, given that Brillat-Savarin was a well-known restaurant diner. Yet the novel space of the restaurant allows little room for either the nostalgic evocation of memorable meals or the mythologizing identified by Mennell as key tropes of gastronomic literature. The home, by contrast, is the focus for a variety of memories and narratives. Ferguson argues that *Physiologie* gives little space to restaurants since they 'fostered an excessive individualism possibly destructive of the social fabric' (2001: 25).
4 Harris has, indeed, co-authored a cookbook, Harris and Warde (2002).

11 Television chefs

1 We are grateful to Joyce Hollows for much of this information.
2 For further discussion of Delia Smith in relation to public service broadcasting, see Moseley (2000) and Bell (2000).
3 In more abstract but precise terms, Bourdieu explains this process as follows:

> In this economic universe [the economy of symbolic goods], whose very functioning is defined by a 'refusal' of the 'commercial' which is in fact a collective disavowal of commercial interests and profits, the most

'anti-economic' and most visibly 'disinterested' behaviours, which in an 'economic' universe would be the most visibly condemned, contain a form of economic rationality (even in the restricted sense) and in no way exclude their authors from even the 'economic' profits awaiting those who conform to the laws of this universe. Producers and vendors who 'go commercial' condemn themselves, and not only from an ethical or aesthetic point of view, because they deprive themselves of the opportunities open to those . . . who, by concealing from themselves and from others the interests that are at stake in the practice, obtain the means of deriving profits from disinterestedness.

(1993: 75)

4 For more on the relationship between masculinity, cooking and leisure, see Hollows, 2002 and 2003b. For a discussion of how Nigella Lawson negotiates a mode of middle-class femininity which acknowledges cooking as both leisure and labour, see Hollows, 2003a.
5 This conflict has itself been dramatized on television in the series *Chef for a Night,* in which expert amateurs tried their hand at running a restaurant kitchen for the night, usually with very limited success.

12 Food ethics and anxieties

1 Available at: <http://www.vegsoc.org> (accessed 14 August 2003).

References

Acton, E. (1968) *The Best of Eliza Acton* (ed. Elizabeth Ray), Harmondsworth: Penguin.

Adair, G. (1986) *Myths and Memories*, London: Flamingo.

Adams, C. (1990) *The Sexual Politics of Meat: a feminist-vegetarian critical theory*. Cambridge: Polity.

Adkins, L. (2002) *Revisions: gender and sexuality in late modernity*, Buckingham: Open University Press.

Ainsworth, J. (ed.) (1995) *The Good Food Guide*, London: Consumers' Association.

Allen, J. (1995) 'Global worlds', in J. Allen and D. Massey (eds) *Geographical Worlds*, Oxford: Oxford University Press.

Anderson, B. (1983) *Imagined Communities*, London: Verso.

Anderson, D. and Walls, M. (1996) *Cooking for Blokes*, London: Warner Books.

Ang, I. (1985) *Watching Dallas: soap opera and the melodramatic imagination*, London: Methuen.

—— (1990) 'Melodramatic Identifications: television fiction and women's fantasy', in M. E. Brown (ed.) *Television and Women's Culture*, London: Sage.

Anon. (1898) *Manners and Rules of Good Society, or Solecisms to be Avoided, by a Member of the Aristocracy* (23rd edn), London: Frederick Warne and Co.

Appadurai, A. (1988) 'How to Make a National Cuisine: cookbooks in contemporary India', *Comparative Studies in Society and History*, 30, 1.

Archer, B. (2002) 'Risen From the Gravy', *The Guardian*, 7 January.

Author Unknown (1988) *The Guardian*, 15 April: 15.

Author Unknown (1999) *Independent on Sunday*, 21 March.

Bakhtin, M. M. (1984) *Rabelais and His World*, Bloomington: Indiana University Press.

Barker, M. and Beezer, A. (1992) 'Introduction: What's in a text?', in M. Barker and A. Beezer (eds) *Reading into Cultural Studies*, London: Routledge.

Barlow, M. (2001) 'The Global Water Crisis and the Commodification of the World's Water Supply', <http:www.corpwatchindia.org/issues/PID.jsp?articleid=503> (accessed 4 December 2002).

Barr, A. and Levy, P. (1984) *The Official Foodie Handbook*, London: Ebury Press.

Barrett, F. (2000) 'Allez Calais, innit', *Mail on Sunday*, 26 November: 98.

Barrie, C. (1999) 'BBC Brands New Global Strategy', *The Guardian*, 19 February.

Barthes, R. (1972) *Mythologies*, London: Paladin.

—— (1997) 'Toward a Psychosociology of Contemporary Food Consumption', in C. Counihan and P. van Esterik (eds) *Food and Culture: a reader*, London: Routledge.

Barwick, S. (1999) 'Last Dinner as Oxo Family Finally Crumbles', *Daily Telegraph*, 31 August.

Bastyra, J. (1996) *Cooking with Dad*, London: Bloomsbury.

Bati, A. (1991) 'Britannia Rules the Waves', *Sunday Times*, 22 September.

Bayless, R. and Bayless, D. G. (1987) *Authentic Mexican: regional cooking from the heart of Mexico*, New York: William Morrow.

Beardsworth, A. and Keil, T. (1992) 'The Vegetarian Option: varieties, conversions, motives and careers', *Sociological Review*, 40, 2.

—— (1997) *Sociology on the Menu: an invitation to the study of food and society*, London: Routledge.

Bell, D. (2000) 'Performing Taste: celebrity chefs and culinary cultural capital', paper delivered at the Third International Crossroads in Cultural Studies conference, University of Birmingham, June 2000.

—— (2002) 'From Writing at the Kitchen Table to TV Dinners: food media, lifestylization and European eating', paper presented at Eat Drink and Be Merry? Cultural Meanings of Food in the 21st Century conference, Amsterdam, June 2002, <http://cf.hum.uva.nl/research/asca/Themediareader.html> (accessed on 20 August 2002).

Bell, D. and Valentine, G. (1997) *Consuming Geographies: we are where we eat*, London: Routledge.

Bennett, T. (1981) 'Popular Culture: history and theory', Open University U203, 1, 3.

Benson, S. (1997) 'The Body, Health and Eating Disorders', in K. Woodward (ed.) *Identity and Difference*, London: Sage.

Bentley, A. (1998) *Eating for Victory: food rationing and the politics of domesticity*, Urbana: University of Illinois Press.

—— (1999) 'Bread, Meat and Rice: exploring cultural elements of food riots', proceedings of the conference Cultural and Historical Aspects of Food: Yesterday, Today, Tomorrow, Oregon State University, April 9–11.

Bhattacharyya, G. (1998) 'Sex, Race and Meat: cultural studies, cultural materialism and the end of the world as we know it', *Keywords*, 1.

Billig, M. (1995) *Banal Nationalism*, London: Sage.

Boshoff, A. (1997) 'BBC's £9m Epic is Outdone by Cookery Shows', *Daily Telegraph*, 6 February.

—— (1998) 'Delia Goes to Work on the Egg', *Daily Telegraph*, 16 June.

Bourdain, A. (2000) *Kitchen Confidential: adventures in the culinary underbelly*, London: Bloomsbury.

—— (2001) *A Cook's Tour*, London: Bloomsbury.

Bourdieu, P. (1971) 'Intellectual Field and Creative Project', in M. F. D. Young

(ed.) *Knowledge and Control: new directions for the sociology of education*, London: Collier-Macmillan.

—— (1984) *Distinction*, London: Routledge.

—— (1990) *The Logic of Practice*, Stanford: Stanford University Press.

—— (1993) *The Field of Cultural Production*, Cambridge: Polity.

Bowlby, R. (1997) 'Supermarket Futures', in P. Falk and C. Campbell (eds) *The Shopping Experience*, London: Sage.

Branca, P. (1975) *Silent Sisterhood: middle-class women in the Victorian home*, London: Croom Helm.

Bridge, S. (2002) *Mail on Sunday*, 28 April, Financial Mail: 7.

Brillat-Savarin, J.-A. (1976) *Physiologie du Goût: méditations de gastronomie transcendante*, Harmondsworth: Penguin.

Broadcasting Standards Commission (1998) *The Bulletin*, No. 11.

Brunsdon, C. (2000) *The Feminist, the Housewife and the Soap Opera*, Oxford: Oxford University Press.

Burch Donald, E. (ed.) (1990) *Debrett's Etiquette and Modern Manners*, Exeter: Webb and Bower.

Burgoyne, J. and Clarke, D. (1983) 'You Are What You Eat: food and family reconstitution', in A. Murcott (ed.) *The Sociology of Food and Eating*, Aldershot: Gower.

Burke, P. (1978) *Popular Culture in Early Modern Europe*, London: Temple Smith.

Burkeman, O. (2002) 'Not So Big, Mac', *The Guardian*, 22 November: G2.

Burnett, J. (1989) *Plenty and Want: a social history of food in England from 1815 to the present day* (3rd edn), London: Routledge.

Caplan, P. (ed.) (1997), *Food, Health and Identity*, London: Routledge

—— (ed.) (2000a) *Risk Revisited*, London: Pluto.

—— (ed.) (2000b) '"Eating British Beef with Confidence": a consideration of consumers' responses to BSE in Britain', in P. Caplan (ed.) *Risk Revisited*, London: Pluto.

Caplan, P., Keane, A., Willetts, A. and Williams, J. (1998) 'Studying Food Choice in its Social and Cultural Contexts: approaches from a social anthropological perspective', in A. Murcott (ed.) *The Nation's Diet: the social science of food choice*, Harlow: Longman.

Caraher, M., Dixon, P., Lang, T. and Carr-Hill, R. (1999) 'The State of Cooking in England: the relationship of cooking skills to food choice', *British Food Journal*, 101, 8.

Carrier, R. (1992) *Feasts of Provence*, London: Weidenfeld and Nicolson.

Castell, H. and Griffin, K. (1993) *Out of the Frying Pan: seven women who changed the course of postwar cookery*, London: BBC.

Charles, N. (1995) 'Food and Family Ideology', in S. Jackson and S. Moores (eds) *The Politics of Domestic Consumption*, Hemel Hempstead: Harvester Wheatsheaf.

Charles, N. and Kerr, M. (1988) *Women, Food and Families: power, status, love, anger*, Manchester: Manchester University Press.

Clarke, A. J. (1997) 'Tupperware: suburbia, sociality and mass consumption', in R. Silverstone (ed.) *Visions of Suburbia*, London: Routledge.

—— (1998) 'Window Shopping at Home: classifieds, catalogues and new consumer skills, in D. Miller (ed.) *Material Cultures: why some things matter*, London: UCL Press.

Clarke, J. (1975) 'Subcultures, Cultures and Class', in S. Hall and T. Jefferson (eds) *Resistance Through Rituals*, London: Routledge.

—— (1979) 'Capital and Culture: the post-war working class revisited', in J. Clarke, C. Critcher and R. Johnson (eds) *Working-class Culture: studies in history and theory*, London: Hutchinson.

—— (1991) *New Times and Old Enemies: essays on cultural studies and America*, London: HarperCollins.

Clarke, S. (1981) *The Foundations of Structuralism: a critique of Lévi-Strauss and the structuralist movement*, Brighton: Harvester Press.

Classen, C. (1996) 'Sugar Cane, Coca-cola and Hypermarkets: consumption and surrealism in the Argentine northwest', in D. Howe (ed.) *Cross-Cultural Consumption*, London: Routledge.

Cohen, S. (1993) *Folk Devils and Moral Panics: the creation of the mods and rockers*, Oxford: Blackwell.

Con Davis, R. and Schleifer, R. (1991) *Criticism and Culture: the role of critique in modern literary theory*, Harlow: Longman.

Cook, I. (1995) 'Constructing the Exotic: the case of tropical fruit', in J. Allen and D. Massey (eds) *Geographical Worlds*, Oxford: Oxford University Press.

Cook, I. and Crang, P. (1996) 'The World on a Plate: culinary culture, displacement and geographical knowledges', *Journal of Material Culture*, 1, 2.

Cook, I., Crang, P. and Thorpe, M. (2000) 'Regions to be Cheerful: culinary authenticity and its geographies' in I. Cook, D. Crouch, S. Naylor and J. Ryan (eds) *Cultural Turns/Geographical Turns: perspectives on cultural geography*, London: Pearson.

Cook, S., Perry, T. and Ward, G. (1998) *USA: the rough guide*, Harmondsworth: Penguin.

Corner, J. and Harvey, S. (1991), 'Mediating Tradition and Modernity: the heritage/enterprise couplet', in J. Corner and S. Harvey (eds) *Enterprise and Heritage: cross-currents of national culture*, London: Routledge.

Counihan, C. and van Esterik, P. (eds) (1997) *Food and Culture: a reader*, London: Routledge.

Coveney, J. (1999) 'The Government of the Table: nutrition expertise and the social organization of family food habits', in J. Germov and L. Williams (eds) *A Sociology of Food and Nutrition: the social appetite*, South Melbourne: Oxford University Press.

Cowan, R. (1983) *More Work for Mother: the ironies of household technology from the open hearth to the microwave*, New York: Basic Books.

Coward, R. (1999) 'Guess Who's Cooking the Dinner', *The Guardian*, 23 December.

Coxon, T. (1983), 'Men in the Kitchen: notes from a cookery class', in A. Murcott (ed.) *The Sociology of Food and Eating*, Aldershot: Gower.

Crotty, P. (1999) 'Food and Class', in J. Germov and L. Williams (eds) *A Sociology of Food and Nutrition: the social appetite*, South Melbourne: Oxford University Press.

Daft, R. (1998) 'The Dish that Ate a Nation', *Mail on Sunday*, 20 December.

David, E. (1966) *French Country Cooking* (2nd rev. edn), Harmondsworth: Penguin.

—— (1968) 'Introduction', in E. Acton, *The Best of Eliza Acton*, Harmondsworth: Penguin.

—— (1986) *An Omelette and a Glass of Wine*, Harmondsworth: Penguin.

—— (1989) *Italian Food* (rev. edn), Harmondsworth: Penguin.

—— (1991) *A Book of Mediterranean Food* (2nd rev. edn), Harmondsworth: Penguin.

Davies, C. (1988) 'The Irish Joke as a Social Phenomenon', in J. Durrant and J. Miller (eds) *Laughing Matters: a serious look at humour*, Harlow: Longman.

Davis, B. (2000) *Home Fires Burning: food, politics and everyday life in World War One Berlin*, Chapel Hill: University of North Carolina Press.

Davis, M. (1990) *City of Quartz*, London: Verso.

De Bens, E. (1998) 'Television Programming: more diversity, more convergence?', in K. Brants, J. Hermes and L. van Zoonen (eds) *The Media in Question: popular cultures and public interests*, London: Sage.

De Bertodano, H. (1997) 'All Rhodes Lead to the City', *Daily Telegraph*, 25 January.

De Certeau, M., Giard, L. and Mayol, P. (1998) *The Practice of Everyday Life. Vol. 2: Cooking and Eating*, Minnesota: University of Minnesota Press.

Derrida, J. (1992) 'Structure, Sign and Play in the Discourse of the Human Sciences', in S. Sim (ed.) *Art: context and value*, Milton Keynes: The Open University.

DeVault, M. (1991) *Feeding the Family: the social organization of caring as gendered work*, Chicago: University of Chicago Press.

Dickinson, R. (1998) 'Modernity, Consumption and Anxiety: television audiences and food choice', in R. Dickinson, R. Haraindranath and O. Linne, *Approaches to Audiences: a reader*, London: Arnold.

Donald, J. (1988) 'How English is it?', *New Formations*, 6.

Douglas, M. (1966) *Purity and Danger: an analysis of the concepts of pollution and taboo*, London: Routledge and Kegan Paul.

—— (1975) *Implicit Meanings: essays in anthropology*, London: Routledge and Kegan Paul.

—— (1997) 'Deciphering a Meal', in C. Counihan and P. van Esterik (eds) *Food and Culture: a reader*, London: Routledge.

Drake McFeeley, M. (2001) *Can She Bake a Cherry Pie? American women and the kitchen in the twentieth century*, Amherst: University of Massachusetts Press.

Du Gay, P., Hall, S., Janes, L., MacKay, H. and Negus, K. (1997) *Doing Cultural Studies: the story of the Sony Walkman*, London: Sage.

During, S. (ed.) (1993) *A Cultural Studies Reader*, London: Routledge.

Eagleton, T. (1983) *Literary Theory: an introduction*, Oxford: Blackwell.

—— (2000) *The Idea of Culture*, Oxford: Blackwell.

Eder, K. (1996) *The Social Construction of Nature: a sociology of ecological enlightenment*, London: Sage.

Eldridge, J. (1999) 'Risk, Society and the Media: now you see it, now you don't', in G. Philo (ed.) *Message Received: Glasgow Media Group research 1993–1998*, London: Longman.

Elias, N. (1978a) *The Civilizing Process: the history of manners*, Oxford: Blackwell.

—— (1978b) *What is Sociology?* London: Hutchinson.

—— (1982) *The Civilizing Process: state formation and civilization*, Oxford: Blackwell.

Ellis, R. (1983) 'The Way to a Man's Heart: food in the violent home', in A. Murcott (ed.) *The Sociology of Food and Eating*, Aldershot: Gower.

Engels, F. (1958) *The Condition of the English Working Class*, Oxford: Basil Blackwell.

Entwistle, J. (1997) '"Power Dressing" and the Construction of the Career Woman', in M. Nava, A. Blake, I. MacRury and B. Richards (eds) *Buy This Book: studies in advertising and consumption*, London: Routledge.

—— (2000) *The Fashioned Body: fashion, dress and modern social theory*, Cambridge: Polity.

Environment, Transport and Regional Affairs Select Committee (1998), *Report on Allotments*, <http://www.parliament.the-stationery-office.co.uk/pa/cm199798/cmselect/cmenvtra/560/56002.htm> (accessed 2 December 2002).

Ezard, J. (2000) 'Harry Makes Mincemeat out of Hannibal and Delia', *The Guardian*, 12 July.

Falk, P. (1994) *The Consuming Body*, London: Sage.

Fantasia, R. (1995) 'Fast Food in France', *Theory and Society*, 24, 2.

Fattorini, J. (1994) 'Food Journalism: a medium for conflict?', *British Food Journal*, 96, 10: 24–8.

Fearnley-Whittingstall, H. (1999) 'Setting an Example', *The Guardian*, 29 August.

—— (2001) *The River Cottage Cookbook*, London: HarperCollins.

Featherstone, M. (1991a) *Consumer Culture and Postmodernism*, London: Sage.

—— (1991b), 'The Body in Consumer Culture', in M. Featherstone, M. Hepworth and B. Turner (eds) *The Body: social process and cultural theory*, London: Sage.

Felski, R. (2000) *Doing Time: feminist theory and postmodern culture*, New York: New York University Press.

Ferguson, M. and Golding, P. (eds) (1997) *Cultural Studies in Question*, London: Sage.

Ferguson, P. (2001) 'A Cultural Field in the Making', in L. Schehr and A. Weiss (eds) *French Food on the Table, on the Page and in French Culture*, London: Routledge.

Ferguson, P. and Zukin, S. (1998) 'The Careers of Chefs', in R. Scapp and B. Seitz (eds) *Eating Culture*, Albany: SUNY Press.

Fiddes, N. (1997) 'Past, Present . . . and Future Imperfect?', in P. Caplan (ed.) *Food, Health and Identity*, London: Routledge.

Fine, B. (1998) *The Political Economy of Diet, Health and Food Policy*, London: Routledge.

Finkelstein, J. (1989) *Dining Out: a sociology of modern manners*, Cambridge: Polity.

—— (1999) 'Rich Food: McDonald's and modern life', in B. Smart (ed.) *Resisting McDonaldization*, London: Sage.

Fischler, C. (1980) 'Food Habits, Social Change and the Nature/Culture Dilemma', *Social Science Information*, 19.

—— (1988) 'Food, Self and Identity', *Social Science Information*, 27.

—— (2000) 'The "McDonaldization" of Culture', in J.-L. Flandrin and M. Montenari (eds) *Food: a culinary history*, New York: Columbia University Press.

Fiske, J. (1989) *Understanding Popular Culture*, Boston: Unwin Hyman.

Fort, M. (1999a) 'A Question of Taste', *The Guardian*, 21 December.

—— (1999b) 'Ready, Steady, Write', *The Guardian*, 16 July.

—— (1999c) 'A Beginner's Guide to Cook Books', *The Guardian*, 10 November.

Forty, A. (1986) *Objects of Desire: design and society since 1750*, London: Thames and Hudson.

Fox Genovese, E. (1991) *Feminism Without Illusions*, Chapel Hill: University of North Carolina Press.

Franklin, A. (1999) *Animals and Modern Cultures: a sociology of human–animal relations in modernity*, London: Sage.

Friedman, J. (1990) 'Being in the World: globalization and localization', in M. Featherstone (ed.) *Global Culture: nationalism, globalization and modernity*, London: Sage.

Gellner, E. (1983) *Nation and Nationalism*, Oxford: Blackwell.

Giard, L. (1998) 'Doing-Cooking', in M. De Certeau, L. Giard and P. Mayol (eds) *The Practice of Everyday Life. Vol. 2: Living and Cooking*, Minneapolis: University of Minnesota Press.

Giddens, A. (1990) *The Consequences of Modernity*, Cambridge: Polity.

—— (1991) *Modernity and Self Identity: self and society in the late modern age*, Cambridge: Polity.

Gillespie, C. H. (1994) 'Gastrosophy and *Nouvelle Cuisine*', *British Food Journal*, 96, 10.

Gillespie, M. (1995) *Television, Ethnicity and Cultural Change*, London: Routledge.

Glancy, J. (1999) 'The Lure of the Aisles', in C. Catterell (ed.) *Food: design and culture*, London: Lawrence King.

Goody, J. (1997) 'Industrial Food: towards the development of a world cuisine', in C. Counihan and P. van Esterik (eds) *Food and Culture: a reader*, London: Routledge.

Gramsci, A. (1991) *Selections from the Prison Notebooks*, London: Lawrence and Wishart.

Gray, R. and Rogers, R. (1995) *The River Café Cookbook*, London: Ebury Press.

Greenslade, R. (1996), 'With Some Guns Blazing', *The Guardian*, 3 June.

Gregoriadis, L. (1999) 'Oxo Serves Up New Ad Recipe', *The Guardian*, 20 December.

Gregson, N. and Crewe, L. (1994) 'Beyond the High Street and the Mall: car boot fairs and the new geographies of consumption', *Area*, 26, 3.

Grigson, J. (1975) *Charcuterie and French Pork Cookery*, Harmondsworth: Penguin.

—— (1991) *Good Things* (rev. edn), Harmondsworth: Penguin.

—— (1992) *English Food* (2nd rev. edn), Harmondsworth: Penguin.

Grossberg, L. (1996) 'The Circulation of Cultural Studies', in J. Storey (ed.) *What is Cultural Studies? A reader*, London: Arnold.

Grunow, J. (1997) *The Sociology of Taste*, London: Routledge.

Hall, S. (1981) 'Notes on Deconstructing "The Popular"', in R. Samuel (ed.) *People's History and Socialist Theory*, London: Routledge.

—— (1991) 'Old and New Identities, Old and New Ethnicities', in A. King (ed.) *Culture, Globalization and the World-System*, London: Macmillan.

—— (1997) 'The Work of Representation', in S. Hall (ed.) *Representation: cultural representations and signifying practices*, London: Sage.

Hall, S. and Jefferson, T. (eds) (1976) *Resistance Through Rituals: youth cultures in post-war Britain*, London: Hutchinson.

Hannerz, U. (1990) 'Cosmopolitans and Locals in World Culture', in Mike Featherstone (ed.) *Global Culture: nationalism, globalization and modernity*, London: Sage.

Harbutt, J. (1997) 'Champion Cheeses', *The Good Food Magazine*, November.

Hardyment, C. (1995) *Slice of Life: the British way of eating since 1945*, London: BBC.

Harman, C. (2000) 'Anti-capitalism: theory and practice', *International Socialism Journal*, 88.

Harris, J. (2000) *Chocolat*, London: Abacus.

—— (2001) *Blackberry Wine*, London: Abacus.

—— (2002) *Five Quarters of the Orange*, London: Abacus.

Harris, J. and Warde, F. (2002) *The French Kitchen: a cook book*, London: Doubleday.

Harris, M. (1997) 'The Abominable Pig', in C. Counihan and P. van Esterik (eds) *Food and Culture: a reader*, London: Routledge.

Haïtalis, D. (1992) *The Best Traditional Recipes of Greek Cooking*, Athens: Editions D. Haïtalis.

Hebdige, D. (1979) *Subculture: the meaning of style*, London: Methuen.

—— (1988) *Hiding in the Light*, London: Routledge.

Henderson, F. (2000) *Nose to Tail Eating*, London: Macmillan.

Hoggart, R. (1968) *The Uses of Literacy*, Harmondsworth: Penguin.

Hollows, J. (2002) 'The Bachelor Dinner: masculinity, class and cooking in *Playboy*, 1953–61', *Continuum: Journal of Media and Cultural Studies*, 16, 2.

—— (2003a) 'Feeling Like a Domestic Goddess: post-feminism and cooking', *European Journal of Cultural Studies*, 6, 2.

—— (2003b) 'Oliver's Twist: leisure, labour and domestic masculinity in *The Naked Chef*', *International Journal of Cultural Studies*, 6, 2.

Horner, J. R. (2000) '*Betty Crocker's Picture Cookbook*: a gendered ritual response to social crises of the postwar era', *Journal of Communication Inquiry*, 24, 3.

Horrigan, S. (1988) *Nature and Culture in Western Discourses*, London: Routledge.

Howell, S. (1997) 'Cultural Studies and Social Anthropology: contesting or complementary discourses?', in S. Nugent and C. Shore (eds) *Anthropology and Cultural Studies*, London: Pluto.

Humphery, K. (1998) *Shelf Life: supermarkets and the changing cultures of consumption*, Cambridge: Cambridge University Press.

Hyman, P. and Hyman, M. (1999) 'Printing the Kitchen: French cookbooks, 1480–1800', in J.-L. Flandrin and M. Montanari (eds) *Food: a culinary history*, New York: Columbia University Press.

Inness, S. (ed.) (2000) *Kitchen Culture in America*, Philadelphia: University of Pennsylvania Press.

—— (2001a) *Dinner Roles: American women and culinary culture*, Iowa City: University of Iowa Press.

—— (ed.) (2001b) *Pilaf, Pozole and Pad Thai: American women and ethnic food*, Amherst: University of Massachusetts Press.

Jackson, P. (1993) 'Towards a Cultural Politics of Consumption', in J. Bird, B. Curtis, T. Putnam, G. Robertson and L. Tickner (eds) *Mapping the Futures: local cultures and global change*, London: Routledge.

Jackson, P. and Thrift, N. (1995) 'Geographies of Consumption', in D. Miller (ed.) *Acknowledging Consumption: a review of new studies*, London: Routledge.

James, A. (1982) 'Confections, Concoctions and Conceptions', in B. Waites, T. Bennett and G. Martin (eds) *Popular Culture: past and present*, London: Croom Helm.

—— (1997), 'How British is British food?', in P. Caplan (ed.) *Food, Health and Identity*, London: Routledge.

Jenks, C. (1993) *Culture*, London: Routledge.

Jennings, C. (1999) 'Can I Get Down Now?', *The Guardian*, 25 June.

Johnson, R. (1986) 'The Story So Far: and further transformations?', in D. Punter (ed.) *Introduction to Contemporary Cultural Studies*, Harlow: Longman.

—— (1996) 'What is Cultural Studies Anyway?', in J. Storey (ed.) *What is Cultural Studies? A reader*, London: Arnold.

Jones, S. and Taylor, B. (2001) 'Food Writing and Food Cultures: the case of Elizabeth David and Jane Grigson', *European Journal of Cultural Studies*, 4, 2.

Kapoor, S. (2001) 'Take One Hot Cookery Writer and Allow to Stew', *The Independent*, Features Section, 23 June.

Kemmer, D. (1999) 'Food Preparation and the Division of Labour among Newly Married Couples', *British Food Journal*, 101, 8.

Kneafsey, M. and Ilbery, B. (2001) 'Regional Images and the Promotion of Speciality Food and Drink in the West Country', *Geography*, 86, 2.

Laberge, S. (1995) 'Towards an Integration of Gender into Bourdieu's Concept of Cultural Capital', *Sociology of Sport Journal*, 12, 2.

Lane, H. (1999) 'Twenty Years On, We're Still in Love with Delia', *The Observer*, 12 December.

—— (2000) 'Lord of the Gas Rings', *The Observer*, 26 March.

Lappé, F. (1971) *Diet for a Small Planet*, New York: Ballantine.

Laudan, R. (1999) 'A World of Inauthentic Cuisine', proceedings of the conference Cultural and Historical Aspects of Food: Yesterday, Today, Tomorrow, Oregon State University, April 9–11.

Lawrence, S. (1998) 'Turks' Delight', *The Sainsbury's Magazine*, March.

Lawson, N. (1998b) 'Can't Cook, Don't Want to', *The Guardian*, 13 October.

—— (1999) 'The Family that Eats Together . . . ', *The Observer*, 5 September.

—— (2000) *How to be a Domestic Goddess: baking and the art of comfort cooking*, London: Chatto & Windus.

Le Roy Ladurie, E. (1979) *Carnival: a people's uprising at Romans 1579–1580*, London: Scolar Press.

Leach, E. (1970) *Lévi-Strauss*, London: Fontana.

—— (1973) 'Structuralism in Social Anthroplogy', in D. Robey (ed.) *Structuralism: an introduction*, Oxford: Clarendon Press.

Leavis, F. and Thompson, D. (1933) *Culture and Environment: the training of critical awareness*, London: Chatto & Windus.

Lee, M. (1993) *Consumer Culture Reborn: the cultural politics of consumption*, London: Routledge.

Levenstein, H. (1993) *Paradox of Plenty: a social history of eating in modern America*, Oxford: Oxford University Press.

Lévi-Strauss, C. (1963) *Structural Anthropology. Vol. 1*, New York: Basic Books.

—— (1966) 'The Culinary Triangle', *Partisan Review*, 33, 4.

—— (1981) *The Naked Man (Introduction to a Science of Mythology: 4)*, London: Jonathan Cape.

—— (1994) *The Raw and the Cooked (Introduction to a Science of Mythology: 1)*, London: Pimlico.

Light, A. (1991) *Forever England: femininity, literature and conservatism between the wars*, London: Routledge.

Linley, D. (1999) *Sunday Times*, 30 June, News Review section.

Luard, E. (2000) *Saffron and Sunshine: tapas, mezze and antipasti*, London: Bantam Press.

Lunt, P. and Livingstone, S. (1992) *Mass Consumption and Personal Identity*, Buckingham: Open University Press.

Lupton, D. (1996) *Food, the Body and the Self*, London: Sage.

—— (1999) *Risk*, London: Routledge.

Lury, C. (1996) *Consumer Culture*, Cambridge: Polity.

Mabey, R. (1972) *Food for Free*, London: Collins.

McCall, L. (1992) 'Does Gender *Fit*? Bourdieu, feminism, and conceptions of social order', *Theory and Society*, 21, 6.

McGuigan, J. (1996) *Culture and the Public Sphere*, London: Routledge.

Macintyre, S., Reilly, J., Miller, D. and Eldridge, J. (1998) 'Food Choice, Food Scares and Health: the role of the media', in A. Murcott (ed.) *The Nation's Diet: the social science of food choice*, London: Longman.

Mackay, H. (ed.) (1997a) *Consumption and Everyday Life*, London: Sage.

—— (1997b) 'Consuming Communication Technologies at Home', in H. Mackay (ed.) *Consumption and Everyday Life*, London: Sage.

McLellan, D. (ed.) (1977) *Selected Writings of Karl Marx*, Oxford: Oxford University Press.

McRobbie, A. (1989) 'Second-Hand Dresses and the Role of the Ragmarket', in A. McRobbie (ed.) *Zoot Suits and Second-Hand Dresses*, London: Macmillan.

Marling, K. A. (1994) *As Seen on TV: the visual culture of everyday life in the 1950s*, Cambridge, MA: Harvard University Press.

Martens, L. (1997) 'Gender and the Eating Out Experience', *British Food Journal*, 99, 1.

Martens, L. and Warde, A. (1997) 'Urban Pleasure? On the meaning of eating out in a northern city', in P. Caplan (ed.) *Food, Health and Identity*, London: Routledge.

Marx, K. (1970) *Capital: a critique of political economy. Vol. 1*, London: Lawrence and Wishart.

Marx, K. and Engels, F. (1973) *Manifesto of the Communist Party*, Peking: Foreign Language Press.

Massey, D. (1994) *Space, Place and Gender*, Cambridge: Polity.

Matless, D. (1998) *Landscape and Englishness*, London: Reaktion.

Maurer, D. (1995) 'Meat as a Social Problem: rhetorical strategies in the contemporary vegetarian literature', in D. Maurer and J. Sobal (eds) *Eating Agendas: food and nutrition as social problems*, Hawthorn: Aldine de Gruyter.

May, J. (1996) 'In Search of Authenticity Off and On the Beaten Track', *Environment and Planning D: Society and Space*, 14.

Mennell, S. (1985) *All Manners of Food: eating and taste in England and France from the Middle Ages to the present*, Oxford: Blackwell.

—— (1992) *Norbert Elias: an introduction*, Oxford: Blackwell.

—— (1996) *All Manners of Food: eating and taste in England and France from the Middle Ages to the present* (2nd edn), Chicago: University of Illinois Press.

Mercer, C. (1984) 'Generating Consent', *Ten.8*, 18.

Middleton, C. (1997) 'The King of Padstein', *Daily Telegraph*, 12 April.

Miller, D. (1994) *Material Culture and Mass Consumption* (2nd edn), Oxford: Blackwell.

—— (1997a) 'Coca-Cola: a black sweet drink from Trinidad', in D. Miller (ed.) *Material Cultures*, London: UCL Press.

—— (1997b) 'Consumption and its Consequences', in H. Mackay (ed.) *Consumption and Everyday Life*, London: Sage.

—— (1998a) *A Theory of Shopping*, Cambridge: Polity.

—— (ed.) (1998b) *Material Cultures: why some things matter*, London: UCL Press.

Miller, R. (1994) '"A Moment of Profound Danger": British cultural studies away from the centre', *Cultural Studies*, 8, 3.

Mintel Marketing Intelligence (1999) *Eating Out Review*.

Mitchell, J. (1999) 'The British Main Meal in the 1990s: has it changed its identity?', *British Food Journal*, 101, 11.

Mitchell, V. and Greatorex, M. (1990), 'Consumer Perceived Risk in the UK Food Market', *British Food Journal*, 92, 2.

Moi, T. (1991) 'Appropriating Bourdieu: feminist theory and Pierre Bourdieu's sociology of culture', *New Literary History*, 22, 4.

Montanari, M. (1996) *The Culture of Food*, Oxford: Blackwell.

Moore, S. (2000) 'Did we Fight for the Right to Bake?', *Mail on Sunday*, 22 October.

Moores, S. (1993) *Interpreting Audiences*, London: Sage.

—— (2000) *Media and Everyday Life in Modern Society*, Edinburgh: Edinburgh University Press.

Morley, D. (1986) *Family Television*, London: Comedia.

—— (1991) 'Where the Global Meets the Local: notes from the sitting room', *Screen*, 32, 1.

—— (1992) 'Electronic Communities and Domestic Rituals', in M. Skovmand and K. Schroder (eds) *Media Cultures: reappraising transnational media*, London: Routledge.

—— (2000) *Home Territories: media, mobility and identity*, London: Routledge.

Morphy, Countess (1937) *Good Food From Italy: a receipt book*, London: Chatto & Windus.

Morris, J. (1953), 'No Kickshaws, Whole Bellyfulls', *Wine and Food*, 78.

Moseley, R. (2001) 'Real Lads *Do* Cook . . . But Some Things Are Still Hard To Talk About: the gendering of 8–9', *European Journal of Cultural Studies*, 4, 1.

Mounin, G. (1974) 'Lévi-Strauss's Use of Linguistics', in I. Rossi (ed.) *The Structuralism of Claude Lévi-Strauss in Perspective*, New York: E. P. Dutton and Co.

Mullan, J. (2001) 'From Sweetheart to Cook', *The Star Online*, <http://thestar.com.my/lifestyle/story.asp?file=/2001/12/12/features/moe1212d> (accessed 4 February 2003).

Munt, I. (1994) 'The "Other" Postmodern Tourism: culture, travel and the new middle classes', *Theory, Culture and Society*, 11, 3.

Murcott, A. (1983) 'Cooking and the Cooked: a note on the domestic preparation of meals', in A. Murcott (ed.) *The Sociology of Food and Eating*, Aldershot: Gower.

—— (1995) '"It's A Pleasure to Cook for Him": food, mealtimes and gender in some South Wales households', in S. Jackson and S. Moores (eds) *The Politics of Domestic Consumption*, Hemel Hempstead: Harvester Wheatsheaf.

—— (1997) 'Family Meals – a Thing of the Past?', in P. Caplan (ed.) *Food, Health and Identity*, London: Routledge.

—— (ed.) (1998) *The Nation's Diet: the social science of food choice*, London: Longman.

Murdock, G. (1995) 'Across the Great Divide', *Critical Studies in Mass Communications*, 12, 1.

Murphy, E., Parker, S. and Phipps, C. (1999) 'Motherhood, Morality and Infant Feeding', in J. Germov and L. Williams (eds) *A Sociology of Food and Nutrition: the social appetite*, South Melbourne: Oxford University Press.

Nairn, T. (1977) *The Break-up of Britain: crisis and neo-nationalism*, London: New Left Books.

Narayan, U. (1995) 'Eating Cultures: incorporation, identity and Indian food', *Social Identities*, 1, 1.

Nead, L. (1988) *Myths of Sexuality: representations of women in Victorian Britain*, Oxford: Basil Blackwell.

Negus, K. (1992) *Producing Pop: culture and conflict in the popular music industry*, London: Arnold.

Nelson, M. (1993) 'Social-class Trends in British Diet, 1860–1980', in C. Geissler and D. J. Oddy (eds) *Food, Diet and Economic Change: past and present*, Leicester: Leicester University Press.

Neuhas, J. (2001) 'Women and Cooking in Marital Sex Manuals, 1920–1963', in S. Inness (ed.), *Kitchen Culture in America: popular representations of food, gender, and race*, Philadelphia: University of Pennsylvania Press.

Normand, J.-M. (1999) 'McDonald's, critiqué mais toujours fréquenté', *Le Monde*, 24 September.

Orwell, G. (1937) *The Road to Wigan Pier*, Harmondsworth: Penguin.

—— (1968a) 'A Nice Cup of Tea', in *The Collected Essays, Journalism and Letters of George Orwell, Vol. 3*, Harmondsworth: Penguin.

—— (1968b) 'In Defence of English Cooking', in *The Collected Essays, Journalism and Letters of George Orwell, Vol. 3*, Harmondsworth: Penguin.

Pendergrast, M. (2002) *Uncommon Grounds: the history of coffee and how it transformed our world*, New York: Basic Books.

Peregrine, A. (2001) 'French Liberation on Bastille Day', *Daily Telegraph*, 14 July.

Perry, N. (1995) 'Travelling Theory/Nomadic Theorising', *Organization*, 2, 1.

Pook, S. (1999) 'Third of Population Dine Alone – With Food from a Packet', *Daily Telegraph*, 19 October.

Probyn, E. (2000) *Carnal Appetites: foodsexidentities*, London: Routledge.

Putnam, R. (2000) *Bowling Alone*, New York: Simon and Schuster.

Putnam, T. (1990) 'Introduction', in T. Putnam and C. Newton (eds) *Household Choices*, London: Middlesex Polytechnic and Future Publications.

Rabelais, F. (1955) *Gargantua and Pantagruel*, Harmondsworth: Penguin.

Radway, J. (1987) *Reading the Romance*, London: Verso.

Raven, C. (2000) 'A Half-baked Fantasy: on why Nigella Lawson has become an icon', *The Guardian*, October 3.

Ray, E. (1968) 'Preface', in E. Acton, *The Best of Eliza Acton*, Harmondsworth: Penguin.

Rée, J. (1992) 'Internationality', *Radical Philosophy*, 60.

Reilly, J. (1999) 'Just Another Food Scare? Public understanding and the BSE crisis', in G. Philo (ed.) *Message Received: Glasgow Media Group research, 1993–1998*, London: Longman.

Reilly, J. and Miller, D. (1997) 'Scaremonger or Scapegoat? The role of the media in the emergence of food as a social issue', in P. Caplan (ed.) *Food, Health and Identity*, London: Routledge.

Rex-Johnson, B. (1997) *The Pike Place Market Cookbook: recipes, anecdotes and personalities from Seattle's renowned public market*, Seattle: Sasquatch Books.

Rhodes, G. (1996) *Open Rhodes Around Britain*, London: BBC.

Richardson, P. (2000) *Cornucopia: a gastronomic tour of Britain*, London: Little Brown.

Riddell, M. (2003) 'We Just Can't Keep Out of Supermarkets', *The Observer*, 19 January.

Rifkin, J. (1993) 'Anatomy of a Cheeseburger', *Granta*, 38, Harmondsworth: Penguin.

Ritzer, G. (1993) *The McDonaldization of Society*, London: Sage.

—— (1998) *The McDonaldization Thesis*, London: Sage.

—— (2000) *The McDonaldization of Society* (New Century edn), Thousand Oaks: Pine Forge Press.

Robertson, R. (1992) *Globalization: social theory and global culture*, London: Sage.

—— (1995) 'Glocalization: time–space and homogeneity–heterogeneity', in M. Featherstone, S. Lash and R. Robertson (eds) *Global Modernities*, London: Sage.

Robins, K. (1996) *Into the Image: culture and politics in the field of vision*, London: Routledge.

Roden, C. (2000) 'The Global Kitchen', *The Observer*, 12 November, *Life* magazine supplement.

Roos, G., Prättälä, R. and Koski, K. (2001) 'Men, Masculinity and Food: interviews with Finnish carpenters and engineers', *Appetite*, 37 (1).

Ross, A. (1989) *No Respect: intellectuals and popular culture*, London: Routledge.

Ross, P. (2001) 'Globalizing and the Closing of the Universe of Discourse: the contemporary relevance of Marcuse's "Marxism",' <http://www.psa.as.uk/cps/2001/Ross%20Phil.pdf> (accessed 4 December 2002).

Rowe, D. (1999) 'A Brief History of Meal Time', *The Guardian*, 1 September.

Rowe, M. (1999) 'Has the Great British Curry House Finally had its Chips?', *Independent on Sunday*, 14 February.

Rozin, P., Haidt, J., McCauley, C. and Imada, S. (1997) 'Disgust: preadaptation and the cultural evolution of a food-based emotion', in H. Macbeth (ed.) *Food, Preference and Taste: continuity and change*, Providence: Berghan Books.

Rushe, D. (2001) 'www.basketcase', *Sunday Times*, 2 September, Business section.

Samuel, R. (1989) 'Exciting to be English', in R. Samuel (ed.) *Patriotism: the making and unmaking of British national identity. Vol. 3*, London: Routledge.

Schlesinger, P. (1987) 'On National Identity', *Social Science Information*, 26, 2.

Schlosser, E. (2001) *Fast Food Nation*, Harmondsworth: Penguin.

Schwarz, B. (1994) 'Where is Cultural Studies?', *Cultural Studies*, 8, 3.

Seenan, G. (1999) 'Ladies and Gentlemen, the Queen', *The Guardian*, 8 July.

Segal, L. (1987) *Is the Future Female? Troubled thoughts on contemporary feminism*, London: Virago.

Shields, R. (1991) *Lifestyle Shopping*, London: Sage.

Shiva, Vandana (2001) 'World Bank, WTO, and corporate control over water', *International Socialist Review*, August/September, <http://www.third worldtraveler.com/Water/Corp_Control_Water_Vshiva.html> (accessed 4 December 2002).

Shove, E. and Southerton, D. (2000), 'Defrosting the Freezer: from novelty to convenience', *Journal of Material Culture*, 5, 3.

Silva, E. (2000) 'The Cook, The Cooker and the Gendering of the Kitchen', *Sociological Review*, 48, 4.

Simmonds, D. (1990), What's Next? Fashion, foodies and the illusion of freedom', in A. Tomlinson (ed.) *Consumption, Identity and Style*, London: Comedia.

Singer, P. (1975) *Animal Liberation*, New York: Random House.

—— (1998) 'A Vegetarian Philosophy', in S. Griffiths and S. Wallace (eds) *Consuming Passions*, Manchester: Manchester University Press.

Skeggs, B. (1997) *Formations of Class and Gender*, London: Sage.

—— (forthcoming) *Class, Self and Culture*, London: Routledge.

Slater, N. (1993) *Real Fast Food*, Harmondsworth: Penguin.

Smart, B. (1993) *Postmodernity*, London: Routledge.

—— (1994) 'Digesting the Modern Diet: gastro-porn, fast food and panic eating', in K. Tester (ed.) *The Flâneur*, London: Routledge.

—— (1999) 'Resisting McDonaldization: theory', in B. Smart (ed.) *Resisting McDonaldization*, London: Sage.

Smith, A. (1991) *National Identity*, Harmondsworth: Penguin.

Smith, D. (1980) *One is Fun!*, London: Coronet.

—— (1982) *Complete Cookery Course*, London: BBC.

—— (1990) *Delia Smith's Christmas*, London: BBC.

—— (1993) *Summer Collection*, London: BBC.

—— (1995) *Winter Collection*, London: BBC.

—— (1998) *How to Cook: Book One*, London: BBC.

—— (1999) *How to Cook: Book Two*, London: BBC.

—— (2001) *How to Cook: Book Three*, London: BBC.

Soper, K. (1995) *What is Nature? Culture, politics and the non-human*, Oxford: Blackwell.

Spigel, L. (1997) 'From Theatre to Space Ship: metaphors of suburban domesticity in postwar America', in R. Silverstone (ed.) *Visions of Suburbia*, London: Routledge.

Stallybrass, P. and White, A. (1986) *The Politics and Poetics of Transgression*, Ithaca: Cornell University Press.

Stassart, P. and Whatmore, S. (2003) 'Metabolizing Risk: food scares, and the un/re-making of Belgian beef', *Environment and Planning A*, 35, 3.

Stedman Jones, G. (1982) 'Working-class Culture and Working-class Politics in London, 1870–1900: notes on the remaking of a working class', in B. Waites, T. Bennett and G. Martin (eds) *Popular Culture: past and present*, London: Croom Helm.

Steingarten, J. (1997) *The Man Who Ate Everything: and other gastronomic feats, disputes and pleasurable pursuits*, New York: Vintage.

Steptoe, A., Wardle, J., Lipsey, Z., Oliver, G., Pollard, T.M. and Davies, G.J. (1998) 'The Effects of Life Stress on Food Choice', in A. Murcott (ed.) *The Nation's Diet: the social science of food choice*, Harlow: Longman.

Stevens, S. (2001) *Feeding Frenzy*, London: Abacus.

Strange, N. (1998) 'Perform, Educate, Entertain: ingredients of the cookery programme genre', in C. Geraghty and D. Lusted (eds) *The Television Studies Book*, London: Arnold.

Straw, J. (2001) 'Globalization is good for us', *The Guardian*, 10 September.

Swallow, K. (ed.) (1994) *Cooking Class Mexican Cookbook*, London: Merehurst.

Taylor, B. (2001) 'Food in France: from *la nouvelle cuisine* to *la malbouffe*', in J. Marks and E. McCaffrey (eds) *French Cultural Debates*, Newark: University of Delaware Press.

Taylor, I., Evans, K. and Fraser, P. (1996) *A Tale of Two Cities*, London: Routledge.

Tester, K. (1994) *Media, Culture and Morality*, London: Routledge.

—— (1999) 'The Moral Malaise of McDonaldization: the values of vegetarianism', in B. Smart (ed.) *Resisting McDonaldization*, London: Sage.

Theophano, J. (2002) *Eat My Words: reading women's lives through the cookbooks they wrote*, New York: Palgrave.

Thompson, E. P. (1982) *The Making of the English Working Class*, Harmondsworth: Penguin.

Thompson, K. (1998) *Moral Panics*, London: Routledge.

Tomlinson, J. (1991) *Cultural Imperialism: a critical introduction*, Baltimore: Johns Hopkins University Press.

—— (1999) *Globalization and Culture*, Cambridge: Polity.

Tomlinson, M. (1998) 'Changes in Taste in Britain, 1985–1992', *British Food Journal*, 100, 6.

Tudor, A. (1999) *Decoding Culture*, London: Sage.

Turner, G. (1990) *British Cultural Studies: an introduction*, London: Unwin Hyman.

Twigg, S. (1983) 'Vegetarianism and the Meanings of Meat', in A. Murcott (ed.) *The Sociology of Food and Eating*, Aldershot: Gower.

Urry J. (1990a) 'The "Consumption" of Tourism', *Sociology*, 24, 1.

—— (1990b) *The Tourist Gaze: leisure and travel in contemporary societies*, London: Sage.

Vaughan, J. (1997) 'Gary Hits the Rhodes', *Daily Telegraph*, 27 September.

Vidal, J. (1997) *McLibel: burger culture on trial*, New York: New Press.

Warde, A. (1997) *Consumption, Food and Taste: culinary antinomies and commodity culture*, London: Sage.

—— (1999) 'Convenience Food: space and timing, *British Food Journal*, 101, 7.

Warde, A. and Hetherington, K. (1994) 'English Households and Routine Food Practices: a research note', *The Sociological Review*, 42, 4.

Warde, A. and Martens, L. (1998a) 'A Sociological Approach to Food Choice: the case of eating out', in A. Murcott (ed.) *The Nation's Diet: the social science of food choice*, Harlow: Longman.

—— (1998b) 'Eating out and the Commercialization of Mental Life', *British Food Journal*, 100, 3.

—— (2000) *Eating Out: social differentiation, consumption and pleasure*, Cambridge: Cambridge University Press.

Webster, S. (2000) 'A–Z of World Food', *The Observer*, 12 November, *Life* magazine supplement.

Willetts, A. (1997) '"Bacon Sandwiches Got the Better of Me": meat-eating and vegetarianism in South-East London', in P. Caplan (ed.) *Food, Health and Identity*, London: Routledge.

Williams, R. (1974) *Television: technology and cultural form*, London: Fontana.

—— (1975) *Culture and Society* (3rd edn), Harmondsworth: Penguin.

—— (1980) *Marxism and Literature*, Oxford: Oxford University Press.

—— (1983) *Towards 2000*, London: Chatto & Windus.

—— (1993) 'Culture is Ordinary', in A. Gray and J. McGuigan (eds) *Studying Culture: an introductory reader*, London: Arnold.

Williamson, J. (1978) *Decoding Advertisements: ideology and meaning in advertising*, London: Marion Boyars.

Willis, P. (1977) *Learning to Labour: how working class kids get working class jobs*, Farnborough: Saxon House.

Wilmott, P. and Young, M. (1957) *Family and Kinship in East London*, London: Routledge and Kegan Paul.

Wilson, J. (1999) 'Delia's Omelette in the Dock Again', *The Guardian*, 4 February.

Winner, M. (1998) 'Winner's Dinners', *Sunday Times*, 19 April.

Wood, R. C. (1994) 'Dining out on Sociological Neglect', *British Food Journal*, 96, 10.

—— (1995) *The Sociology of the Meal*, Edinburgh: Edinburgh University Press.

—— (1996) 'Talking to Themselves: food commentators, food snobbery and market reality', *British Food Journal*, 98, 10.

Wouters, C. (1986) 'Formalization and Informalization: changing tension balances in civilizing processes', *Theory, Culture and Society*, 3, 2.

—— (1987) 'Developments in the Behavioural Codes Between the Sexes: the formalization of informalization in the Netherlands, 1930–85', *Theory, Culture and Society*, 4, 2–3.

Wright, P. (1985) *On Living in an Old Country*, London: Verso.

Wrigley, N. (1998) 'How British Retailers have Shaped Food Choice', in A. Murcott (ed.) *The Nation's Diet: the social science of food choice*, Harlow: Longman.

Wyatt, J. (1994) *High Concept: movies and marketing in Hollywood*, Austin: Texas University Press.

Young, T., Burton, M. and Dorsett, R. (1998) 'Consumer Theory and Food Choice in Economics, with an Example', in A. Murcott (ed.) *The Nation's Diet: the social science of food choice*, Harlow: Longman.

Zen, Z. (2000) *A Cookbook for a Man Who Probably Only Owns One Saucepan: idiot-proof recipes*, Boston: Lagoon.

Zukin, S. (1991) *Landscapes of Power: from Detroit to Disneyland*, Berkeley: California University Press.

Index